FUTURES

A Personal Seminar

NEW YORK INSTITUTE OF FINANCE

NEW YORK • TORONTO • SYDNEY • TOKYO • SINGAPORE

Library of Congress Cataloging-in-Publication Data

Futures : a personal seminar.
 Includes index.
 ISBN 0-13-658196-X
 1. Futures. 2. Futures market. I. New York
Institute of Finance.
HG6024.A3F87 1988 88-28847
332.64'4 CIP

Printed in the United States of America

10 9

This publication is designed to provide accurate and authoritative information in regard to the subject matter covered. It is sold with the understanding that the publisher is not engaged in rendering legal, accounting, or other professional service. If legal advice or other expert assistance is required, the services of a competent professional person should be sought.
—*From the Declaration of Principles jointly adopted by a Committee of the American Bar Association and a Committee of Publishers and Associations*

ISBN 0-13-658196-X

ATTENTION: CORPORATIONS AND SCHOOLS

NYIF books are available at quantity discounts with bulk purchase for educational, business, or sales promotional use. For information, please write to: Prentice Hall Career & Personal Development Special Sales, 240 Frisch Court, Paramus, New Jersey 07652. Please supply: title of book, ISBN number, quantity, how the book will be used, date needed.

 NEW YORK INSTITUTE OF FINANCE
Paramus, NJ 07652

A Simon & Schuster Company

On the World Wide Web at http://www.phdirect.com

Prentice-Hall International (UK) Limited, *London*
Prentice-Hall of Australia Pty. Limited, *Sydney*
Prentice-Hall Canada Inc., *Toronto*
Prentice-Hall Hispanoamericana, S.A., *Mexico*
Prentice-Hall of India Private Limited, *New Delhi*
Prentice-Hall of Japan, Inc., *Tokyo*
Simon & Schuster Asia Pte. Ltd., *Singapore*
Editora Prentice-Hall do Brasil, Ltda., *Rio de Janeiro*

Contents

Introduction

Have you ever wondered whether trading in futures could make you rich? Well, it can—*if* you know what you're doing. And *if* you accept the reality that, at times, even well-informed and experienced traders lose—and they *can* lose big. But if you are seriously interested in participating in the futures markets, and ready to become as well-informed as possible, then this workbook is an invaluable first step toward that aim.

As with any form of trading or investing, certain precautions must be taken and certain preparations must be made before positioning any capital.

The *precaution* is to go slowly. The futures markets present fascinating possibilities for gain, but they are very unlike investing in stocks and bonds. They also involve much more risk.

The *preparation* is to *investigate* the possibilities, benefits, advantages, and rewards. You must get to know the market, become familiar with the terminology, procedures, and techniques. You must first determine your investment objectives and *evaluate* how the futures industry can help you meet those objectives.

If you are serious about trading in the futures market, or if you simply want to know more about how it works, then this guide will help you. You will learn about futures—what they are, how they

came to be, how they are used, and the strategies behind them. The purpose of this workbook is to inform you about this trading vehicle in such a way that no pressure is felt, no hard-to-grasp concepts are thrown at you, and no "insider" terms are left unexplained.

But the special feature of this workbook is that it does not just set forth all the facts and information and then leave you to sort it out on your own. Instead, throughout the text, you will be presented with sections entitled "Try This" and "Here's Why." In the "Try This" section, you will be asked a brief multiple choice or a probing "thought" question that will test your knowledge of what you have just read. Then check your answer against the answer in the "Here's Why" section, and you will know what you grasped and what you still need to review in each chapter. Together, these questions and answers will help you sort through the world of futures trading and prepare you for real situations you will encounter in the markets.

So take as much or as little time as you feel is necessary to comprehend and utilize this information for your own investment purposes. *You* set the pace. *You* determine your degree of involvement. *You* concentrate on what's important to you. It's that simple.

Here are the areas you will cover:

Chapter 1 discusses the basic topics of information you need to know regarding futures and commodities: what they are, their origins, the commodity exchange, trading limits, price fluctuations, risks, and federal regulations.

Chapter 2 examines the mechanics of trading a futures contract: you will learn what is in the contract itself, what is involved in the market, in the logistics of handling an account, and in the margin account.

Chapter 3 covers the different types of orders that you can place, such as the market order, stop order, limit order, and others.

Chapter 4 tells you about the role of the clearinghouse in the futures market: what it does, how it operates, how it handles an order, and its overall responsibilities.

Chapter 5 delves into the world of market analysis and how it is used in relation to the futures industry. It provides details regarding technical analysis and fundamental analysis, how they differ, how they are related, and how they may be helpful to you in market forecasting.

Chapter 6 covers two concepts very important to futures trad-

ing: volume of trading and open interest. You will learn what they are, how they are used, what influences them, and how you should interpret changes in these two indicators.

Chapter 7 discusses the complexities of hedging in the futures market: its advantages, disadvantages, risks, and applications, as well as basic strategies you should know before you become a hedger.

Chapter 8 talks about trading techniques, specifically speculation and spreading: what they are, how they work, how they are used, and the strategies you need to know to become a speculator.

Chapter 9 describes, in more detail, the different types of futures markets: currency futures, interest rate futures, commodities, and stock index futures.

And, as mentioned before, in each chapter you will frequently check your own grasp of the futures markets and strategies by working through the questions and answers in the "Try This" and "Here's Why" sections.

Now you're ready to take that first step toward learning about and participating in the exciting world of futures markets.

1

What Are Futures?

The Futures Contract

Futures trading has been a part of the world economic scene for a long time. Its basic concept goes back to the beginnings of commercial trade when merchants tried to protect themselves from a variety of adverse conditions, including declining and advancing prices. When signing a futures (forward delivery) contract, the parties involved agree to make or take delivery of a specified quantity and quality of a commodity (anything from cattle to corn to currency) at a specified future time and price. The price is often subject to supply and demand factors and a certain element of risk is involved.

Origin

The existence of risk is precisely what prompted the first use of a futures contract. Take farming for example. When an independent farmer plants crops for his own use, no outside party depends on him to produce. However, when a farmer plants to derive a profit from selling the crop, that's a different story. In the spring when

the farmer plants his corn, he faces many risks between the plant-ing and the harvesting of his crop. Some of the risks include blight, drought, vermin, and bad weather. There are even risks involved in having a good crop. If an abundance of corn at harvest time drives prices below the break-even point, the farmer risks losing his profit because his and his competitors' supply outweighs de-mand.

Clearly, the risks are there. With the advent of futures trading, a third party steps in to assume some of those risks. Often, a speculator who has money pays the farmer for the right to assume the risk as well as some of the future profit. The speculator arranges a contract to sell the commodity (corn in this case) to an interested buyer such as a grain miller.

The speculator feels secure in his commitment because he has analyzed the prospect of price changes in corn and feels the changes will be in his favor. While providing a service to those involved by assuming some of the risk, he also hopes to make a profit on his deal based on some market forecasting he has done. The primary reason for the establishment of the futures contract is to allay some of the inherent price risks of producing, storing, and marketing the corn.

History

The term *future* itself connotes how a trade is handled and the reasoning behind it.

Around the time of the Civil War, the farmer usually took the brunt of market fluctuations. If he was ready to sell soon after the harvest, so was everyone else. Consequently, at that time supplies were usually well in excess of immediate requirements—a situa-tion that resulted in depressed price levels. Farmers had several alternatives: accept whatever price they could get for their crops in an already oversupplied market, put their crops in storage (incur-ring additional costs) and hope prices would improve, or haul their crops back home. Often, finding anyone who would even make a bid for their hard-earned crop was difficult.

However, the situation reversed itself toward the end of the crop year. As the season's crop was consumed, the supply of available unsold grain became smaller and smaller, and this scarci-ty resulted in higher prices. This meant grain merchants were

forced to buy the bulk of their year's supply (more than they could use at the time of purchase) during the harvest period. Or they had to pay high prices late in the marketing year, before the next season's crops were available. In order to keep their mills running, manufacturers competed with each other for the dwindling supply. On the other hand, during the years of oversupply, producers had to dispose of their goods at fire-sale prices. Similar situations occurred with other commodities as well.

In order to protect themselves against seasonal price fluctuations, producers and consumers of agricultural commodities began to buy and sell for *forward delivery*. These transactions, which became known as *to-arrive contracts*, involved a binding sale by a farmer to a buyer for a designated amount of grain (or other crop) to arrive 10, 20, 30, or 60 days later.

> EXAMPLE: A miller agrees on September 1 to buy 5,000 bushels of corn from a farmer for $2.20 per bushel. The corn is to be delivered on November 1. The buyer and the seller have agreed on a price for a product "to arrive" two months later—hence the term *to arrive*.

Contracting for deferred delivery did not, of course, eliminate the risk, nor did it solve the problem of the market risk. The risk, when you think about it, was not completely off the shoulders of the seller. Of course, the producer/seller had estimated sufficient return for a crop before it was even harvested and need only be concerned with the production of the crop and its delivery to the buyer. But the seller could still lose potential profit. He had to deal with the possibility that the price of the commodity would rise before delivery. If the price of corn advanced to, say, $2.40 by November 1, he stood to lose out on additional profit. The buyer, on the other hand, still had to fear a price decrease. Should the price of corn drop to $2.00 by the time of delivery, the buyer would suffer a loss of 20 cents per bushel if his competitors bought the cheaper merchandise.

Contracting for deferred delivery, however, did at least enable a merchant, manufacturer, or processor to schedule raw material shipments for arrival at designated intervals and to know their costs. Insuring the availability of raw materials for operating needs at all times tended to stabilize the market to a degree, because product prices could be projected from known costs.

Eventually, these forward contracts were bought and sold without waiting for delivery. Many other people who were not in

the grain trade were willing to assume the risks but were not willing to take the actual delivery. These speculators were interested in a possible gain on any change in value, not in profits on the sale of the physical commodities themselves. The merchant with a contract, who did not want to absorb the risk at all, could transfer ownership of the contract to a third party (dealer or speculator) who was willing to take a chance solely in the hope of making a profit.

Once speculators became interested in the futures contract as such—that is, as a negotiable item on its own—the futures contract market became a viable adjunct to the actual commodities market, or *cash* market as it is sometimes called.

The Commodities Exchange

A commodity exchange is merely a central meeting place where buyers and sellers (or their orders) meet to transact business. Facilities are provided where transactions can easily take place between members, the only persons permitted to trade on the floor of the exchange. Exchanges do not buy or sell commodities or contracts or establish prices. They enforce rules and regulations in order to promote uniform practices among buyers and sellers in the market and provide for an orderly market. They also act to quickly adjust business disputes and to distribute price and market information valuable to members and their customers.

Cash Market vs. Futures Market

Today, commodities may be transacted in either the cash or the futures market, two separate but related markets. The establishment of the futures market has come to augment the cash market. You'll see why.

The *cash market*, sometimes referred to as the *actual* or *spot* market, is where the commodities themselves are bought and sold on a negotiated basis. Most of the time, the contract calls for the actual transfer of a commodity; it may specify immediate delivery or forward delivery (at a set time in the future).

In the *futures market*, however, standardized contractual agreements are bought and sold, not the actual commodities themselves. A futures contract is very specific as to quantity, quality,

and date, but it does not involve immediate transfer of ownership of the commodity, unless you trade in the spot delivery. You can buy and sell commodities in a futures market regardless of whether or not you have, or own, the particular commodity. Two basic facts to remember when buying and selling futures are:

1. When you *buy* a futures contract, you are *going long*. You are simply agreeing to receive delivery and to pay in full for a specific quantity and grade of a particular item to be delivered to you at a specific place in some designated month in the future.
2. On the other hand, when you *sell* a futures contract, you are *going short*. Here, you agree to deliver a specific quantity and grade of a particular item at a specific place in some month in the future, at which time you will be paid in full.

The difference in price between the two similar yet different markets (futures and cash) is called the *basis*. The cash price is the actual price of the physical commodity; the futures price is the price of a contract in the futures market. The two prices are not the same initially, but they do have a tendency to parallel each other. Because of this relationship, trading techniques (such as hedging and spreads) and speculation are quite viable and useful to the futures investor. More basic information must first be covered before jumping into price relationships. These topics and the discussion of different types of futures markets are covered in later chapters.

The Fundamentals

At one time, trading in commodities was extremely simple. For many years the definition of commodities was confined to agricultural products, and understanding commodities was fairly easy: A grower sold the crop for the best price as soon as it was harvested—or stored it until either imminent spoilage forced a sale or the price was right.

Well, now, not only does the term "commodities" include a long list of products, but it also involves two separate yet parallel markets that we mentioned earlier: the cash market and the futures market. Though commodities futures trading can no longer be considered simple, it is still no harder than any other product subject to the law of supply and demand.

Commodity

A *commodity* is any product, service, financial instrument, or foreign currency that is bought and sold on a recognized exchange. *Commodity futures,* on the other hand, are predetermined contracts whose terms are defined by an exchange. There are approximately 80 different commodities traded on 12 different exchanges in the United States. A list of these is included in Figure 1-1. There are ongoing additions and deletions to the commodities list, usually as a result of unsuccessful contracts.

FIGURE 1-1 **Organized Commodity Exchanges in the U.S. and the Commodities Traded on Each**

Exchange	Commodities Trades
Chicago Board of Trade	Corn, oats, soybeans, soybean meal, soybean oil, wheat, western plywood, unleaded reg. gas, gold—1 kilo, gold—100 oz., silver—1000 oz., silver—5000 oz., GNMA's, T-bonds, T-notes, C-deposits, crude oil, heating oil, T-bond options.
Chicago Mercantile Exchange	Live cattle, live hogs, feeder cattle, pork bellies, shell eggs, fresh broilers, random-length lumber.
(International Monetary Market)	Foreign currencies (British pound, Canadian dollar, Dutch guilder, Deutsche mark, French franc, Swiss franc, Japanese yen, Mexican peso), gold—100 oz., C-deposit, Eurodollar, Standard & Poors 500 Stock Price Index, Treasury bills—13 wk & 1 yr., Standard & Poors Options.
Coffee, Sugar & Cocoa	Coffee C, sugar #11, sugar #12, cocoa
Commodity Exchange Inc.	Gold, silver, copper, gold options
Cotton Exchange, Inc.	Cotton, orange juice, liquid propane gas
Kansas City Board of Trade	Wheat, value line average stock index, value line options
Mid-America Commodity Exchange	Corn, oats, soybeans, wheat, cattle, hogs, sugar, N.Y. silver, silver—1000 oz., gold—33.2 oz, Treasury bills, Treasury bonds.
Minneapolis Grain Exchange	Wheat, sunflower seeds
New Orleans Commodity Exchange	Cotton, rice—rough, rice-milled, corn, soybeans
New York Futures Exchange	NYSE Composite Index, Treasury bonds, NYSE Index Options
New York Mercantile Exchange	Potatoes, platinum, palladium, crude oil, heating oil (N.Y. & Gulf) leaded reg. gas (N.Y. & Gulf) unleaded reg. gas (N.Y. & Gulf).

Trading commodity contracts is very similar to trading securities inasmuch as both are influenced by the forces of supply and demand. However, unlike securities, where a company may offer a set number of stocks for sale, a commodity contract exists whenever there is a buyer and a seller. Contracts exist when both the buyer and seller mutually agree to transact business at a given price. Thus, there is no limit to the number of futures contracts that can be created.

This brings up an interesting situation: The number of contracts for any particular time frame may exceed the actual supply of the commodity. However, as the delivery month draws near, the number of contracts tends to decrease naturally. Here's how it works:

A futures contract trades in months, ranging from one year to almost three years before the contract expires. Unlike the stock market, for which corporations decide how many shares of stocks will be available for sale, in the commodities futures industry no contracts exist when the trading begins. And no contracts would exist if no one was interested in trading. But, as mentioned earlier, as soon as a buyer finds a seller, a contract is created. All the buyer and seller recognize is that a commodity will be available and they want to speculate on price action.

The process of contract creation can theoretically go on as long as buyers find sellers and vice versa. This is an interesting facet of the commodities market that also makes establishing positions easier. As you are probably aware, going *long* in the stock market simply means buying stock; going *long* in commodities means buying a futures contract that involves the possibility of accepting delivery. In stocks, selling *short* means selling stocks the investor does not own; stocks must be borrowed somewhere to deliver against the sale. In commodities, however, since contracts can be created indefinitely, selling may involve two situations: selling short for the purpose of making delivery or selling to liquidate a position.

So how are trades made to eventually balance the number of contracts with the commodity supply? The vast majority of futures trades are settled by offset (liquidation). In fact, less than 2% of all futures contracts that are traded actually result in delivery. Ninety-eight percent of the contracts are settled long before delivery is even an issue. The speculators, and most hedgers, are offsetting, leaving the actual commodity dealers to deal. Contracts that re-

main at the time trading ends must be honored through delivery. If the deliverable supply of a commodity is greater than the amount totaled up in all the open contracts, then prices tend to drop because supply exceeds demand. The surplus of a commodity brings the buyers of contracts (the longs) under pressure to sell off (to liquidate) as many and as fast as possible. Needless to say, the selling behavior of the speculative longs becomes increasingly aggressive as the delivery month approaches because they have to liquidate (offset) or risk taking a delivery.

On the other hand, if the commodity is in scarce supply, then the sellers (or the shorts) would come under pressure to meet their obligations. In simple terms, the shorts would not have enough commodity to fill all the futures contracts. In the cash market, the price would go up because of the scarce supply. But in the futures market, whatever contracts go unfilled have to be bought back from the longs. Buying a contract back from a long is called *covering*. In such a case, the longs could hold out for a favorable price— one probably a lot higher than that anticipated by the shorts.

The Contract

The contract is a very standardized document that leaves very little open to negotiation. About the only thing that is negotiated is the price, which is settled on the floor of the exchange. Items that are routinely included in the contract include:

1. the commodity sold,
2. the quantity,
3. the grade, delivery point, delivery period, and
4. the delivery terms.

Though each category is fairly straightforward, the quantity of a commodity needs some explanation. Each commodity futures contract has a standardized unit of trading. For example, a round lot of grain is 5,000 bushels. Two contracts of grain would be 10,000 bushels. In soybean oil, 60,000 pounds constitute a contract; in soybean meal, 100 tons. Figure 1-2 includes a selected list of commodities and their units of trading. Other commodities' units of trading are based on the accepted custom and usage of the indus-

FIGURE 1-2 Trading Units and Other Facts

Commodity	Exch.	Trading Time (Centrl. Time)	Delivery Months	Contract Unit	Price Quoted In	Minimum Fluctuation	$ Value of Minimum Tick	Daily Trading Limit
Corn	CBT	9:30-1:15	Z,H,K,N,U,	5,000 bu.	¢/bu.	$.0025/bu.	12.50	$.10/bu.
Soybeans	CBT	9:30-1:15	F,H,K,N,Q,U,X	5,000 bu.	¢/bu.	$.0025/bu.	12.50	$.30/bu.
Soybean Meal	CBT	9:30-1:15	V,Z,F,H,K,N,Q,U	100 tons	$/ton	10¢/ton	10.00	$10/ton
Soybean Oil	CBT	9:30-1:15	V,Z,F,H,K,N,Q,U	60,000 lbs.	¢/lb.	$.0001/lb.	6.00	1¢/lb.
Wheat	CBT	9:30-1:15	N,U,Z,H,K	5,000 bu.	¢/bu.	$.0025/bu.	12.50	$.20/bu.
U.S. T- Bonds	CBT	8:00-2:00	H,M,V,Z	$100,000 face	% pts.	1/32 pt./100 pts.	31.25	64/32
U.S. T- Notes	CBT	8:00-2:00	H,M,U,Z	$100,000 face	% pts.	1/32 pt.	31.25	64/32
Major Market Index	CBT	8:45-3:15	All Months	100 times index	index pts.	1.25 pt.	12.50	none
Municipal Bond Index	CBT	8:00-2:00	H,M,U,Z	100 times index	index pts.	1/32 pt.	31.25	none
Wheat	KCBT	9:30-1:15	N,U,Z,H,K	5,000 bu.	¢/bu.	$.0025/bu.	12.50	$.25/bu.
KC Value Line Futures	KCBT	9:30-3:15	H,M,U,Z	500 times index	index pts.	.05 pt.	25.00	none
Wheat	MGE	9:30-1:15	N,U,Z,H,K	5,000 bu.	¢/bu.	$.0025/bu.	12.50	$.20/bu.
Live Cattle	CME	9:05-1:00	G,J,M,Q,V,Z	40,000 lbs.	¢/lb.	2.5¢/cwt.	10.00	1.5¢/lb.
Live Hogs	CME	9:10-1:00	G,J,M,N,Q,V,Z	30,000 lbs.	¢/lb.	2.5¢/cwt.	7.50	1.5¢/lb.
Pork Bellies	CME	9:10-1:00	G,H,K,N,Q	38,000 lbs.	¢/lb.	2.5¢/cwt.	9.50	2.0¢/lb.
S&P 500 Futures Index	CME	9:00-3:15	H,M,U,Z	500 times index	index pts.	.05 pt.	25.00	none
Cocoa	CSCE	8:30-2:00	H,K,N,U,Z	10 metric tons	$/ton	$1.00/m.t.	10.00	$88/m.t.
Coffee "C"	CSCE	8:45-1:30	H,K,N,U,Z	37,500 lbs.	¢/lb.	$.0001/lb.	3.75	4¢/lb.
Sugar #11	CSCE	9:00-12:43	F,H,K,N,U,V	112,000 lbs.	¢/lb.	$.0001/lb.	11.20	.5¢/lb.

FIGURE 1-2 (continued)

Commodity	Exch.	Trading Time (Centrl. Time)	Delivery Months	Contract Unit	Price Quoted In	Minimum Fluctuation	$ Value of Minimum Tick	Daily Trading Limit
Cotton #2	NYCE	9:30-2:00	H,K,N,V,Z	50,000 lbs.	¢/lb.	$.0001/lb.	5.00	2¢/lb.
Orange Juice	NYCE	9:15-1:45	F,H,K,N,U,X	15,000 lbs.	¢/lb.	$.0005/lbs.	7.50	5¢/lb.
U.S. Dollar Index	NYCE	8:20-2:40	H,M,U,Z	500 times index	index pts.	.01 pt.	5.00	none
Platinum	NYME	8:00-1:30	F,J,N,V	50 Troy oz.	$/oz.	$.10/oz.	5.00	$25/oz.
No. 2 Heating Oil—New York	NYME	8:50-2:05	All months	42,000 gal.	$/gal.	$.0001/gal.	4.20	2¢/gal.
Crude Oil	NYME	8:45-2:10	All months	1,000 bbl.	$/bbl.	$.01/bbl.	10.00	2¢/gal.
Unleaded Gasoline	NYME	8:30-2:00	All months	42,000 gal.	$/gal.	$.0001/gal	4.20	2¢/gal.
Pound Sterling	IMM	7:30-1:24	H,M,U,Z	25,000 BP	$/BP	.05¢/BP	12.50	none
Canadian Dollar	IMM	7:30-1:26	H,M,U,Z	100,000 CD	$/CD	$.0001/CD	10.00	none
Japanese Yen	IMM	7:30-1:22	H,M,U,Z	12,500,000 JY	$/JY	$.000001/JY	12.50	none
Swiss Franc	IMM	7:30-1:16	H,M,U,Z	125,000 SF	$/SF	$.0001/SF	12.50	none
Deutsche Mark	IMM	7:30-1:20	H,M,U,Z	125,000 DM	$/DM	$.0001/DM	12.50	none
Eurodollars	IMM	7:30-2:00	H,M,U,Z	$1,000,000	% pts.	.01 pt.	25.00	1.0 pt.
U.S. T-Bills (90-day)	IMM	7:30-2:00	H,M,U,Z	$1,000,000	% pts.	.01 pt.	25.00	0.5 pt.
Copper	COMEX	8:50-1:00	F,H,K,N,V,Z	25,000 lb.	¢/lb.	$.0005/lb.	12.50	none
Gold	COMEX	8:00-1:30	G,J,M,Q,V,Z	100 Troy oz.	$/oz.	$.10/oz.	10.00	none
Silver	COMEX	8:05-1:25	F,H,K,N,V,Z	5,000 Troy oz.	¢/oz.	$.001/oz.	5.00	none
NYSE Composite Index	NYFE	9:00-4:10	H,M,U,Z	500 times index	index pts.	.05 pt.	25.00	none

Key to Contract Months

1st Year	Month	2nd Year		1st Year	Month	2nd Year		1st Year	Month	2nd Year
F	January	A		K	May	E		U	September	P
G	February	B		M	June	I		V	October	R
H	March	C		N	July	L		X	November	S
J	April	D		Q	August	O		Z	December	T

Key to Exchange Abbreviations

CBT	Chicago Board of Trade	CSCE	Coffee, Sugar, & Cocoa Exchange
KCBT	Kansas City Board of Trade	NYCE	New York Cotton Exchange
MGE	Minneapolis Grain Exchange	NYME	New York Mercantile Exchange
CME	Chicago Mercantile Exchange		

IMM International Monetary Market (a division of the CME)
COMEX Commodity Exchange, Inc.
NYFE New York Futures Exchange

trial commodity. For instance, lumber is traded in units of board feet, copper in pounds, precious metals in troy ounces, and so on. All orders for these commodities are entered in contracts. However, when placing orders in grains, traded in multiples of 5,000 bushels, the investor must specify the number of bushels, not the number of contracts.

EXAMPLE: A client places an order to buy one contract of wheat, which is 5,000 bushels. The broker must enter an order to "buy 5,000 bushels of May wheat." If the client wants to buy two contracts, the order would then read, "buy 10,000 bushels of May wheat."

Price Quotations

Quotations are found on the financial pages of many newspapers. The commodities are generally categorized as follows:

1. grains and oilseeds
2. livestock and meats
3. food and fiber
4. metals
5. industrial products (e.g., lumber and petroleum)
6. financial

Figure 1-3 illustrates the *Wall Street Journal*'s futures prices page from March 11, 1987. The prices on this page are those at the close of business on March 10, 1987. To find the daily statistics on May 1987 corn, look under the GRAINS AND OILSEEDS section. Next to the word *Corn* is the exchange on which this particular corn contract is traded, the size of the contract, and how it is quoted. The corn on this particular page is the 5,000-bushel contract that is traded on the Chicago Board of Trade. The first column gives the delivery month: May 1987. The second column indicates where the contract opened: 158½ = ($1.58½ per bushel). The next two columns give the range of trading for the day with the highest price (158¾) in column three and the lowest price (155½) in column four. Column five is the settlement price: 156. This price is established by the designated committee of the exchange as representative of trading during the official closing period. The sixth column repre-

FIGURE 1-3 Sample Futures Page

FUTURES PRICES

sents the change in price from the previous day's settlement price. May 87 corn closed 2¾ cents lower than where it settled on the previous trading day. Columns seven and eight indicate the highest and the lowest prices for the contract since trading began in this particular delivery month. The highest price at which May 87 corn has traded is 242, and the lowest price is 149¼. The last column represents the open interest, or the number of open contracts for each delivery month, as of the close of business two days earlier.

There were 51,715 contracts of May 87 corn open on March 9. The bottom line of the section contains cumulative volume and open interest figures. These statistics are for all delivery months combined. The first number is the estimated volume of trading on March 10: there were 35,000 contracts of Chicago Board of Trade corn traded. Next to that is the actual volume of trading on March 9: there were 24,273 contracts. The open interest figure of 132,955 is also for March 9 and is 366 contracts less than at the close of the previous trading session. This open interest figure can be derived by totaling the open interest figures that are given for each delivery month in column nine. (Note, though, that newspapers do not always print all the delivery months for which there are open contracts.)

Minimum Fluctuations

The minimum amount by which a commodity's price can change is established by the exchange on which trading takes place and is known as *minimum fluctuation*, or *tick*. Depending on the type of commodity, prices and their fluctuations can be reported in many different ways.

Grains are quoted in dollars, cents, and fractions of a cent per bushel. Price changes are registered in multiples of ¼ of one cent per bushel, the equivalent of $12.50 per contract. In other words, the minimum fluctuation, or *tick*, in the price of wheat, corn, oats, and soybeans is a ¼ cent per bushel.

EXAMPLE: If the last transaction in May wheat was $2.50½, the minimum change would be to either $2.50¼ or $2.50¾. Or suppose the price of corn advances from $2.50 per bushel to $2.51. Since there are 5,000 bushels in each contract of grain, a fluctuation of 1 cent per bushel represents the dollar equivalent of $50 (5,000 bushels × $0.01 = $50) per contract. Since a 1-cent fluctuation is equal to $50 per contract, a ¼-cent fluctuation is equal to $12.50 per contract

(5,000 bushels × ¼ cent = $12.50). Therefore, if the price of corn advances from $2.50 to $2.50¼ per bushel, the price increase would be ¼ cent per bushel, or $12.50.

TRY THIS

If a customer purchased May wheat at $3.05 and later sold it at $3.12½, how much profit was realized? (Refer to Figure 1-2, Trading Units and Other Facts.)

HERE'S WHY

Looking at the wheat column in Figure 1-2, you know that a wheat contract trades in units of 5,000 bushels, and we just mentioned that it is quoted in dollars, cents, and quarters. Each cent move, or point value = $50 (5,000 × $0.01), so a 7½ cent price change is $375 ($50 × 7.5).

Other commodities are quoted in cents and hundredths of a cent per pound. Soybean oil, coffee, cotton, and sugar are quoted this way. Price changes are registered in multiples of 1/100th of a cent per pound, which is called *one point*. Since 1 cent obviously consists of 100/100ths, a fluctuation of 1 cent is equal to 100 points. The minimum allowable change in the price of these commodities is one point. If the last trade in soybean was 17.25 cents, the minimum change has to be either to 17.24 cents or 17.26 cents.

EXAMPLE: An increase in the price of soybean oil from 17.00 to 18.00 cents per pound would be a 1-cent-per-pound increase. Since there are 60,000 pounds in a contract of soybean oil (refer to Figure 1-2), a 1-cent-per-pound fluctuation would be equal to $600 per contract (60,000 × $0.01 = $600). Therefore, if a price change in soybean oil of 1 cent per pound is equal to $600 and 1 cent also equals 100 points, then each point in soybean oil is equal to $6.00 per contract unit.

TRY THIS

Let's see if you were paying attention. Here's a simple one: Many nonfinancial futures trade in points. How much does a point represent?

HERE'S WHY

As we just mentioned, most trading in such contracts is in cents and hundredths of a cent per unit. Decimally each hundredth of a cent (a point) is $0.0001. That wasn't too hard, was it?

Corn is quoted in cents per bushel. Price changes are registered in multiples of ⅛ of 1 cent per bushel, the equivalent of $1.25 per contract. Since a contract of corn contains 1,000 bushels, a fluctuation of 1 cent is equivalent to $10 per contract (1,000 bushels × $0.01 = $10).

Soybean meal, unlike soybean oil, is quoted in dollars and cents per ton. Price changes are registered in multiples of 10 cents per ton, or $10 per contract. A fluctuation of $1.00 per ton in a 100-ton contract of soybean meal is the equivalent of $100 per contract (100 tons × $1 = $100).

EXAMPLE: If the last transaction took place at $70.20, the minimum change in price must be to at least either $70.10 or $70.30 (a 10-cent change per ton). Or if the price of soybean meal advanced from $70.20 per ton to $70.80, the 60-cent advance would represent a $60 increase on the contract, since each increase of 10 cents is equal to $10.00 per contract.

Pork bellies, hogs, and live cattle are quoted in cents and fractions of a cent per pound. However, price changes are registered in multiples of 2.5/100ths of 1 cent per pound, which is the equivalent of $9.50 per contract for pork bellies, $7.50 per contract for hogs, and $10 per contract for live cattle.

The arithmetic for these figures is routine. Since a pork belly contract contains 38,000 pounds, a one-cent fluctuation is equal to $380, and a 1/100th-of-one-cent (or 1-point) fluctuation equals $3.80 per contract. However, the minimum fluctuation is 2.5/100ths of a cent or 2½ points per pound: if 1 point is equal to $3.80 per contract, 2½ points are equal to $9.50 per contract. The least pork bellies prices may fluctuate is 2½ points at a time.

EXAMPLE: If the last transaction took place at 36 cents, the minimum amount that the pork bellies price can change is to either 36.02½ cents or 35.97½ cents. The 35.97½-cent price would be shown as 35.97 cents, and 36.02½ cents would be shown as 36.02 cents in the newspaper.

Daily Trading Limits

As with many other investment or trading vehicles, futures markets are from time to time jolted by developments that cause dramatic short-run price changes. Weather shifts, outbreaks of war, and unexpected crop or economic reports are among the sparks that set off such price explosions. In an effort to contain the effects of these unexpected and potentially dangerous price changes on both traders and on the entire futures trading system, most U.S. exchanges have established daily trading limits on prices. These limits for some of the more active U.S. futures contracts can be found in the last column in Figure 1-2.

Daily trading limits define the amount by which the price of a futures contract can rise above or fall below the previous day's settlement price. These limits tend to take the edge off a price panic by allowing the market to digest developments in an atmosphere that is free of rapidly escalating or declining prices. They also make more orderly the clearinghouse process of paying and collecting margin funds, because large price changes result in major transfers of funds between customers and clearinghouses. These processes are discussed in more detail in later chapters.

In some cases, an exchange may feel that on the basis of its own merits a market can trade over the limits. Some exchanges allow greater-than-normal limits, or *variable daily price limits*, during periods of extended price volatility. It has been found that limits can be an artificial restraint on a commodity that is advancing rapidly on its own merit and not as the result of extraordinary and temporary circumstances. The variable daily price limits may be subject to the approval of the board of directors or managers of the exchange.

The daily limitations on price fluctuations of certain commodities do not apply to trading the current, or *spot*, delivery month. Any removal or modification of daily limits during the spot delivery month after the *first notice day* (generally the last business day of the month preceding the delivery month) or after a specified time applies *only* to the spot delivery month. The regular daily limits remain in effect on all other delivery months trading at that time.

> EXAMPLE: On December 31, the first notice day, the daily limit on January delivery soybean meal is removed until the contract expires at the end of January. The daily limit of $10 per ton for the March, May, July, August, September, October, and December deliveries remains in effect.

The fact that transactions may only take place within these price limits leaves yet another interesting difference between trading commodities and trading securities.

TRY THIS

When trading reaches the maximum daily price limit, what happens to subsequent trading that day?

a. trading may continue at or up to the limit, but not exceed it
b. trading then continues at the expanded limit
c. trading is temporarily halted pending a ruling by exchange officials
d. trading ceases

HERE'S WHY

The answer is (a). Actually, (d) comes close to being true in the practical sense; however, there is no bar to trading *within* the price limits and sometimes such trades do occur. Because it takes two to make a trade, on the other hand, trading often *does* cease because one side refuses. For example, if the market goes "limit down," potential buyers usually pull their bids off the market waiting for still lower prices. Even though the sellers may wish to offset their position, they find no buyers at prices within the limits.

TRY THIS

When are trading limits normally removed?

HERE'S WHY

Limits are removed on the first delivery day of a particular contract (or a day approaching this time as determined by the rules of the exchange). This is considered the final month, or spot month, of the contract. During this time, transferable notices for delivery and notices of intention to deliver are often issued. For example, the normal daily limit on soybean oil of 1 cent per pound is removed during the spot delivery month on and after the first notice day. The objective of this is to avoid creation of a situation showing widely disparate prices between spot month futures prices and prices in the cash markets that have no limits.

Commission Rates

Commissions in commodities are paid only after both the buying and selling of transactions are completed. Commissions are incurred on a *roundturn* basis. This is the practice of charging a single commission to both buy *and* sell a futures contract. This is still another difference in commodity trading when compared to the trading of securities. When you buy a contract, the commission may not be charged until you have liquidated your position by a subsequent sale in the same delivery month or until you take delivery. Also, commissions are usually established on the unit of trading rather than on the dollar value of the contract.

Although all commissions are subject to negotiation, most brokerage firms operate on a two-tier system. Less active customers tend to come under "house rates," a schedule of rates that a brokerage firm feels provides adequate profit for low-volume accounts. Although house rates vary, it is reasonable to assume that a typical roundturn rate of commission under the house schedule will be $40 to $80 per contract. For those accounts where high volume justifies negotiation, commission rates can be as low as $15 to $25 per contract.

A *day-trade* commission, for example, may be charged when a position is established and closed on the same day. These commissions are approximately half the normal roundturn rate.

A *spread* commission is charged during a transaction when the purchase of one delivery and the sale of another delivery in the same commodity is initiated and closed at the same time. This type of commission is *usually* less than the commission charged on two contracts but more than the commission charged for a net long or short. The term "usually" is necessary because, with negotiated commissions, sometimes the outright sale is so low that it is impractical to lower it further for spreads.

TRY THIS

Commissions on futures transactions are:

a. fixed by the Commodity Futures Trading Commission
b. fixed by each exchange
c. negotiable only for hedgers
d. totally negotiable

> ### HERE'S WHY
>
> Yes, you read and remember very well. The answer is (d). This has been so since 1978.

Risks

Many novice futures traders (and even some professionals) erroneously think that the primary reason that futures trading is notoriously risky is that futures prices are more volatile than are prices in other investment arenas. However, statistical analysis shows that the volatility of futures prices is approximately the same as that of equity prices, for example. What makes futures trading a risky affair is the low margin required and the resulting high leverage. If we were able to trade common stocks on thin margin, they too would be considered very risky investments. In the 1920s, listed equities were traded with margin requirements comparable to those in today's futures markets. Economists and historians still disagree on the extent (if any) to which this leverage contributed to the stock market crash of 1929 and the subsequent Great Depression.

As is explained in greater detail in Chapter 2, every holder of a long or short contract must deposit with his or her brokerage house a certain amount of money to guarantee performance on the contract. This deposit is known as *margin*, and its size plays an important role in the explanation of why futures trading can be both very risky and very profitable.

Leverage, the ratio of an investment's full value to the amount of capital that is required to own or to control it is also a risk factor when trading in futures. For example, if we buy something worth $100 by putting up a deposit of $50, our leverage is 2:1. If we pay for something in full, the leverage is 1:1. In futures trading, the available leverage is often 10:1 to 20:1, or more. It is important to realize that the greater the leverage, the smaller the price move that is required to bring about the same percent change in the value of the investment.

The subjects of margin, leverage, and risk are quite complex and often misunderstood in connection with futures trading. Because of their complexity, these concepts are discussed further in Chapter 7.

Hedging

Hedging is the use of the futures market to reduce the risk of a cash market position. It involves entering into a futures transaction that is a temporary substitute for a similar transaction in the cash market. This futures market position is the opposite of the net position in the cash market and serves to negate or minimize the risk of this position.

Successful hedging is dependent on a close ongoing relationship between the price of the cash commodity or financial instrument and the price of a futures contract. The closer the relationship, the more effective the hedge. However, we know that there is never a perfect correlation between cash and futures. There is always the risk that a negative change in cash prices will not be fully matched by an offsetting change in futures prices. The resulting change in the basis exposes the hedger to both risk and opportunity. The essence of hedging is that the hedger substitutes this basis risk for the usually far greater risk of having an unprotected position in the cash market.

Futures contracts have been found to satisfy the criteria for a means of reducing risk: They are highly liquid instruments that can be entered into or liquidated on short notice at almost all times. They are "paper" transactions that do not interfere with regular business operations. The credit exposure is always to a futures clearinghouse (see Chapter 4). Finally, low margins and commissions make them a relatively inexpensive source of price protection.

The role of the futures market, therefore, is to provide a temporary, flexible means of reducing risks. For example, a dealer may have an inventory of bonds, half of which have been sold at a favorable price. Rather than risk exposure to a price decline on the uncovered half, he or she can sell the appropriate number of futures contracts. If prices decline, the short position in the futures market will "shelter" the loss on the inventory. As the dealer arranges to sell more of the inventory, the futures market position will be reduced.

Regulation of Futures Trading

Successful futures markets require effective regulation. Markets cannot flourish without a large and diverse group of participants,

and the group will not remain either large or diverse for very long if some participants are permitted to take systematic advantage of others.

The varied interests and concerns of different market participants make regulation of futures markets a multifaceted challenge. For example, the removal of a particular grain elevator from the list of permissible delivery locations for corn would be of no consequence to retail commission houses and their customers but would be of great interest to many people in the grain trade. On the other hand, grain-market professionals would be unconcerned about changes in customer margin procedures that might seriously affect commission-house business. Likewise, floor brokers would likely pay little attention to either delivery locations or margin procedures for nonmembers but would take keen interest in regulations that affect record-keeping or trading details on the exchange floor.

Commodity Futures Trading Commission

Reconciling the often diverse interests of varied groups to ensure fair and efficient futures markets is a task that is shared in the United States by the federal *Commodity Futures Trading Commission* (the CFTC, or the Commission) and the futures industry itself. The basic approach can be described as supervised self-regulation. The CFTC has ultimate authority over the entire U.S. futures industry, but in practice it relies heavily on industry participants to develop and implement effective procedures for the prevention of market abuses. The CFTC continually monitors these self-regulatory efforts to ensure that they are in accord with the Commission's overall guidelines.

Both the theory and the practice of modern futures market regulation in the U.S. can be better understood with some knowledge of how the regulatory framework evolved to its current state. This evolution has naturally paralleled that of the futures industry itself. It has been motivated by changing business practices and by concerns over the years about various abuses—some actual, some possible, and some imaginary. The present legislation evolved through a number of Congressional actions, some of which are highlighted on the following pages.

Legislative Acts

The Grain Futures Act of 1922 was an attempt by the United States government to bring the widespread speculation in grain futures under control. This act enabled the government to deal with the exchanges themselves rather than with the traders. Investigatory powers and enforcement were the responsibilities of the U.S. Department of Agriculture. The Commodity Exchange Act of 1936 increased the scope of the previously legislated act of 1922.

In 1968, Congress made additional changes in the act. The most forceful change affected the *futures commission merchant* (FCM), which is any person or organization that buys or sells futures contracts for a customer on commission. An FCM must meet specified minimum financial standards. Amendments were added to try to bring commodity trading under stricter control.

However, after the 1968 amendments, the existing regulations appeared to be inadequate. The dollar value of futures trading in all commodities, both regulated and not regulated, rose to $500 billion on an annual basis in 1973.

Congress then passed the Commodity Futures Trading Commission Act of 1974, which created an independent Commodity Futures Trading Commission (CFTC) similar to the Securities and Exchange Commission (SEC). The CFTC replaced the regulatory agency that had been under the Department of Agriculture.

The CFTC's main responsibilities include close regulation of FCMs and protection of FCM customers. The CFTC designates exchanges, and approves and regulates all commodities traded on any exchange. The act gives broader authority to the Commission by expanding the definition of commodities to include all items that are traded for future delivery on a recognized exchange. This increased the regulatory arm to include previously unregulated commodities such as coffee, sugar, metals, and so on. All newly introduced contracts require CFTC approval.

The 1974 act requires the Commission to oversee the registration and regulation of FCMs and *associated persons* (APs). The CFTC is also required to register and regulate *commodity trading advisors* (CTAs) and *commodity pool operators* (CPOs).

In addition, the Commission is required to regulate transaction activities on all contract exchanges in order to provide for an orderly flow of transactions, to control speculation, and, ultimately, to protect the investor.

The Commission also has authority to go into any U.S. District Court to obtain an order requiring an exchange or any person to desist from violating any of the act's provisions or any rules or regulations set down by the Commission. The Commission may issue cease and desist orders and is authorized to assess penalties of up to $100,000 for each violation. It has the authority to suspend or terminate any individual's or corporation's participation in the futures markets. It limits the size of any speculative position.

National Futures Association

The National Futures Association (NFA), formed in 1982 by an act of Congress, is an industry-wide, self-regulatory body that is self-financed through membership dues and other revenues from users of futures markets. NFA's two main objectives are:

1. to regulate areas of the futures community previously outside the scope of exchange regulation; and
2. to control regulatory expenses by eliminating duplication, overlap, and conflict among governmental and other self-regulatory programs. The NFA has been given the powers to enforce compliance, as well as to monitor for it.

TRY THIS

Which of the following is NOT a responsibility of the CFTC?

a. designation of an exchange as a contract market
b. registration of all associated persons
c. fixing position and trading limits
d. testing registered commodities representatives

HERE'S WHY

If you chose (d), you have obviously been following very closely and are correct. Currently, the examinations are created by an industry committee and administered by the National Association of Securities Dealers.

TRY THIS

We'll end this chapter with a very simple one. What organization does the National Futures Association most resemble, by virtue of its functions and powers?

HERE'S WHY

Right again—the National Association of Securities Dealers (NASD) because of similar self-regulatory powers. Both have powers devolved on them by the regulatory agencies established by Congress.

2

The Mechanics of Trading

How futures are traded and how deals are made are similar in many ways to how stocks are traded on the securities exchanges. Rules and regulations must be followed, market conditions must be observed, and certain strategies must be planned. This chapter deals with some of those issues and characteristics of trading futures. It also discusses the processes of opening and maintaining an account.

Organizational Structure of the Futures Commission Merchant

The futures brokerage industry is a large network of approximately 400 futures commission merchants (FCMs) with more than 50,000 sales representatives who operate out of branch offices throughout the world. These FCMs, basically firms that handle customer orders or supervise those that do, act as the conduits through which travel all of the transactions executed on the U.S. futures exchanges as well as in foreign markets. The futures commission merchants, most of whom have membership privileges on one or more major U.S. futures exchanges, also act as member-brokers for

nonmember retail and institutional customers. As such, an FCM transmits customer orders to the exchange floors, arranges for their execution, and acts as the clearing agent for its customers' transactions. Some FCMs handle only futures business; others offer a full range of brokerage services that includes stocks, bonds, and other financial instruments. Although FCMs have become more diversified in recent years, the main line of business for most continues to be providing order execution, bookkeeping, and clearing functions in exchange for commission fees.

The central processing "plant" of most brokerage firms is a headquarters office that is located in New York or Chicago. While most orders originate from the branch offices that are spread across the country and around the world, the processing, bookkeeping, and margin functions are generally housed in the headquarters office. Organizational structure varies among the many FCMs, but the following provides a general description of the major working departments.

New Accounts Department

Most new accounts are brought into an FCM by account executives who operate from local branch offices. The account executive's job is to be sure that customers understand the risks associated with futures trading and that they are financially qualified to bear those risks. The account executive arranges for the full and accurate execution of all new account documents by the customer and forwards these documents to the new accounts department in the headquarters office. The new accounts department reviews the documents and, after performing a credit check on the prospective customer, assigns him or her an account number.

Margin Department

Once the new account is open and adequate funds are on deposit with the FCM, the margin department sets the account's margin requirements and grants approval for trading. After trading begins, this department both monitors the account to be sure that it is always adequately funded and issues margin calls (the customer must deposit additional money in the account) if and when de-

ficiencies occur. The margin department, along with senior management, decides what action is to be taken when margin calls go unanswered. It also has responsibility for approving all withdrawals of funds from customer accounts. Margin accounts are discussed in detail later.

Floor-and-Order Department

The job of the floor-and-order department is to provide for the roundturn communication and execution of all orders that are generated by branch offices and trading departments. Orders reach the trading floors in one of two ways: by wire or by telephone. Many of the large, multiproduct brokerage firms make use of their own wire systems, which are vast electronic communications networks that connect every branch office with the trading floors. Orders are handed by the account executive to an order desk in the branch office where they are typed on a machine that automatically transmits them to a receiving station on the trading floor. On the trading floor, the order is torn off the machine and taken by a runner into the trading pit for execution. Once filled, the order is reported to the branch office by a sending machine on the trading floor. This cycle generally takes a matter of minutes although, in extremely busy markets, account executives have been known to wait hours for reports from the floor. Orders that are more time- or price-sensitive are usually placed by telephone directly to booths on the trading floor.

Data Processing Department

Once executed and reported back to the customer, all filled orders are sent to the data processing area of the firm. Here, transactions are keypunched and entered into the computer system. From the computer flow a number of reports and statements that confirm the details of the transaction. Confirmations and purchase and sale statements are generated and sent to the customer as well as the customer's account executive. Equity statements that detail the account's position and margin status are forwarded to the account executive and to the margin department. Transaction statements are compiled and sent to the clearing department, which ensures

that all trades have been properly recorded at the various clearing-houses and that payments to or collections from the clearing-houses are executed. Timely and accurate data processing is crucial to the successful operation of an FCM. It ensures that:

1. the customers and their account executives are always aware of the status of the customers' accounts,
2. the margin department is able to monitor problem situations,
3. senior management is aware of the firm's total customer position and, therefore, its exposure,
4. the FCM is always in proper balance with the various clearing-houses, and
5. all necessary reports are filed with exchanges and regulatory agencies.

Delivery Department

This department handles all deliveries and receipts of physical commodities that arise from futures contracts, as well as cash settlements for those futures that do not require physical delivery. It determines that exchange-approved inventories are on hand, processes and issues delivery notices, makes payment for and receives delivery of exchange-approved commodities and financial instruments and, in general, keeps all relevant areas of the firm informed of delivery dates and procedures. Chapter 4 discusses this department in more detail.

Another major area of the FCM is the sales division, which has responsibility for branch-office management, marketing and sales development, and research. The research department has the responsibility for publishing periodic reports on factors that influence the prices of various futures markets. Other internal departments include personnel, accounting, legal, and compliance.

TRY THIS

Any individual partnership, association, or corporation that buys or sells futures contracts on commission is best described as a (an):

a. associated person
b. futures commission merchant

c. commodity trading advisor

d. commodity pool operator

HERE'S WHY

The correct answer is quite simply (b). Most well-known brokerage firms who are members of an exchange are called futures commission merchants (FCMs).

The Market

Futures markets today are among the most efficient and liquid investment mechanisms in existence. The greater the number of participants in any market, the greater is that market's liquidity. Buyers are forced to compete with one another, as are sellers. In highly liquid markets, the spread between the buyers' bid prices and seller's asking prices at any time is driven down by this competition. Thus, the size of the bid/ask spread is a good measure of market liquidity.

In today's futures markets, bid/ask spreads can represent as little as 0.1% or less of the price of the commodity or financial instrument. For instance, if gold is trading at about $400.00 per ounce, a typical quote from the futures trading floor might be $400.00 bid, $400.20 asked. This means that buyers are presently willing to pay $400.00 per ounce and that sellers are willing to sell at $400.20 per ounce. With ample volume on both sides of the quote, sellers are reasonably assured that the lowest price at which they will sell is $400.00. Needless to say, quotes will change in time, but at any moment the bid/ask spread is likely to remain at about 20 cents per ounce. This 20 cents equates to less than 0.1% of the price of gold. Compare this with the securities market, where a stock trading at $50.00 per share might have a bid/ask spread of 25 cents. This equates to 0.5% of the price of the stock. Compare it again, to the real estate market where the bid/ask spread on a $200,000 house might be as great as $20,000, which equates to 10% of the price. The bid/ask spread in futures markets, and therefore the liquidity of these markets, has few rivals in the trading world. As mentioned earlier, it is this high degree of liquidity that has

helped futures trading gain such a prominent role in commerce and finance.

Futures markets today are more active and more economically beneficial than at any other time in their history. Among their most important functions, futures markets provide the following:

1. *A mechanism for shifting price risk from those who do not want this risk to those who do want it.* As we discussed in Chapter 1, shifting risk is one of the reasons for the birth of the futures contract. One important byproduct of this risk shifting is the enhanced creditworthiness of commercial enterprises, which would otherwise be more vulnerable to price fluctuations. Banks and other funding sources are prepared to extend more favorable financing terms to individuals and to organizations that are less exposed to possible changes in the prices of their products or raw materials. This translates into reduced financing costs that, in turn, lead to lower prices for consumers and to a more efficient economy.

2. *Increased price stability.* Critics of futures markets often claim that futures trading leads to abnormal price volatility, but the facts say otherwise. Numerous studies have supported the premise that liquid futures markets increase price stability.

3. *A forum for price discovery.* Each day, the prices of contracts that are traded on futures exchanges reflect, and make public, the broad consensus of what the worth of commodities and financial instruments will be at various times in the future. This allows more sensible planning by industry participants than would be possible without access to such unbiased consensus forecasts.

4. *Order in the trading practices of diverse market participants.* Futures markets provide a central reference point for prices to all those interested. The markets provide rules and regulations that promote fair and orderly trading conditions.

5. *A forum for collection and dissemination of information.* This free and open distribution of information affecting prices enables traders to compete on nearly equal terms. Insider information is at a minimum, and prices tend to reflect as accurately as possible all the known forces that influence the supply of and demand for the financial instrument or commodity.

Successful Futures Contracts

Since the beginning of futures trading, contracts have been devised for a large number of underlying commodities and financial instruments. Many of these contracts have succeeded, but, also, many have failed. Frozen pork belly futures are active while boneless-beef futures are dormant. Silver and copper futures thrive while aluminum futures languish. Eurodollar futures are vastly more successful than certificate of deposit futures. It is interesting to ponder why one futures contract succeeds and another fails—why one has an average daily trading volume of 100,000 contracts, for example, while another has less than 500. The following have been found to be the most important characteristics that make futures contracts successful:

1. The supply of and demand for the product or financial instrument must be large. Otherwise, too few people will care about the price to generate the broad interest that is needed to sustain active futures trading. This explains why, for example, corn futures trade far more actively than rye futures and why the enormous success of U.S. Treasury bond futures would not be repeated if an exchange introduced a futures contract on Milwaukee general revenue bonds. Large supply is also an important deterrent to price manipulation. Consider that both hedgers and speculators (discussed in Chapters 7 and 8) would be reluctant to trade contracts that could easily be manipulated by others with greater financial resources.

2. Different units of the underlying item must be interchangeable. This is a prerequisite for the development of standardized, transferable contracts, which are, in turn, a prerequisite for active, liquid markets. One of the great advantages of futures contracts is that traders need not worry about which particular Treasury bill or bar of gold they are trading. Once the contract specifications are agreed upon, all contracts are equivalent. Certain potentially useful futures contracts (such as real estate futures) have never been developed because of the inability to standardize units.

 The items that underlie a successful futures contract need not, and indeed cannot, be strictly uniform, as the live cattle and

live hog futures contracts prove. One hog is not identical to another in the same sense that every Swiss franc is identical to every other. What is important is a degree of standardization that is both narrow enough to be consistent with commercial realities and broad enough to include the required breadth of supply. A contract specifying delivery of "a hog" would never get far. Few buyers would, so to speak, purchase a pig in a poke. On the other hand, a futures contract specifying that the hog must weigh exactly 185 pounds and be 221 days old would be too restrictive to permit liquid trading. Striking the correct balance between standardization and breadth of supply is one of the major challenges for designers of futures contracts.

3. Pricing of the underlying item must be determined by free market forces, without monopolistic or governmental control. No single buyer, seller, or regulator should have such influence on prices. This is one reason why there is no Moscow Futures Exchange. When prices are fixed by the government there is little incentive to hedge because the price will not change except by government decree.

 This situation may sound appealing from a planning perspective, but problems arise if the price that has been fixed by the planning authorities is too high or too low. Expected future prices not only permit planning—they also influence planning. For example, if a government agency sets the price of soybeans too high, farmers will produce a huge surplus; if it sets the price too low, there will be a shortage. The economic advantage of freely traded futures markets is that they are more likely than are centralized planners to react appropriately to changing market conditions and outlooks and are more likely to help keep supply and demand aligned. Few things highlight the difference between free market economies and planned economies more starkly than the existence of thriving futures markets in the former and their complete absence in the latter.

4. Prices must fluctuate. If they are stable, or almost so, then there is no incentive for hedgers to hedge and no incentive for speculators to participate in the market. Interest rate futures would not have been as successful in the 1950s as they have been in the 1970s and 1980s because the stability of interest rates during the earlier era would have been a disincentive to both hedgers and speculators.

5. The contract should have the support of commercial interests. Hedgers contribute greatly to the volume of trading in any futures contract. Their activities, including the making and the taking of delivery, also provide an important link to the underlying cash market, without which prices might be subject to disruptive speculative forces. Of particular importance here is participation by dealers. Dealers are those who trade the underlying commodity or financial instrument for short-term profit and are an important lubricant in the machinery of any market. Once they come to use a futures market as a central pricing point, its success is virtually guaranteed.

6. The futures contract must be supported by a well-capitalized group of traders on the exchange floor. This is particularly important from the perspective of commercial hedgers, who tend to trade in large quantities and expect enough liquidity on the exchange floor to accommodate these quantities. If this liquidity is not present, an exchange will have difficulty attracting the commercial participation necessary for a contract's success.

7. The futures contract must be sufficiently different from other existing contracts to attract speculative participation. "Me-too" contracts are all but doomed to fail, as we've seen time and again since the mid-1970s when the success of interest rate and stock index futures contracts spawned a multitude of unsuccessful financial contracts. From the perspective of most speculators, one long-term interest rate futures contract is pretty much the same as another. Fixed-income professionals may distinguish between 10-year and 7-year Treasury notes, but few speculators care about the difference. When a particular type of futures contract (e.g., soybeans, long-term U.S. government interest rates) is established and active, it is very hard to induce speculators to forego existing liquidity and trade another contract that is simply a slight variation on the established theme.

These characteristics are crucial to the success of a futures contract, but they certainly do not ensure success. Futures contracts are products, like automobiles and tickets to baseball games, and products seldom sell themselves. Effective promotion is usually necessary, and some futures exchanges are better than others at promoting their contracts. The time of a contract's introduction is

also important. Futures exchanges must compete with securities exchanges, the real estate market—essentially the entire spectrum of trading and investment possibilities. If opportunities abound elsewhere, a new futures contract may have difficulty attracting attention and participation. Weighing all these factors to develop and maintain a roster of active contracts is one of the key challenges that every exchange must face. Exchanges that adapt existing contracts or that introduce appropriate new contracts as economic conditions change will thrive; those that are less responsive will languish or even disappear from the futures scene.

TRY THIS

Is the following statement true or false?
 A scarce supply of the actual commodity generally causes futures prices to rise.

HERE'S WHY

Generally, an abundance of a commodity, for example, a "bumper crop," is *bad for the long* (buy) and *good for the short* (sell) as prices go down when supply exceeds demand. A scarcity obviously has the reverse effect.

Now that you are aware of the basic organizational structure of the brokerage firm, and what impact the futures market has on traders, and vice versa, it's time to discuss the customer account. As you have read, the success or failure of a futures contract has a direct impact on the investor. Equipped with that knowledge, or warning, you can now open an account!

Types of Commodities Accounts

Commodity Futures Trading Commission regulations require that commodity accounts be divided into certain classes. Brokerage firms abide by this rule and have found that categorizing accounts also helps their bookkeeping procedures. Although the actual names and numbers of the classes vary from one firm to another, there are still three basic types:

1. Class 1—regulated
2. Class 2—nonregulated
3. Class 3—spot cash

Class 1—Regulated Accounts

These accounts deal in all commodities traded on domestic exchanges and that consequently come under regulation of the CFTC.

Class 2—Nonregulated Accounts

This class of accounts deals in commodity products not under control of the Commission; that is, commodities traded on foreign exchanges. For example, gold or flaxseed traded on the Winnipeg exchange or cocoa, coffee, silver, or rubber traded in London are all nonregulated.

Class 3—Spot Cash Accounts

This classification is used in the event that an investor actually receives or makes delivery of the physical commodity. Use of this type of account is usually reserved for hedgers.

TRY THIS

Match the following futures contracts with the type of account it is: regulated or nonregulated.

Gold (New York)
Deutsche marks (Chicago)
Gas oil (London)
Eurodollar (Singapore)

HERE'S WHY

Gold (New York) *regulated*
Deutsche marks (Chicago) *regulated*
Gas oil (London) *nonregulated*
Eurodollar (Singapore) *nonregulated*

Only commodities traded on a U.S. market are CFTC regulated. Thus, the Singapore Eurodollar is unregulated when traded on a market outside the United States, but, when traded on the International Monetary Market of the Chicago Mercantile Exchange, it is regulated. The same is true for other commodities that trade in the U.S. as well as foreign exchanges (gold, sugar, cocoa, and so forth).

Types of Transactions

Transactions are divided into two categories. This is usually done for determining margin and for easy reporting.

Type 1—Regular Account

This includes any and all transactions that are not part of a spread or straddle (the purchase of one commodity future and the sale of another).

Type 2—Spread Account

Commodity transactions not grouped in a Regular Account must be for a spread and belong to this type. The differentiation is made because transactions in this type of account qualify for reduced commission rates and lower margin rates.

Opening an Account

Though the details of procedure and the specific forms used in opening an account vary from firm to firm, the general process is pretty much the same throughout the industry. Some firms soliciting or accepting commodity business from customers are also members of the New York Stock Exchange and are required to follow the same rules and regulations as in the opening of a stock account. Firms handling commodity business who are not members of the NYSE are not necessarily bound by these regulations,

but as a general rule they do follow the same basic procedures in opening an account.

To open a new account, a customer must fill out a new account report form, a sample of which can be seen in Figure 2-1. Essential information such as name, address, telephone number are obviously necessary for the broker to have on file. However, other information, such as financial data, is used to help determine the suitability of the customer to trade futures. Along these lines, the CFTC requires that every new account sign a risk disclosure statement (see Figure 2-2) that spells out some of the risks associated with futures trading.

A new customer must also sign the customer agreement (shown in Figure 2-3), which details the rights and duties of the FCM. It covers every aspect of the client/FCM relationship—from margin and delivery procedures to the rights of the FCM in the event of your death.

Just as an aside, the customer and the broker must adhere to the New York Stock Exchange Rule 405 "Know Your Customer," a regulation applying to all commodity accounts carried by NYSE members. Under this rule, the brokerage firm should know enough about a customer to determine that it wants to do business with that customer. It should know that the customer has not only the financial responsibility for his or her trading actions, but also the willingness to act on obligations incurred. All commodity brokers must, under the suitability concept, "know their customers."

Because the risk is so much greater in trading futures contracts than it is in buying and selling securities, you have to be very carefully and forcefully advised when opening an account. This is one of the main reasons for the risk disclosure statement. The risk is so much greater, in fact, that the CFTC requires FCMs to give each new customer a strongly worded statement that basically says: "A person who does not have extra capital he can afford to lose should not trade in the futures market. No 'safe' trading system has ever been devised, and no one can guarantee you profits or freedom from loss. In fact, no one can even guarantee to limit the extent of your loss."

When you do go, as a customer, to discuss opening such an account with your broker, if you are not given the third degree and presented with such warnings and advisories, then by all means, seek out another broker—one you can trust to do things right for you, from the beginning.

FIGURE 2-1 New Account Report

NEW ACCOUNT REPORT

Mr.
Mrs.
Miss _____
 (NAME OF CUSTOMER)
SOCIAL SECURITY NUMBER OR
TAXPAYER IDENTIFYING NO. _____ CITIZEN OF _____
ADDRESSES _____ (HOME) _____
 (BUSINESS)
TELEPHONES _____ CUSTOMER'S AGE, IF UNDER TWENTY-FIVE _____
 (BUSINESS) (HOME)
OCCUPATION AND EMPLOYER _____ POSITION _____
INTRODUCED TO REGISTERED REPRESENTATIVE BY _____ HOW LONG HAVE YOU KNOWN CLIENT? _____
NAME OF BANK REFERENCE _____
OTHER REFERENCES _____
OTHER BROKERS (IF ANY) _____
TYPE OF ACCOUNT □ STOCK □ CASH STOCK TO BE TRANSFERRED? YES □ NO □ IF SO, PRINT
 □ COMMODITY □ MARGIN PROPER INSCRIPTION & FORWARDING ADDRESS BELOW
INITIAL TRANSACTION _____
MARGIN DEPOSITED _____
SIGNATURE CARD GIVEN TO _____
STOCK LOAN CARD GIVEN TO _____
CUSTOMER'S AGREEMENT GIVEN TO _____
CUSTOMER OF _____ (USE UNIFORM ABBREVIATIONS WHERE POSSIBLE)

(CUSTOMER'S FULL SIGNATURE FOR IDENTIFICATION PURPOSES) NEW ACCOUNT REPORT

 ASEF Form 111

IS ACCOUNT BEING OPERATED BY PERSON OTHER THAN THE OWNER? _____
IF SO, HAS PROPER POWER OF ATTORNEY BEEN EXECUTED AND PLACED ON FILE IN MAIN OFFICE? _____
IF SO, GIVE FOLLOWING INFORMATION FOR PERSON OPERATING ACCOUNT:
 (A) NATURE OF BUSINESS _____
 (B) BY WHICH REGULARLY EMPLOYED: _____
 (C) ADDRESS: _____
SIGNATURE CARD SIGNED BY ALL OFFICERS, ETC. CORPORATION-RESOLUTION: COPY OF CHARTER
WOMAN'S ACCOUNT—NAME OF HUSBAND: BY WHOM EMPLOYED: OCCUPATION

 ADDITIONAL INFORMATION

DATED, _____
_____ APPROVED BY
 (CITY) (STATE)
_____ _____
 SIGNATURE OF REGISTERED REPRESENTATIVE SIGNATURE OF PARTNER OR OFFICER

Joint Account

Accounts can be opened by two or more individuals who have a
joint interest in the account—hence, the name *joint* account. It is
required that each participant sign an individual account form as

FIGURE 2-2 Risk Disclosure Statement

RISK DISCLOSURE STATEMENT

Account No._____

This statement is furnished to you because rule 1.55 of the Commodity Futures Trading Commission requires it.

The risk of loss in trading commodity futures contracts can be substantial. You should therefore carefully consider whether such trading is suitable for you in light of your financial condition. In considering whether to trade, you should be aware of the following:

1. You may sustain a total loss of the initial margin funds and any additional funds that you deposit with your broker to establish or maintain a position in the commodity futures market. If the market moves against your position, you may be called upon by your broker to deposit a substantial amount of additional margin funds, on short notice, in order to maintain your position. If you do not provide the required funds within the prescribed time, your position may be liquidated at a loss, and you will be liable for any resulting deficit in your account.

2. Under certain market conditions, you may find it difficult or impossible to liquidate a position. This can occur, for example, when the market makes a "limit move."

3. Placing contingent orders, such as a "stop-loss" or "stop-limit" order, will not necessarily limit your losses to the intended amount, since market conditions may make it impossible to execute such orders.

4. A "spread" position may not be less risky than a simple "long" or "short" position.

5. The high degree of leverage that is often obtainable in futures trading because of the small margin requirements can work against you as well as for you. The use of leverage can lead to large losses as well as gains.

This brief statement cannot, of course, disclose all the risks and other significant aspects of the commodity markets. You should therefore carefully study futures trading before you trade.

I HAVE RECEIVED A COPY OF THIS RISK DISCLOSURE STATEMENT, HAVE READ IT, AND UNDERSTAND IT.

THIS FORM MUST BE SIGNED AND DATED

Customer Signature	Date
	Date

well as a joint account agreement form. A sample of the joint form is shown in Figure 2-4.

This account can be in the name of both husband and wife, for example, or in the name of two or more other related or unrelated persons. They can be as joint tenants with rights of survivorship or as tenants-in-common.

In the former case, upon the death of either of the joint tenants, the entire interest in the account is vested in the survivor or survivors. The estate of the deceased has no claim on the account.

With a tenants-in-common account, each participant has a fractional interest in the account. This means that if one of the tenants-in-common should die, the estate of the decedent continues to have the same fractional interest in the account.

FIGURE 2-3 Customer Agreement

BROKER & CO.
INCORPORATED

CUSTOMER'S AGREEMENT

1. I agree as follows with respect to all of my accounts, in which I have an interest alone or with others, which I have opened or open in the future, with you for the purchase and sale of securities and commodities:

2. I am of full age and represent that I am not an employee of any exchange or of a Member Firm of any Exchange or the NASD, or of a bank, trust company, or insurance company and that I will promptly notify you if I become so employed.

3. All transactions for my account shall be subject to the constitution, rules, regulations, customs and usages, as the same may be constituted from time to time, of the exchange or market (and its clearing house, if any) where executed.

4. Any and all credit balances, securities, commodities or contracts relating thereto, and all other property of whatsoever kind belonging to me or in which I may have an interest held by you or carried for my accounts shall be subject to a general lien for the discharge of my obligations to you (including unmatured and contingent obligations) however arising and without regard to whether or not you have made advances with respect to such property and without notice to me may be carried in your general loans and all securities may be pledged, repledged, hypothecated or re-hypothecated, separately or in common with other securities or any other property, for the sum due to you thereon or for a greater sum and without retaining in your possession and control for delivery a like amount of similar securities or other property. At any time and from time to time you may, in your discretion, without notice to me, apply and/or transfer any securities, commodities, contracts relating thereto, cash or any other property therein, interchangeably between any of my accounts, whether individual or joint or from any of my accounts to any account guaranteed by me. You are specifically authorized to transfer to my cash account on the settlement day following a purchase made in that account, excess funds available in any of my other accounts, including but not limited to any free balances in any margin account or in any non-regulated commodities account, sufficient to make full payment of this cash purchase. I agree that any debit occurring in any of my accounts may be transferred by you at your option to my margin account.

5. I will maintain such margins as you may in your discretion require from time to time and will pay on demand any debit balance owing with respect to any of my accounts. Whenever in your discretion you deem it desirable for your protection, (and without the necessity of a margin call) including but not limited to an instance where a petition in bankruptcy or for the appointment of a receiver is filed by or against me, or an attachment is levied against my account, or in the event of notice of my death or incapacity, or in compliance with the orders of any Exchange, you may, without prior demand, tender, and without any notice of the time or place of sale, all of which are expressly waived, sell any or all securities, or commodities or contracts relating thereto which may be in your possession, or which you may be carrying for me, or buy any securities, or commodities or contracts relating thereto of which my account or accounts may be short, in order to close out in whole or in part any commitment in my behalf or you may place stop orders with respects to such securities or commodities and such sale or purchase may be made at your discretion on any Exchange or other market where such business is then transacted, or at public auction or private sale, with or without advertising and no demands, calls, tenders or notices which you may make or give in any one or more instances shall invalidate the aforesaid waivers on my part. You shall have the right to purchase for your own account any or all of the aforesaid property at any such sale, discharged of any right of redemption, which is hereby waived.

6. All orders for the purchase or sale of commodities for future delivery may be closed out by you as and when authorized or required by the Exchange where made. Against a "long" position in any commodity contract, prior to maturity thereof, and at least five business days before the first notice day of the delivery month, I will give instructions to liquidate, or place you in sufficient funds to take delivery; and in default thereof, or in the event such liquidating instructions cannot be executed under prevailing conditions, you may, without notice or demand, close out the contracts or take delivery and dispose of the commodity upon any terms and by any method which may be feasible. Against a "short" position in any commodity contract, prior to maturity thereof, and at least five business days before the last trading day of the delivery month, I will give you instructions to cover, or furnish you with all necessary delivery documents; and in default thereof, you may without demand or notice, cover the contracts, or if orders to buy in such contracts cannot be executed under prevailing conditions, you may procure the actual commodity and make delivery thereof upon any terms and by any method which may be feasible.

7. All transactions in any of my accounts are to be paid for or required margin deposited no later than 2:00 p.m. on the settlement date.

8. I agree to pay interest and service charges upon my accounts monthly at the prevailing rate as determined by you.

9. I agree that, in giving orders to sell, all "short" sale orders will be designated as "short" and all "long" sale orders will be designated as "long" and that the designation of a sell order as "long" is a representation on my part that I own the security and; if the security is not in your possession that it is not then possible to deliver the security to you forthwith and I will deliver it on or before the settlement date.

10. Reports of the execution of orders and statements of my account shall be conclusive if not objected to in writing within five days and ten days, respectively, after transmittal to me by mail or otherwise.

11. All communications including margin calls may be sent to me at my address given you, or at such other address as I may hereafter give you in writing, and all communications so sent, whether in writing or otherwise, shall be deemed given to me personally, whether actually received or not.

12. No waiver of any provision of this agreement shall be deemed a waiver of any other provision, nor a continuing waiver of the provision or provisions so waived.

13. I understand that no provision of this agreement can be amended or waived except in writing signed by an officer of your Company, and that this agreement shall continue in force until its termination by me is acknowledged in writing by an officer of your Company; or until written notice of termination by you shall have been mailed to me at my address last given you.

14. This contract shall be governed by the laws of the State of New York, and shall inure to the benefit of your successors and assigns, and shall be binding on the undersigned, his heirs, executors, administrators and assigns. Any controversy arising out of or relating to my account, to transactions with or for me or to this agreement or the breach thereof, shall be settled by arbitration in accordance with the rules then obtaining of either the American Arbitration Association or the Board of Governors of the New York Stock Exchange as I may elect, except that any controversy arising out of or relating to transactions in commodities or contracts relating thereto, whether executed or to be executed within or outside of the United States shall be settled by arbitration in accordance with the rules then obtaining of the Exchange (if any) where the transaction took place, if within the United States, and provided such Exchange has arbitration facilities or under the rules of the American Arbitration Association as I may elect. If I do not make such election by registered mail addressed to you at your main office within five days after demand by you that I make such election, then you may make such election. Notice preliminary to, in conjunction with, or incident to such arbitration proceeding, may be sent to me by mail and personal service is hereby waived. Judgment upon any award rendered by the arbitrators may be entered in any court having jurisdiction thereof, without notice to me.

15. If any provision hereof is or at any time should become inconsistent with any present or future law, rule or regulation of any securities or commodities exchange or of any sovereign government or a regulatory body thereof and if any of these bodies have jurisdiction over the subject matter of this agreement, said provision shall be deemed to be superseded or modified to conform to such law, rule or regulation, but in all other respects this agreement shall continue and remain in full force and effect.

DATE_____ CUSTOMER'S SIGNATURE _____ _____

LENDING AGREEMENT

YOU AND ANY FIRM SUCCEEDING TO YOUR FIRM ARE HEREBY AUTHORIZED FROM TIME TO TIME TO LEND SEPARATELY OR TOGETHER WITH THE PROPERTY OF OTHERS EITHER TO YOURSELVES OR TO OTHERS ANY PROPERTY WHICH YOU MAY BE CARRYING FOR ME ON MARGIN. THIS AUTHORIZATION SHALL APPLY TO ALL ACCOUNTS CARRIED BY YOU FOR ME AND SHALL REMAIN IN FULL FORCE UNTIL WRITTEN NOTICE OF REVOCATION IS RECEIVED BY YOU AT YOUR PRINCIPAL OFFICE IN NEW YORK.

DATE_____ CUSTOMER'S SIGNATURE _____ _____

KINDLY SIGN THIS FORM IN THE TWO SIGNATURE SPACES INDICATED ABOVE. IN THE CASE OF JOINT ACCOUNTS, BOTH TENANTS SHOULD SIGN IN BOTH SIGNATURE SPACES. RETURN THIS ORIGINAL (WHITE) TO THE BACHE OFFICE WHICH SERVICES YOUR ACCOUNT. THE DUPLICATE (BUFF) SHOULD BE RETAINED FOR YOUR PERSONAL RECORDS.

FIGURE 2-4 **Joint Account Agreement Form**

JOINT ACCOUNT AGREEMENT

ACCOUNT NUMBER

Dear Sirs

1. The undersigned (herinafter referred to as "we") hereby request you to open an account in our behalf on the terms and conditions stated herein, and in your usual form of customers' agreement signed by us or on our behalf, and any one of the undersigned is hereby authorized to sign such agreement on behalf of all of us. We intend to deal through you as brokers, in stocks, bonds and other securities and/or in commodities and futures contracts. You may carry the account under such designation as we may instruct.

2. We hereby state that we are:

IMPORTANT CLAUSE (a) OR (b) MUST BE CROSSED OUT BEFORE SIGNING

(a) joint tenants with right of survivorship and not tenants in common. In the event of the death of either or any of us, the entire interest in the account shall be vested in the survivor, or survivors, on the same terms and conditions as theretofore held and the estate of the decedent shall have no interest in the assets of the account at the date of death or in its operation thereafter. The estate shall, however, remain liable for obligations of the account as provided in paragraph 3 below.

(b) tenants in common, each of us having an undivided interest therein. In the event of the death of either or any of us, you may, in your sole discretion either liquidate the account or accept the instructions of the survivor, or a majority of the survivors, as the case may be, as to its continuance and as to the respective interest of the parties (including the estate) therein, and in either event the decedent's estate shall remain liable for obligations of the account as provided in paragraph 3 below.

3. We hereby state that whether we are joint tenants or tenants in common, our liability hereunder shall be joint and several, and you shall have a lien on the separate property of each of us, as well as on the property in said account, to secure our joint and several liability. We will give you immediate notice in writing of the death of any one of us. You may in the event of the death of any one of us, whether we are joint tenants or tenants in common, take such steps as you may deem necessary or desirable to protect yourselves with respect to taxes and other claims; and you may, before releasing any of the properties in the account, require such proofs of death, tax waivers, other documents, and instruments of guarantee by the survivors as in your judgment may be necessary or desirable in connection with the liquidation or continuation of the account. The estate of any of us who shall have died shall be liable, and the survivor, or survivors, shall continue liable, jointly and severally, for any debit balance or loss in the account resulting from the completion of transactions initiated prior to the receipt by you of written notice of the death of any one of us, or incurred in the liquidation of the account.

4. None of us is under a legal disability and no one other than the undersigned has an interest in this joint account. Each of us shall have authority: (1) to give any instructions with respect to the account, including but not limited to instructions with respect to buying or selling or withdrawals of excess funds, (2) to receive any demands, notices, confirmations, reports, statements, and other communications of any kind; and (3) generally to deal with you in connection herewith as fully and completely as if the other joint tenant or tenants had no interest herein. You shall be under no duty or obligation to inquire into the purpose or propriety of any instruction given and shall be under no obligation to see to the application of any funds so delivered.

5. We agree that if the account shall at any time have no open commitments and no debit or credit balance, you may in your sole discretion treat it as closed, or you may regard it as remaining open subject to further orders or activity, in accordance with the terms of this agreement and the customers agreement signed by or for us. Either, or any of us, however, may terminate the authority of any other of us to reopen the account after it has been closed, upon written notice actually delivered to you.

6. We hereby ratify and confirm all transactions heretofore entered into for said account by any of us. This agreement and your customers' agreement signed by or for us shall be binding upon each of us and our respective heirs, legal representatives and assigns.

NOTE: THIS AGREEMENT IS INEFFECTIVE UNLESS EITHER 2(a) OR 2(b) IS CROSSED OUT. ONE TENANCY MUST BE ELECTED.

_____ 19 ___

Date

Signatures

TRY THIS

If an account is opened with the following title: "Oliver Holmes and Elizabeth Holmes, Joint Tenants with Rights of Survivorship," what happens to the property if Elizabeth Holmes dies?

HERE'S WHY

A Joint-Tenancy-with-Rights-of-Survivorship account is defined as follows: "an account whereby one tenant receives the entire property upon the death of the other." Therefore, Oliver Holmes would retain all the property upon Elizabeth's death.

Partnership Account

A *partnership* is an association formed by two or more people to carry on a business as co-owners and is liable for all acts or representations by each partner in the course of partnership business. Generally, each partner is deemed the agent for all the other partners, but before buying or selling a commodity, all the partners must sign a partnership agreement. This form allows the trader to act in the partnership's behalf—give orders, receive money, issue notices—and directs where all notices and communications can be sent to the partnership.

Other Accounts

There are a number of other types of accounts that you may be interested in learning about. Chances are that you will not be directly involved in the following types of accounts, but you may be curious about them nevertheless.

There are four other more prominently known types of accounts; they are:

1. corporation account
2. account with power of attorney
3. trade or hedge account
4. omnibus account

A corporation is an artificial entity recognized as a person only through its agents or officers, who have no authority to bind the corporation merely by virtue of their offices. The power of a corporation is limited to the scope defined in the corporate charter,

which also determines whether trading in commodity futures is provided for.

Power of attorney provides that any person having the capacity to contract in his or her own right may appoint another person to perform any act that the principal may legally perform. The same requirements and restrictions that apply to an individual apply to the appointed person. However, such an appointment must be carefully documented and supported by the proper legal forms.

In trade or hedge accounts, a hedge letter is required from the hedger. Anyone who handles actual commodities—individuals, proprietorships, partnerships, or corporations—usually maintains trade or hedge accounts to protect his or her investments. A hedge account deals in certain commodity futures transactions at more favorable margin terms than do speculative accounts. Such an account also has more liberal position limits. The dealer's purpose is not necessarily to make money on the hedging process, but rather to avoid losing a great portion of the investments.

An omnibus account, sometimes referred to as a customer's account, is an account of one futures commission merchant carried by another in which (a) the transactions of two or more persons are combined rather than designated separately, and (b) the identity of individual accounts is not disclosed.

TRY THIS

In a hedge account, a cotton mill owner might deal in cotton futures. What might a feed lot operator trade in?

a. cattle futures

b. gold futures

c. Eurodollars

HERE'S WHY

Just by process of elimination, the correct answer is (a). More on the strategy behind hedging is discussed in Chapter 7.

Transferring Accounts

Generally, all purchases and sales of any futures contracts are executed openly and competitively. Transactions take place as brokers cry out their bids and offers in the trading pit during the regular trading hours as prescribed by the exchange for the given contract market. Competitive executions are required by the CFTC as well as by the exchanges themselves. (The only exception to this requirement is *transfer trades*, that is, trades that involve an exchange of futures for actual commodities. Such trades are known as *ex-pit transactions* because they are transactions that do not have to be carried out in the trading pit.)

The transfer of accounts is initiated by a customer who wishes to switch an account or accounts from one brokerage firm (or FCM) to another. To do so, the customer must send written instructions to the brokers of both companies.

When transferring futures contracts from one house to another, the customer may incur extra commission expenses. Not only does the losing firm charge the customer for its handling of the contract, but the new firm may also charge the regular commission when the trade is completed.

TRY THIS

Which of the following is an ex-pit transaction?

a. spread
b. short hedge
c. floor give-up
d. transfer trade

HERE'S WHY

Transfer trades, sometimes referred to as "office trades," are really simple transfers of a contract from one firm to another. The transaction is usually done outside the trading pit.

Handling the Account

All the federal regulations, all the exchange rules and regulations have one overriding purpose: to maintain an orderly commodities market in which all parties have an equal chance to trade. To accomplish this, the government, the exchanges, and the people who work in the marketplace, strive to keep the customers' interests "up front." Failure to protect these interests could eventually lead to the abuse of privileged information and the misuse of a customer's funds. Such practices could ultimately lead to the breakdown of an orderly market.

Once the customer account has been opened and approved for trading, it is the responsibility of the FCM and its account representative to:

1. make sure that the account is properly margined at all times (this is explained in more detail later on),
2. accept and promptly transmit to the trading floor all customer trading instructions (orders), and
3. keep the customer informed of all trading or other activity in the account.

Reporting Duties

The primary duty of the broker is to execute the trading instructions of his or her client. It is then necessary for the broker to immediately advise the client of all transactions in the account, sending a prompt written report. A record of every transaction a broker makes for a customer is entered into the account record. These entries are made immediately upon the completion of the transaction and on the same day as the transaction. At the end of the month, the broker sends a copy of the account record to the customer.

Customer Statements

When a trade is executed, the broker usually reports verbally to the customer the results of the transaction. This must be followed by a

written confirmation of the transaction the same day as the trade. The written confirmation, or *confirm*, must indicate:

- what commodity was bought or sold,
- the exchange on which the order was executed,
- the quantity,
- the contract maturity (delivery month), and
- the price.

Not only must a confirm be sent out when a client first purchases a contract but also when the contract is sold. A sample of each is shown in Figures 2-5 and 2-6.

Whenever a client offsets a position, that is, sells a contract to offset (or close out) a long position or buys a contract to offset a short position, the position is said to be closed out. In addition to the other confirmations, a *purchase and sale (P&S)* statement (illustrated in Figure 2-7) must be sent out. This statement indicates:

- the quantities bought and sold,
- the prices of the position's purchase and sale,
- the gross profit (or loss) on the price difference,
- the commission charges, and
- the net credit (or debit) on the transactions.

All transactions for the month are sent to the customer on a monthly statement. At the end of the month, making up the customer's statement is a simple matter of retyping the logged transactions and relevant information onto a standard form. This includes all trades and all debits or credits as well as a statement of open position with the equity value of these positions clearly stated.

The monthly statement, however, is more than just a simple record-keeping device. It serves as a history of the account. When either the broker or the customer reviews the statement, the trends, errors, successes, right-and-wrong guesses can all be viewed as lessons for future decisions in the marketplace.

FIGURE 2-5 Written Confirmation of Trade (Purchase)

<table>
<tr><td colspan="2">BROKER & CO.
INCORPORATED
NEW YORK, N.Y. 10011
MEMBERS NEW YORK STOCK EXCHANGE
AMERICAN STOCK EXCHANGE · TORONTO STOCK EXCHANGE
AND OTHER LEADING STOCK AND COMMODITY EXCHANGES</td><td>P = Statement of
Purchase & Sale
C = Confirmation
★ ★ SEE REVERSE SIDE ★ ★</td><td colspan="3">NOTIFICATION OF COMMODITY TRANSACTION
WE HAVE DEBITED OR CREDITED YOUR ACCOUNT WITH THE AMOUNT SHOWN IN THE
NET AMOUNT COLUMN, RESULTING FROM YOUR PURCHASE AND SALE AS FOLLOWS</td></tr>
</table>

DATE	QUANTITY BOUGHT	QUANTITY SOLD	DESCRIPTION	MKT	C/L	PRICE	T	C/P	DIFFERENCE	FEES	COMMISSION	NET AMOUNT
030679	5M		BUS JULY CORN	01	1	142		1 C				

OFF	ACCOUNT NUMBER	R.R.							RATE OF EXCHANGE	U.S. EQUIVALENT	MONTH DAY YEAR
AB	12345	9	•							FOREIGN TRANSACTIONS ONLY	Mar 06 79

FORM
936-5 NAME OF OTHER PARTY IN CONTRACT
FURNISHED ON REQUEST

As indicated above we have this day **BOUGHT** OR **SOLD** for your account and risk, subject to the By-Laws, Rules, Regulations and Customs as now existing or hereafter amended or adopted, of the Exchange where the transaction was made and its Clearing House, and subject to all applicable Federal and State laws and to the regulations of any Government agency having authority with respect thereto;

FIGURE 2-6 Written Confirmation of Trade (Sale)

FIGURE 2-7 Purchase and Sale (P&S) Statement

BROKER & CO.
INCORPORATED
NEW YORK, N.Y. 10011

MEMBERS NEW YORK STOCK EXCHANGE
AMERICAN STOCK EXCHANGE · TORONTO STOCK EXCHANGE
AND OTHER LEADING STOCK AND COMMODITY EXCHANGES

NOTIFICATION OF **COMMODITY** TRANSACTION

P = Statement of Purchase & Sale
C = Confirmation

* = SEE REVERSE SIDE

WE HAVE DEBITED OR CREDITED YOUR ACCOUNT WITH THE AMOUNT SHOWN IN THE
NET AMOUNT COLUMN, RESULTING FROM YOUR PURCHASE AND SALE AS FOLLOWS

DATE	QUANTITY BOUGHT	QUANTITY SOLD	DESCRIPTION	MKT	CL	PRICE	T/%	DIFFERENCE	FEES	COMMISSION	NET AMOUNT
030679	5M		BUS JULY CORN	01	1	142	1P				
032279		5M	BUS JULY CORN	01	1	145½	1P	175.00 CR		22.00	153.00 CR

AB	12345	9
OFF	ACCOUNT NUMBER	R.R.

RATE OF EXCHANGE U.S. EQUIVALENT
FOREIGN TRANSACTIONS ONLY

Mar 22 '79
MONTH DAY YEAR

As indicated above we have this day **BOUGHT OR SOLD** for your account and
risk, subject to the By-Laws, Rules, Regulations and Customs as now existing or
hereafter amended or adopted, of the Exchange where the transaction was made and
its Clearing House, and subject to all applicable Federal and State laws and to the
regulations of any Government agency having authority with respect thereto:

FORM
936-5

NAME OF OTHER PARTY IN CONTRACT
FURNISHED ON REQUEST

49

Reporting Errors

Despite all the controls and supervisory techniques used in the brokerage firms, occasionally clerical errors do occur. Often the error involves a statement or confirmation that does not reflect the true price at which an order was executed. As long as the actual execution was at the price and quantity stated in the customer's order, the firm must send out—and the customer must accept—a corrected report of the transaction, even when the error was in the customer's favor.

If the actual execution was not at the price and quantity specified by the customer's order, the broker must report the error promptly to an officer or partner for handling of the correction.

Death of a Customer

In general, if a customer dies, the procedure is to cancel any outstanding orders. Because of the volatile nature of futures prices, the broker must be ready to liquidate all open positions. Existing positions are liquidated upon receipt of instructions from an accredited member of the decedent's estate. The broker may also liquidate, without instructions, if the account is in danger of going into deficit.

Closing the Account

According to the rules of the CFTC, a speculative customer cannot be long (buy) and short (sell) in the same delivery at the same time. An FCM who executes a sale for a customer must apply that sale, on the same day, against an existing long position. The FCM must also send the customer a P&S statement showing the financial result of the transactions. The same procedure is followed when an existing short position is offset by a purchase.

> EXAMPLE: Miss Joy Bean is long 5,000 bushels of July soybeans, and she subsequently sells 5,000 bushels of July soybeans (same commodity, same delivery month). The sale *offsets* her original purchase and consequently closes the position. The broker then sends out a P&S statement.

Sometimes the long and short positions do not balance out perfectly. If so, the client should instruct the broker as to which position should be offset; the customer may want to keep an older position open and close out a more recent (perhaps less profitable) position. If the client does not instruct the FCM in any way, then the FCM is obliged to apply the order against the earliest (or oldest) position in the account.

> EXAMPLE: Miss Bean establishes a long position of 5,000 bushels of November soybeans on March 1 and another long position of 5,000 bushels of November soybeans on June 1. She then sells 5,000 bushels of November soybeans on July 1, without giving the broker any instructions as to which contract to close out. According to the law, the broker is mandated to close out the March 1 purchase because it is the earlier position—even if the position is the less profitable one to close out, and even if the close-out spells a loss to the customer.
>
> Miss Bean, however, could and should have specified to the broker which position she wanted to close out. She is entitled to close out the later, and newer, position, as long as she does not remain both long and short in the same commodity and in the same month.

Margin Account

Margin is the lifeblood of the futures market system. Each day, as prices rise and fall, many millions of dollars pass back and forth between customers and their clearing firms and between those clearing firms and the central clearinghouses of the exchanges. The smooth circulation of these funds through the system is vital to the health of the futures market because they represent the ultimate guarantee that all participants in the marketplace will fulfill the financial obligations of their market positions. Just how they pass through the clearinghouses is discussed in Chapter 4.

In the more familiar margin system of the securities market, margin refers to money that is borrowed from a brokerage firm to purchase securities. The percent of cash that must be deposited with a broker to buy securities on margin is set by the Federal Reserve and, since 1974, has been 50% for common stock. Thus, you can buy $20,000 worth of stock for $10,000 in cash, borrowing the remainder from and paying interest to your brokerage house, with the securities used as collateral.

The futures margin, however, differs from the securities margin in both concept and mechanics. Because futures contracts do not entail the immediate delivery of their underlying asset as do securities transactions, no immediate payment in full is necessary. All commodity transactions are margin transactions. Instead of representing partial payment for something purchased, the futures margin is a good faith deposit that is intended to protect the seller against the buyer's default should prices fall, and the buyer against the seller's default should prices rise. The amount of margin is set by the exchange and depends on the type of commodity and the volatility of the contract. The margin should be enough to offset unexpected losses by the client.

Because the amount of margin required varies, there are several terms you should understand.

Original margin is the deposit that must be made when a futures position (long or short) is initiated. It is the amount required for each position cleared but not offset.

The minimum level of this original margin is determined by the exchange on which the contract is traded and varies according to price level, price volatility, and other factors. FCMs can have higher (but not lower) margins. Original margins are fixed-dollar amounts and generally range from about 2% to 10% of the value of the contract. Margin requirements are usually changed only after fairly substantial moves in the price level of the underlying commodity or financial instrument. Under normal circumstances, minimum original margin requirements for a given item might be adjusted up or down only several times in the course of a year. In periods of extremely rapid price change, margin requirements may be adjusted on a weekly, or even daily, basis. Besides price level, another factor that determines original margin is price volatility. As noted above, margin requirements from 2% to 10% of the value of the contract are conventional. In times of high price volatility and greater-than-usual risk, an exchange may fix margin requirements at the upper end of this conventional range or, in some cases, even higher.

Futures exchanges and clearinghouses are guided by two opposing considerations when determining the appropriate levels for margin requirements. On the one hand, margins must be low enough to allow the broad participation that provides market liquidity. On the other hand, they must be high enough to ensure the financial integrity of the contracts.

A demand for additional funds that is made by the FCM when, for whatever reason, there is insufficient cash or equity in the account to *establish* a position, is called an *original margin call*.

Original margin must be met, that is, paid in full. Though customers may be able to sell the position at a profit, they still have to meet the original margin call with cash. The amount will vary by commodity, by exchange, and by brokerage firm.

TRY THIS

As a speculator, you have $50,000 in your account and decide to buy 20 contracts of silver. The original margin requirements are $3,000 per contract. While most brokerage firms demand that full margin be posted with the firm before a trade is initiated, allowances are sometimes made when your creditworthiness is known to the FCM. In this case, the FCM lets you buy 20 contracts of silver on your word that you will send the remaining $10,000 immediately. What would happen if, the next morning, the margin department of the FCM noted that a position was established with insufficient capital in your account?

HERE'S WHY

An original margin call for $10,000 would be issued.

Maintenance margin is an additional margin required by the broker from the client. When there has been a price decline or advance on the contract that effects a paper loss in the margin account, the client must deposit just enough money to bring the amount of margin back to the original margin—then the client can continue trading. The call for the maintenance margin is a *variation call* because a change in the market price required the additional margin, and not because the customer had insufficient funds in his account to begin with.

Most exchanges set maintenance margin requirements at about 75% of original margin requirements. Therefore, if a customer's equity drops to less than 75% of his original requirements, the

brokerage firm will ask the client for the amount of money that will restore his equity to the original level.

> EXAMPLE: A client has $4,000 in his trading account and is long two March Eurodollar contracts at a price of 91.50. Original margin requirements are $2,000 per contract (or $4,000 total) and maintenance margin is $1,500 per contract (or $3,000 total). March Eurodollars fall to 91.20, which results in a loss of $750 per contract (or $1,500 total). Thus, the value of the customer's account falls from $4,000 to $2,500. Because this is below the $3,000 maintenance requirement (for two contracts), the customer will receive a variation margin call for $1,500. Notice that the variation call is for the amount of money that will restore the account to the full original margin that is required ($4,000), not to the maintenance level ($3,000).

TRY THIS

A customer buys one silver contract and deposits the required $1,000 *initial* margin. If the *maintenance* level is $750 and a market drop reduces the equity to $650, what *minimum* amount must the customer deposit?

a. $100
b. $250
c. $350
d. $1,000

HERE'S WHY

The correct answer is (c). This reflects the usual commodity margin situation where the equity must be replenished to the original (initial) margin level once the variation level has been reached.

Margin Calls and Closeout

When a customer fails to put up funds to meet a variation or an original margin call, the broker has the right to liquidate or close out the account. The broker may do this after *due notification*, which usually takes the form of a telegram. The broker will have the authority to sell out or buy in because the customer will have signed a consent form to do so when the account was opened.

Rule Call

Though most brokerage firms call for additional variation margin when the client's equity is reduced by 25% or more, this practice is a house policy for each firm's own protection. Not all exchanges require as much. They do require, however, that member firms receive additional margin from their clients when their equity falls below a point specified by the exchange. A call to satisfy these margin requirements is a *rule call*. The amount of additional funds varies from firm to firm.

EXAMPLE: Mr. Peter Burr buys 5,000 bushels of corn on the Chicago Board of Trade through Broker Co. His broker, a member of the exchange, requires that he deposit the minimum exchange requirement of 20 cents per bushel, or $1,000 per contract, as original margin. Although Broker Co. generally calls for additional margin if the client's equity declines 5 cents per bushel, or $250 per contract, the CBOT does not require Broker to call for additional margin unless Burr's equity declines 10 cents per bushel, $500 per contract, or more. As long as Burr's equity remains above 10 cents per bushel, $500 per contract, a rule call is not required. However, if Burr's equity falls below that point, a call for additional funds must be made.

TRY THIS

Identify the type of requirement (either exchange or broker) that each of the following calls is:

original margin call
variation margin call
rule call

HERE'S WHY

original margin call	*exchange requirement*
variation margin call	*house/broker requirement*
rule call	*exchange requirement*

Up to this point we have looked at scenarios in which the client has had to put up additional margin because of a decline in market prices. But suppose the market moves in favor of the client? In this case, because the value of the contract increases (we are assuming the customer is long), the client enjoys additional value in his account. This is called an increase in his *equity* in the account. This additional value may be withdrawn or be used for other trading by the client—with the approval of his or her FCM.

Trade Account Requirements

A brokerage firm is usually allowed by the various exchanges to handle *trade accounts*, which are also known as *hedge accounts*. These accounts deal in certain commodity futures transactions at more favorable margin terms than speculative accounts. The margin rate is lower because the risk is less: A hedge, or a trade account, either sells futures as a hedge against inventory or buys futures as a hedge against forward sales.

To qualify for hedge status, trade clients must, on most exchanges, also be involved in the industry of the commodity itself. Their operations must represent hedging. For example, a wheat processor is entitled to trade requirements for wheat futures transactions—as long as such transactions are for hedging purposes. But that processor of wheat is not entitled to trade requirements in any other commodity. In other words, an individual or company in the wheat business is entitled to trade requirements in wheat if they are hedging—but not in soybeans or any other commodity.

Day-Trade Requirements

Commodity day trades are transactions in which a customer establishes and closes out one or more contracts of a future on the same day. A day trade occurs either when an investor buys a contract and offsets it by a subsequent sale on the same day or when the investor sells a contract and offsets it by a subsequent purchase on the same day.

Commodity exchanges do not require members to obtain margin to cover day trades for established accounts. However, most of the firms themselves require that at least 50% of the original mar-

gin required for an outright position be on deposit, in addition to the margin required for other open positions in the account, prior to accepting day-trade orders.

Spread Margin Requirements

Margin requirements for transactions involving *spreads*—that is, the simultaneous purchase of one delivery and the sale of another—are usually smaller than for net long or short positions. The reason for the reduced rate is that fluctuations in the spread difference are normally less volatile than fluctuations in the outright price of the commodity. As in other transactions, reductions in house spread requirements are usually arranged only on the approval by a credit manager or some other authorized person.

The exchanges establish the minimum spread requirement, but member firms may impose larger requirements on their customers if they feel it is necessary.

TRY THIS

Answer True or False for the following statements regarding day-trading margin.

_____ New customers must post full original margin.
_____ Exchange rules require no margin for day trades.
_____ Most firms require 50% of original margin.

HERE'S WHY

New customers must post full original margin. __T__
Exchange rules require no margin for day trades. __T__
Most firms require 50% of original margin. __T__

3
Orders

If the trader can be considered a kind of craftsperson and if investing money can be considered analogous to a skill, then the various types of orders available must be considered tools of the trade. They are the tools by which the craftsperson builds his or her tactics and strategies.

And if the tool fits the job, the job is done all the better. A knowledge of orders—even though you may rely on only a few for the majority of your transactions—makes for greater capability and, ultimately, greater financial success.

We'll begin with the simplest and quickest type of order and work on to some of the more complicated, sophisticated, and obscure.

An order is a request by the customer to the broker to either buy or sell a futures contract or to execute a straddle. Instructions by a customer may also include canceling a previous order. The order form used by the broker typically includes the following information:

1. The name of the exchange where the order is to be executed.
2. The type of order, whether a buy (BUY) or sell (SL). In the case of cancellations, a customer may wish to change something about an earlier order already entered, such as the quantity or

price. The broker must then enter *cancel a former order* (CFO) in order to cancel the previous order. An outright or *straight* cancel means the customer wants to completely eliminate the previous order.

3. The number of contracts. In most cases, futures contracts are in terms of number of contracts. Orders for grain are placed in bushels. For example, an order to buy one contract (5,000 bushels) of May wheat would read, "Buy 5M May wheat." An order to buy one contract of July soybean oil (60,000 pounds) would read, "Buy 1 July soybean oil."

4. Name of contract, including delivery month.

5. The price. This can be a fixed price at which the customer desires to buy or sell the contract. The price can also be an *at-the-market* (MKT) order, which means that the trade is to be executed at whatever the going price is when the order arrives at the trading ring.

6. Qualifications. These are limitations and conditions, set by the investor, on the execution price.

7. Duration of the order. The broker will consider an order to be in effect for the day unless there are specifications to the contrary. Types of duration that may be indicated are briefly described here. Some are described in more detail later in the chapter.

 a. day orders—when a time limit is not indicated on the order, the broker is to assume that the order expires at the close of the market that day.

 b. open orders—these remain in effect until executed or canceled by the customer. This order is also referred to as *good-till-canceled* (GTC).

 c. good this week (GTW)—the order is good only until the close of the last day of trading for that week.

 d. good this month (GTM)—the order remains in effect only until the close of the last business day of the calendar month during which it was entered.

 e. good through date (GT)—the order is good until the close of business on the indicated date.

Sometimes other information may not always be necessary and is not included. But this second set of information is necessary if the order is a CFO (cancel a former order), a spread or switch, or a

contingent order (grouped orders that are entered as one, with each execution depending on the execution of the other).

A third set of information relates to the account. Account information includes the firm's office, the customer's account number, and the registered representative's number. This information is necessary to identify an account.

Placing an Order

The order-processing sequence (shown in Figure 3-1) is initiated when a customer gives the registered commodity representative (RCR) an order. The RCR writes the customer's instructions on the firm's order ticket and submits it to the wire room or order desk where, in compliance with the CFTC regulation, it must be time-stamped before transmission. From there it is teletyped or telephoned to the firm's representative on the trading floor. (Occasionally, a slight delay may occur in entering an order that refers to a previously entered order.) After recording and time stamping the order, the representative relays it, in writing, to the floor broker handling the commodity. Immediately upon execution, the floor broker records (or endorses) the price on the ticket; the quantity (if the order is a partial execution) is also recorded. The ticket is then returned to the floor representative.

The executed order (or trade) now travels in the reverse sequence, as illustrated in Figure 3-1. The entire process, from beginning to end, usually takes a couple of minutes under normal conditions. Should the markets be very active and/or the traffic on the firm's wire system very heavy, a customer may experience a delay in receiving a report.

As mentioned in Chapter 2, the exchange floor is where contracts are transacted by open outcry. Futures contracts are traded in *pits* or rings. Most often, one commodity is traded in each pit or ring. On the exchange floor, business is carried out by two types of traders:

1. A *floor broker* is someone who executes trades for customers and is paid a brokerage fee for each execution.
2. A *local* is a floor trader who trades for his or her own account. To do so, the local must own or rent a membership. (In previous years, some floor traders who traded for a profit on small fluctuations and price changes, were referred to as *scalpers*.

FIGURE 3-1 Sequence of Events in Processing an Order

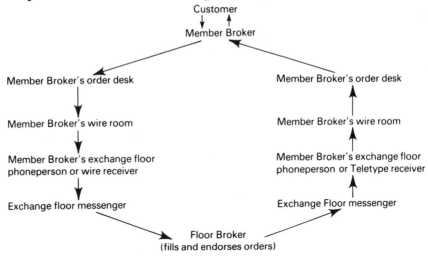

Nowadays, however, this term is used only in a derogatory sense.)

Market Order

A *market order* is an order to be executed at the best possible price at the time the order reaches the trading floor. The price changes, of course, as buyers compete with other buyers and as sellers vie with other sellers. The continuously changing bids and offers persist until a buyer and a seller agree on a price. (Obviously, the *bid* is what a buyer is willing to pay, and the *offer* is what the seller expects to receive for a commodity futures contract.) The best possible "at-the-market" price is therefore an agreed-on price. That results from bids and offers arriving at the same price level.

Market Order to Buy

Figure 3-2 shows a typical market order to buy form.

> EXAMPLE: Floyd, a floor broker, receives an order to buy 100M (bushels) of May wheat at the market. The May wheat delivery is currently being quoted at $2.60 a bushel bid and $2.60½ offered.
> Floyd feels he can get a better price, however, so he shouts out,

FIGURE 3-2 Market Order to Buy

EXCH.	BUY·SL CFO·CXL	QTY.	SYMBOL DESCRIPTION	PRICE	QUAL	DURATION
CBOT	BUY	100m	May Wheat	Mkt		

ABC & CO. ORDER	BUY·SL	QTY	ADD'L ORDER FACTS	PRICE	QUAL	DURATION

OFFICE	ACCOUNT NO.	RR	
AB	12345 - 1	9	

"One quarter for May!" No one responds on the first bid, so he repeats himself. Someone from another side of the pit responds by yelling out, "Sold!" and pointing to Floyd. For some reason, that broker's client is willing to sell at $2.60¼.

TRY THIS

What would happen if there was no response to Floyd's offer?

HERE'S WHY

If no one responded despite Floyd's efforts to do better than the offered price, he would then have had to shout out, "Take it!" in response to someone's offer of $2.60½.

Market Order to Sell

Figure 3-3 illustrates a typical order form for a market order to sell.

EXAMPLE: A cocoa floor broker, Gladys, is given a market order (shown in Figure 3-3) to execute. In the ring, she finds that the July cocoa is going for $18.00 bid and $18.10 offered. She decides to try to do better and shouts out, "July at 05!" meaning $18.05. Someone on the other side of the ring immediately yells, "Take it!"

FIGURE 3-3 Market Order to Sell

EXCH.	BUY·SL CFO·CXL	QTY.	SYMBOL DESCRIPTION	PRICE	QUAL	DURATION
Cocoa	*SL*	*20*	*July Cocoa*	*Mkt*		

ABC & CO. ORDER	BUY·SL	QTY	ADD'L ORDER FACTS	PRICE	QUAL	DURATION

OFFICE	ACCOUNT NO.	RR
AO	*1V345 -1*	*9*

TRY THIS

What would Gladys do if she had no takers?

HERE'S WHY

If she had no takers, then she would have had to say "Sold!" at $18.00.

Limit Order

A customer who wishes either to buy or to sell only at a specified price (or one that is more favorable) must place a limit on the price. A *limit order* is an order that tells the broker to execute a transaction only at a specified price or at one that is more favorable to the client. A limit order to buy is to be executed at or below the specified limit. A limit order to sell is to be executed at or above the price limit.

The main advantage of a limit order is that the customer determines the least favorable price he or she is willing to pay or to accept. The customer does not have to continuously stay in touch with the broker to get the results if the market moves to the specified limit. In effect, the client is instructing his FCM as follows: "I expect the market to give me the opportunity to buy (or

sell) at the level specified in my order. So if the market price hits that level, tell the floor broker to fill this order at that price or at any price that is better. But do not fill the order at any price less favorable than the limit."

Limit Order to Buy

EXAMPLE: The last trade of March oats is at $1.28. Mr. Hoos feels that March oats are an attractive purchase at $1.27 (see Figure 3-4). Floyd, the floor broker, receives the order slip, and he finds that the price is still at $1.28. The limit order to buy mandates him to buy only at $1.27 or lower. His obligation to the customer mandates him to concentrate on getting a price better than the $1.27, if possible.

If the price dips to $1.27 or below, Floyd will buy the 20M bushels called for on his order. If the price stays at $1.28—or goes up—he has to do something to try to execute the order. He might therefore bid at $1.27 or lower.

And if the day's trading closes at a price equal to or higher than $1.27¼, the order will never be executed because Mr. Hoos did not put a duration on the order. Floyd would have to report an "unable" to the client at the close of trading. It is therefore considered a day order.

Limit Order to Sell

EXAMPLE: Gladys receives the limit order to sell shown in Figure 3-5. In the pit, she finds the price at $1.28. At that point, she does nothing because the market price is lower than the limit at which the client wishes to sell.

FIGURE 3-4 Limit Order to Buy

EXCH.	BUY-SL CFO-CXL	QTY.	SYMBOL DESCRIPTION	PRICE	QUAL	DURATION
CBOT	Buy	20M	March Oats	1.27		

ABC & CO. ORDER	BUY-SL	QTY	ADD'L ORDER FACTS	PRICE	QUAL	DURATION

OFFICE	ACCOUNT NO.	RR	
AB	1V345 -1	9	

FIGURE 3-5 Limit Order to Sell

EXCH.	BUY - SL CFO - CXL	QTY.	SYMBOL DESCRIPTION	PRICE	QUAL	DURATION
CBOT	*SL*	*20M*	*March Oats*	*1.30*		

ABC & CO. ORDER	BUY - SL	QTY	ADD'L ORDER FACTS	PRICE	QUAL	DURATION

OFFICE	ACCOUNT NO.	RR				
AB	*1 2 3 4 5 - 1*	*9*				

In the meantime, however, she also has several other orders to buy which can be filled immediately. She yells out, "Take it!" to two brokers who are offering, and she becomes involved for a few seconds in the other transaction.

In those few seconds, the bid price rises to $1.35. No sooner does she look up than another broker has yelled, "Sold!" She "missed the market," as the saying goes, because she did not fill her order.

But luckily for her client, the price continues to rise to $1.36—and this time Gladys hits the bid.

Market-if-Touched (MIT) Order

A *market-if-touched* (MIT) order is an order to execute a transaction at the best available price when the market reaches a price specified by the customer. An MIT order to buy becomes a market order to buy when the futures trade at or below the order price. An MIT order to sell becomes a market order to sell when the futures trade at or above the order price.

The MIT order is therefore like a limit order in some ways but like a market order in others. Like a limit order, the MIT order is not executed until the specified price is reached or "touched." Also like a limit order, the MIT must not be filled if the market never touches the order price. But unlike a limit order, the MIT becomes a market order once the price is touched, and it must be executed at the best possible price. Even if it is impossible to execute the order at the specified price, the MIT must be filled. So the best possible price could be better or worse than the limit.

MIT Order to Buy

An MIT order to buy is used by someone who wants to establish a long position or to cover a short position when the market declines to a specific level; usually, that "specific" level is lower than the current market level. The order does not have to be executed at the MIT price, but it has to be executed when the market trades or is offered at or below the MIT price.

EXAMPLE: Mrs. Polk wants to buy 10 contracts of July pork bellies at the market when the market declines to 47.75 cents. The market is currently 48.00 cents. She places an order to buy 10 July pork bellies at 47.75 cents MIT, as shown in Figure 3-6. Subsequently, the price of July pork bellies declines and then quickly drops to 47.75 cents. Mrs. Polk's order then becomes a market order and her broker tries to get the best possible price at the time. Since her MIT order became a market order when the MIT price was touched, her order was executed at 47.75 cents.

TRY THIS

What would have happened if the market had remained at 48.00 cents?

HERE'S WHY

Since the level of 47.75 that Mrs. Polk specified was not reached, the order would not have been executed.

MIT Order to Sell

An MIT order to sell is used to establish a short position or to liquidate a long position when the market advances to a certain level. Again, the "certain level" is usually higher than the prevailing market price. The MIT, of course, assures the investor of getting the order filled if the market trades to his limit. This person does not want to take the chance of not being able to sell, as could happen with a limit order when the broker is unable to execute the order at or above the limit price.

FIGURE 3-6 MIT Order to Buy

EXCH.	BUY-SL CFO-CXL	QTY.	SYMBOL DESCRIPTION	PRICE	QUAL	DURATION
CMF	Buy	10	July Pork Bellies	47.75	MIT	

ABC & CO. ORDER	BUY-SL	QTY	ADD'L ORDER FACTS	PRICE	QUAL	DURATION

OFFICE	ACCOUNT NO.	RR	
AB	1V 345-1	9	

EXAMPLE: Mrs. Polk buys 10 contracts of December hogs at 37.50 cents and wants to take profits when the market reaches 38.00 cents. She places an order to sell 10 December hogs at 38.00 cents MIT (as shown in Figure 3-7). The same day, December hogs are traded or bid at 38.00 cents, and her order becomes a market order. The floor broker in the pit gets the best price obtainable at the time. Since Polk's MIT order becomes a market order, it may be filled at 38.00 cents, at a price above 38.00 cents, or at a price below 38.00 cents depending on market circumstances at the time the MIT price is elected.

By the same token, if she wanted to initiate a short position, should December hogs advance to 38.00 cents, she would put in an order to sell 10 December hogs at 38.00 cents MIT.

Stop-Loss Order

A *stop order*, sometimes called a *stop-loss order*, or simply *stop*, is an order to buy or sell at the market when the market reaches a specified price. A stop order to buy, entered above the prevailing market, becomes a market order when the contract is either traded or bid at or above the stop price. A stop order to sell, entered below the prevailing market, becomes a market order when the contract is either traded or offered at or below the stop price.

Stop orders differ from MITs principally in their relationships to prevailing price levels. Stop orders to buy are entered above the prevailing market price; stops to sell are entered below. MITs are entered in an opposite manner. This reversal is illustrated in Figure 3-8.

FIGURE 3-7 MIT Order to Sell

EXCH.	BUY-SL CFO-CXL	QTY.	SYMBOL DESCRIPTION	PRICE	QUAL	DURATION
CME	*SL*	*10*	*Dec Hogs*	*38.00*	*MIT*	

ABC & CO. ORDER	BUY-SL	QTY	ADD'L ORDER FACTS	PRICE	QUAL	DURATION

OFFICE	ACCOUNT NO.	RR	
AO	*1 v 3 4 5 − 1*	*9*	

Time Orders

Orders may be good for a specified period of time, or they may be *open*, that is, effective until explicitly canceled by the customer. An order may be entered to be good for a day, a week, a month, or until canceled.

Day Order

A day order is an order that expires automatically at the end of the trading session on the day the order is entered, unless it is canceled or executed before the session closes. All orders are considered to be day orders unless otherwise specified by the customer. They are good only for the day on which they are entered or for that part of the trading session that remains after the order has been entered.

FIGURE 3-8 The Difference Between a Stop Order and an MIT

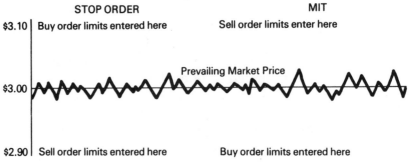

STOP ORDER	MIT
$3.10 Buy order limits entered here	Sell order limits enter here

Prevailing Market Price

$3.00

| $2.90 Sell order limits entered here | Buy order limits entered here |

Time-of-the-Day Order

A time-of-the-day order is one that must be executed at a specific time or at specific intervals during the trading session.

Off-at-a-Specific-Time Order

This is a day order with a time contingency. It remains in effect only until the time indicated, when it will be canceled if not executed.

Open Order

An open order, also known as a GTC order, is "good-till-canceled." However, an open order automatically expires at the end of the trading session on the last trading day when that delivery expires. Open orders remain in effect until the customer explicitly cancels them or until the contract expires. A speculator uses this type of order when he or she feels the market action will eventually bring the desired price, at which time the order will go into effect automatically.

Other Orders

Other types of orders that you may come across in your futures dealings, although you may not directly use, include the following:

- *Fill-or-Kill*—must be executed immediately upon receipt by the broker or be automatically canceled.
- *Combination*—two orders entered at the same time, with one contingent on the other.
- *On-the-Opening*—order executed during the opening period of the trading session.
- *On-the-Close*—order executed during the closing period.
- *Spread*—order to buy one contract and sell another of either the same or different futures, in the same or different markets. Both buy and sell must be executed at the differential between them specified in the order.

- *Scale*—order to buy or sell one or more lots of the same future at designated price intervals.
- *Contingent*—grouped orders, entered as one but with the execution of each dependent on the other.
- *Stop-Limit*—contains both a stop price and a limit price.
- *Switch*—simultaneous sale of a commodity with one delivery month and the purchase of another in a different month.

TRY THESE

1. An order to buy 3 December gold at $395 is what kind of order?
2. The market price of hogs is currently 34.15. What kind of order would buy at the market if the price rises to 34.50?
3. A stop-limit order becomes a market order when the stop price is touched or exceeded. True or False?

HERE'S WHY

1. A limit order. The customer is specifying the payment up to and including (but not exceeding) $395 per ounce. The order might be filled at $395 or any lower price.
2. A stop order to buy. If (and when) the market rises to the 34.50 price, the order will be activated or triggered, and purchases will be made at whatever price prevails at that time.
3. False. This one was an exercise in careful question reading. A stop-limit order becomes a limit order (not a market order) when the stop price is breached.

TRY THIS

Match the items in column *A* with the correct descriptions in column *B*.

A		*B*
A. ____	MIT order	1. Buy or sell on the close within the closing range of prices
B. ____	Day order	2. Open order

C. ____ GTC order 3. Board order
D. ____ Market order 4. Best bid/offer on the market
E. ____ On-the-Close order 5. Expires automatically at the
 end of the trading day

HERE'S WHY

Now check your answers against these: A-3; B-5; C-2; D-4; E-1.

Initiating a Position

Knowing the types of orders and types of markets in the futures industry is all good and fine—but knowing how to apply that knowledge is usually best left to the professional. Trading techniques are discussed in some detail in Chapter 8, but they are also touched upon lightly here to give you a feel for the best application of the orders you have just read about.

First, make a careful analysis of the fundamentals to see which situation has the best profit potential. Analyze a market to determine whether a market situation is bullish or bearish and whether it warrants buying or selling. After determining the direction of the market trend, you must then project its extent—whether it is of major or minor importance. Chapter 5 can help you with these analyses.

Also weigh risk versus profit potential. Enter only those situations in which the profit potential is compatible with the risk you are assuming. For instance, a situation may have a large profit potential, but it may also entail an equally large risk. Furthermore, the profit potential must be sufficiently large in relation to the transaction cost.

Second, you must determine that the timing is right for entry into the market. It is best to take advantage of a high profit potential, with a minimum of risk. In the very fast-moving commodity futures markets, timing is of extreme importance. You might have the right ideas, but if your timing is wrong you may face heavy losses before the situation begins to work. Getting into a good situation at the wrong time can be just as bad as getting into a poor situation from the start.

Establish a long position only when the trend of the market is clearly up or a short position only if the trend of the market is clearly down. If no clear-cut trend is evident or if any doubt is in your mind as to what the trend may be, don't establish a position. When in doubt, stay out. Be patient and wait for conditions—both fundamental and technical—to be right before initiating a position. The market will still be there tomorrow, with several dozen commodities in which you may trade.

Enter the market only when the fundamental and technical factors we've outlined in Chapter 5 agree. When the fundamental and technical factors are not in harmony—that is, when both do not indicate higher prices or lower prices—stay out.

Don't try to anticipate a trend. Wait until a trend has started before initiating a position, then trade with it. Don't attempt to forecast what will happen. Be guided by what has already begun to happen. Remember, the trend is your friend.

Limiting Your Losses

Being patient and not going for the biggest profit are only a part of a winning scheme. The biggest failing of the unsuccessful trader is that he or she stays too long with a losing trade and gets out of a winning situation too early. Inexperienced speculators have a tendency to hesitate closing out losing trades. Consequently, what could have been a relatively small loss often turns into a major loss. They are reluctant to admit to themselves that their judgment was wrong and to get out of a position that is not working. They tend to procrastinate and stubbornly hold on, hoping that the market will eventually recover. Hopefully, this won't be you.

While some traders hesitate and take a loss, others are often too quick to take their profits, fearing that their profits will slip away from them. Although there is nothing basically wrong with taking profits, making a practice of taking small profits—again—requires that your judgment be correct most of the time (which is hardly likely) or that your losses be correspondingly smaller than profits to show an overall profit.

There is no sure-fire method of beating the market—one that guarantees a profit on every trade. However, you do not have to be right on the market every time to make money trading commodities. But you do have to make more money on those trades when

your judgment is correct than you lose on those occasions when the market does not perform as you expect. In other words, you can even be wrong more often than you are right and still make an overall profit—as long as you limit losses on your unsuccessful trades and let your profits run on your successful trades. Your dollar return on the fewer sucessful trades will exceed your dollar loss, even though the unsuccessful trades were more numerous. By limiting your losses and letting your profits run, you tend to gain a lot more when you are right than you lose when you are wrong.

Protecting a Position

Once you have initiated your position and have determined that the fundamental and technical factors for a particular commodity are in sync and you place an order with your broker, you should at the same time determine how far you are willing to let the market go against you before you abandon the position.

TRY THIS

If the market does not perform as you had anticipated, what can you use to minimize your loss in the event of poor judgment?

HERE'S WHY

In this instance, a stop order would do the trick. A stop-loss order is a built-in safeguard for the speculator. When properly used, it acts as a safety valve and may save you from unwarranted "excesses of optimism."

A chart of the price action of a particular commodity is useful in helping you determine where to place a stop order. You should be cautious not to place a stop too close to the market where a minor reaction will eliminate your position; but neither should you place it too far away from the market where you would suffer a greater-than-necessary loss before it is activated. The amplitude of the daily price fluctuations should be considered in your decision as to where a stop order should be placed.

EXAMPLE: You decide to buy soybeans at $5.90. Before entering into a transaction, you decide how much you are willing to let the market go against you before you liquidate your position. You choose to limit your loss to approximately 3 cents. You then place a stop order to sell 3 cents below the market, or at $5.87. If the market reaches that price, your broker will have a market order to sell at the best price obtainable. The market goes against you, and your sell stop is elected. Your long position is liquidated (sold) at the market price at that time.

Though you have incurred a loss, you have limited it to an approximate predetermined amount. If the market moves in your favor, you can always cancel your original stop and raise the stop price to protect your profit.

Enhancing Your Profit

Making the most of the profits you earn when trading in the futures market can perhaps be one of the wisest and most rewarding aspects of trading. Since these profits are far from being dependable, as are the dividends on a stock or interest from a CD, they can only be made when profitable situations develop. This is a fact that traders too often lose sight of in their desire to obtain a profit.

When you *have to* make a certain amount of money by trading, you cannot possibly analyze situations as objectively as if the necessity for profits were not a consideration. Your desire and need for profits will almost certainly cause you to make serious trading errors. Hope and desire have no place in commodity trading. To be successful, a trader must analyze situations in an objective manner as they develop. You must have patience, and you must put yourself in a position to take advantage of profitable situations when they occur. But you should never attempt to force profits out of a situation that doesn't offer them.

The tendency to overtrade very often contributes to trading losses. Continued success in commodity trading requires *conservative* trading, with money you can afford to risk. To trade conservatively, you should have trading capital equal to at least double the minimum margin required by your broker. You do not have to deposit more margin than required, but the additional funds that are earmarked for trading purposes should at least be available if needed. This will make your profits all that more rewarding be-

cause the stress and anxiety accompanying the fear of losing your capital will not be there.

Do not risk everything on any one situation. To do so is to invest recklessly. To make money in commodities with any consistency, you have to program your trading in such a way as to spread your risks over various situations. "Spreading risk" does not mean that you must trade in a number of different commodities at the same time. In fact, for the average speculator, trading in too many commodities at one time is probably a mistake. Pick one or two actively traded commodities, particularly if you have relatively limited trading funds, and confine your trading to them. Get your diversification of risk by participating in various situations over an extended period.

To trade successfully in commodities, you have to follow some very basic guidelines:

- Never depend on your profits; accept them when they are available.
- Trade conservatively, with money you can afford to risk.
- Don't risk all your trading capital on one situation.

Doing these things will not only limit your risk, it will also make your successes much more enjoyable.

4

Deliveries
and the Role
of the
Clearinghouse

Throughout the course of a trading day on an exchange, many transactions are finalized. These transactions must be "matched up" according to the delivery months and prices, which can be a very difficult job. To make this task easier, all trades are cleared through an organization called a clearinghouse or clearing association.

A clearinghouse, although a separate entity, works very closely with an exchange. Its primary job is to net out all the crisscrossing transactions of each day, offsetting contracts of one clearing member with those of others. The function is similar to that of the clearinghouse that banking firms utilize—namely, to match and settle transactions with a minimum of handling of cash transfers and actual deliveries.

The clearing operation is vital to the commodities industry. Without it, trading would quickly collapse into a jumble of errors and confusion. And if it could survive—if only briefly—the transactions would undoubtedly bog down in one legal sandtrap after another. Its behind-the-scenes activity guarantees performance on the customer's contracts in such a way that he or she never knows it's being done.

Functions of the Clearinghouse

All the transactions of one day's trading session have to be "cleared" before the start of the next—a difficult and indispensable function. But the clearinghouse does even more.

It guarantees the performance for each transaction that it clears. In other words, it guarantees proper and timely delivery to every buyer (if the buyer wishes to take delivery) and payment upon delivery to every seller (if the seller wishes to make delivery). Further, it guarantees payment, whenever a net position warrants payment, on any contracts that are to be closed out by offsetting transactions.

In a word, the clearinghouse frees up the FCMs to conduct business on behalf of their customers with the confidence that any transactions that are conducted in accordance with exchange regulations will be honored one way or the other. The clearinghouse is a source of confidence and integrity for the exchange.

In commodity trading, the clearinghouse therefore serves three functions:

1. It provides a quick and simple way for traders to settle contracts.
2. It greatly simplifies deliveries against futures contracts by matching deliveries by shorts to open.
3. It provides uniform and continuing protection against default on contracts by guaranteeing performance of all trades of its members.

Membership in the Clearing Association

In order for the clearinghouse to do its job and fulfill its obligations, each member of the exchange must perform according to the rules of the exchange. Anyone who buys a "seat" on the exchange is a member of the exchange; but members of an exchange are not required to be members of a clearing association. Any exchange member who transacts business on the exchange for his or her own account or on behalf of a customer must have those transactions cleared through a member of the clearinghouse.

Members of the clearinghouse are subject to strict financial and other types of qualifications. One qualification requires the clearinghouse member to have an office within a short distance of the clearinghouse. This requirement expedites the handling of delivery notices and the daily pickup of transaction sheets.

TRY THIS

All exchange members must also be clearinghouse members. True or False?

HERE'S WHY

False. Many exchange members, including most of the independent floor brokers ("locals") clear their trades through larger organizations with such facilities. The expense of developing the support necessary for clearing membership is very large and beyond the means (and needs) of individuals and a number of smaller firms.

The Principle of Substitution

Once all the contracts are accepted by the clearinghouse, the original parties involved in the transaction no longer deal with one another. From the time the trade is turned over to the clearinghouse, the member firm deals only with the clearinghouse. In turn, the clearinghouse assumes the role of the other party in the transaction: It becomes the "buyer" of all contracts that were sold and the "seller" of all contracts that were bought. In assuming this role, the clearinghouse can accomplish two things.

First, since the contract is between the clearing member firm and the clearinghouse, the firm (or its client) can offset the contract at any time without getting permission (to "break" the contract) from the originating party. "The other party" is, of course, the clearinghouse through which all trades are cleared and guaranteed anyway. The clearinghouse makes the futures markets a great deal more flexible and convenient by assuming this role. Trading can be conducted more freely and with far less legal difficulty.

Second, since traders are buying and selling identical contracts, the contracts are easily matchable and therefore can be substituted. Once the customer buys back the contract that was originally sold or sells one that was originally bought, he or she no longer has a contractual obligation.

EXAMPLE: ABC Company, a member broker, buys a contract from XYZ Company. At the end of the trading session, the clearinghouse substitutes itself as the other party to the contract: It becomes the seller of the contract that ABC bought and the buyer of the contract that XYZ sold.

The next day, ABC decides to sell the contract to EFG Company. The clearinghouse again substitutes itself as "the other party" to each side of the transaction: It becomes the buyer of the contract that ABC sold and the seller of the contract that EFG bought. ABC, in effect, bought from the clearinghouse and then sold to the clearinghouse. ABC's obligation to the clearinghouse is finished. The difference between the buying price and the selling price, less commission, is ABC's profit or loss. ABC merely transfers its contractual obligations to EFG. XYZ is still short with the clearinghouse, and EFG is now long with the clearinghouse.

TRY THIS

What if EFG were covering a previously established short position when it bought the contract that ABC was selling?

HERE'S WHY

The number of contracts outstanding would have been reduced by one. XYZ would, however, still be short and someone else would be long.

Guaranteeing Transactions

The clearinghouse guards against the slightest possibility of financial loss to any member or the clearinghouse itself. When the clearinghouse stands in the shoes of every buyer and seller, bound

thus to fulfill all contracts, it also guarantees performance of all of them. To be able to do so, it must obtain some form of guarantee from its member firms. It therefore requires that each member deposit money for each contract that is cleared *but not offset*. The performance money deposited by the member firms is called *original margin*.

Original Margin

The original margin is deposited in an escrow account at a bank for the joint benefit of the member and the clearinghouse. The member keeps the original proof of deposit, while the clearinghouse holds a duplicate.

Only three types of security may be used as original margin. They are:

1. *Obligations of the U.S. government.* Since a clearing member does not receive interest on cash deposited as margin, some members deposit U.S. Treasury bills or short-term U.S. bonds and notes, which earn interest anyway from the government. They are accepted but subject to a "haircut," that is, a discount from face value.

2. *Stock in the clearinghouse.* Sometimes, when the clearinghouse is a stock company, members must buy the stock when they join; the quantity depends on the volume of trades cleared and number of positions carried. The stock is valued at the latest book value of the shares.

3. *Cash.* As the members' margin needs allow, the cash must be deposited or may be withdrawn.

Variation Margin

Just as do individuals who deal with a brokerage house, members of clearing firms must put up original margin or a cash deposit, as we just mentioned. When a change in net position or a price change renders the original margin insufficient to meet the required margin, the clearing firm member is subject to *variation margin*. However, whereas the firms must meet the variation call with cash, customers may meet such a call by liquidating existing positions.

Calculating Variation Margin

Variation margin is based on the difference between the price at which the contract was traded and the settlement price at the close of each day's trading. Should the closing (or settlement) price be below the price at the time of the purchase, the net figure will be a *pay*, which is an amount the member must pay the clearinghouse. Should the opposite occur, when the market moves in favor of the firm, the figure will be a *collect* and the clearinghouse will pay the member.

> EXAMPLE: The price of March wheat declines 1 cent during the course of trading in one day. All members with a net long position in March wheat now owe the clearinghouse 1 cent per bushel, or $50 per contract. The market for March wheat has moved unfavorably, bringing about a difference of 1 cent between the opening and closing prices, which is equal to the variation margin call.
>
> Early that morning, ABC Company buys 20,000 bushels (four contracts) of March wheat at $2.50 per bushel and watches the price decline gradually all day long. Since at the start of the day, it had no open position with the clearinghouse, its position at the end of the day is net long 20M March wheat. Since ABC bought at $2.50 and the price declined to $2.49 (a decrease that works out to $50 per contract), ABC owes the clearing corporation $200 in variation margin (four contracts at $50 per contract). It is a "pay" situation for the ABC Company.

TRY THIS

What if another firm, EFG Company, sold 20,000 bushels of March wheat on the opening call at $2.50 per bushel, and on the closing call, it bought back the four contracts at $2.49 per bushel?

HERE'S WHY

EFG would make a $200 profit. The transactions proved profitable, of course, but since one transaction offset the other, EFG would simply pocket $200—the clearing corporation does not require any additional margin.

Since the settlement and all variation calls are made daily, margin is kept up to its original levels ("to the market") on a day-to-day basis, thereby shielding both members and the clearinghouse from losses.

As an even greater protection in time of volatile trading, when prices are fluctuating dramatically, the clearinghouse can make variation calls during the trading hours to bring a member's position approximately to the market. In such situations, the amount of variation margin is based on the commitment outstanding at the close of the preceding day and the intraday price change.

Obviously, the clearing corporation makes no investment profits on its activities. Its position is always equal and opposite to each of its members. And since the total long position for the whole exchange is always equal to the total short position on the exchange, the clearinghouse's position has to be always "net even" on the market. Its prime concern is balancing out the transactions and guaranteeing performance. Further, since the total of all variation margin debits is always equal to the total of variation margin credits, these funds are merely passed through the clearinghouse and all open positions are adjusted to the market.

TRY THIS

Each of the following type of security may be deposited with the clearinghouse as original margin EXCEPT:

a. stock in the clearing house

b. NYSE-listed AAA bonds

c. U.S. Treasury bills

d. cash

HERE'S WHY

The correct answer is (b). Other than cash and stock in the clearinghouse itself, only U.S. government securities are acceptable deposits on original margin.

Making and Taking Delivery

Another function of the clearinghouse is to distribute notices of delivery. As a seller to all buyers and as a buyer to all sellers through substitution, the clearinghouse allows deliveries to be made directly from a short wishing to make delivery, to the oldest eligible outstanding long. (Some clearinghouses deliver to the "longest" longs, not the oldest.) Interim buyers and sellers are not involved in the ultimate settlement, since, through offset before maturity, they fulfill their contractual obligations.

> EXAMPLE: In February, Mr. Pone sells 25,000 bushels (five contracts) of corn for delivery the following September. During the months that follow, he does not offset his contracts by a subsequent purchase, and he is therefore still short when the delivery month (September) arrives. The seller is obligated either to make delivery of the quantity he contracted to sell or to buy back the contracts he sold. Mr. Pone chooses to make delivery. He has the choice of making delivery during any business day during the month of September until the designated cut-off date. On September 10 he decides to make delivery and issues five notices, one for each contract sold, since a separate notice is required for each contract.

Delivery of Commodities

Approximately 2% of all commodity contracts are settled by physical delivery of the underlying cash commodity. However, delivery procedures and, in particular, the timing involved, need to be discussed so that the role of the clearinghouse in the delivery process can be better understood.

Early in the century, legislators enacted a bill that provided for federal supervision of grain grading and inspection. This establishment of standard grades is said to have been the most important development to promote futures trading. Because of this, a customer does not have to actually view the physical commodity before accepting delivery. The purchaser can be confident of a product that will be delivered several months down the road because of the consistencies specified by the standard grades. This advantage has stimulated trading of forward deliveries.

Timing

Commodities are traded up to 12 to 18 months (depending on the commodity) ahead of delivery; some are traded only in selected months (that is, March, May, July, September, and December) rather than spread out over the whole year. This system evolved from harvest and market times. The selection of a few months for trading is still practical today because it is felt that this method adds to market liquidity. Financial futures, on the other hand, almost always trade in a regular pattern of months, 90 days apart. These contracts are available for delivery in March, June, September, or December.

Seller's Option

In order to keep a steady supply at stable prices, sellers have been given flexibility in their delivery of the commodity. At delivery time, the seller may specify the place of delivery, the grade or quality (out of a range of grades), and the specific day of delivery. Deliveries may be made only from facilities on locations authorized by the specific exchange on which the trade is made.

TRY THIS

Which of the following are selected by the seller of a futures contract?

I. The exact place of delivery

II. The day of delivery

III. The particular grade of commodity being delivered

 a. I only

 b. II only

 c. I and III only

 d. I, II, and III

HERE'S WHY

The correct answer is (d). This is referred to as the "seller's option" nature of futures which you just read about. Unlike options, to which they have many similarities, futures leave no choices in the hands of the long (buyer).

Delivery Periods

Contracts trade up to and including the last day of trading, which is the last day that a futures contract may be liquidated by an offsetting transaction.

Notices of intention to deliver are submitted to clearinghouses. The initiation of the delivery period is known as first notice day. This notice may come one to seven days before the first delivery day. However, the last trading day and delivery periods all vary by commodity and exchange.

Delivery Grades

As mentioned earlier, the seller has the option to deliver any grade within a range of grades, as permitted by the exchange rules. The differences in grades are deliverable with premiums or discounts to the contract price. These premiums or discounts are established on the basis of the differences that exist normally in the cash market between the various grades.

In the futures market for some commodities, such as financial instruments or gold, there is only one grade deliverable, so the problem of premium and discounts versus grade does not exist.

Delivery Points

Exchanges designate from which point commodities may be shipped—authorized warehouse facilities, grain elevators, and other places of storage. The seller holds a negotiable receipt issued by the authorized facility. The delivery is made by the transfer of the endorsed receipt from the seller to the buyer. At this time, the buyer hands over a certified check, and the delivery is completed.

TRY THIS

When a short delivers grain to an exchange-authorized storage point, what does he or she receive?

HERE'S WHY

If you were reading closely, you would have come up with the correct answer, which is a warehouse receipt. The seller receives cash upon tendering an endorsed warehouse receipt to the buyer, who pays by certified check.

Delivery Notice

When the seller decides to make delivery, the clearing broker issues a *delivery notice* form to the clearinghouse. The delivery notice has all the essential facts regarding the delivery:

- the grade of the commodity,
- its price,
- the place of delivery, and
- the day on which delivery will be made.

One thing it does not provide, however, is the name of any specific individual to whom delivery is to be made.

The delivery date is most often the business day following the issuance of the notice. For instance, if the notice was issued on a Monday, the delivery would be made on Tuesday, unless a holiday intervenes. If it were issued on a Friday, the commodity would be delivered on the following Monday. The price (the price the deliverer is to receive from the long who accepts the notice) is the settlement price of the previous session, when the notice was prepared. In other words, if the notice is issued on Monday, the notice price is the settlement price of the preceding Friday.

Types of Delivery

Some notices are transferable and some are nontransferable. On the New York Cocoa Exchange and the Cotton Exchange, for example, they are transferable. On the CBOT, they are not.

If a holder of a long position, a so-called long, receives a transferable notice—even while the contract is still trading, before the end of the delivery month—he or she must accept it. However, all the long has to do is sell it and pass the notice on or "transfer" it

to the buyer. Since the commodity is in the warehouse, certified as to grade and ready for delivery, a time limitation is set on the transfer. Delivery must be made the next day, so anyone who does not wish to accept delivery must sell it within a half-hour. On the notice itself are lines for endorsement by each long and a box for the time it was received. A sample transferable delivery notice is shown in Figure 4-1(a). If the notice stays in the long's hands longer than a half-hour, it is considered accepted, or *stopped*. The long must then take delivery.

A nontransferable delivery notice, on the other hand, is handled differently. The long, upon receiving the notice, can still sell the contract to avoid delivery. But the notice cannot be transferred to the buyer immediately. The receiver of the notice, the long, must keep it overnight and absorb one day's charges: He is "stuck," as the saying goes. However, since he has sold and gone short, he now causes a new notice to be issued and sent to the clearinghouse after the market closes. In so doing, the long is said to be "retendering" the notice. The following morning the clearinghouse resumes the procedure. The long has two transactions in the account, one for the futures position and the other for the cash or actual position. The gain or loss in the actual position is the difference between the selling price and the settlement price of the retendered notice. An example of this type of notice is shown in Figure 4-1(b).

TRY THIS

If a trader takes a long position in the spot month (delivery month) and receives a delivery notice that is "stopped," must he accept delivery?

HERE'S WHY

Yes; once the notice is "stopped," the long holding it must take delivery. Because the number of times a notice is transferred may be restricted by exchange rules, a long may buy intending to day-trade and transfer the notice, only to find he has bought a "stopped" delivery notice and now owns the physicals. This is just one of the many dangers for speculative traders operating in the delivery month.

FIGURE 4-1(a) Transferable Delivery Notice (*On the back of this sheet is a log for keeping track of who accepted the notice, when, and to whom it was transferred.*)

New York Cotton Exchange Transferable Notice

C/H No._____ Contract No._____

10:29 A.M. New York,_____

To_____

Please take notice that, on_____, in accordance with and subject to the New York Cotton Exchange By-Laws and Rules applicable to Contract No. 2 and the Internal Revenue Code, Section 4863, we shall deliver to you or the last acceptor of this notice,_____square bales of cotton weighing 50,000 pounds (1% more or less) at the transferable notice price of_____cents per pound, basis Strict Low Middling 1-1/16 Inch, warehoused in _____micronaire-tested by the U.S.D.A. at not less than 3.5 nor more than 4.9 and classed and reviewed by

(Point of Delivery)

the United States Department of Agriculture as follows:

B/C	GRADES	1-$\frac{1}{16}$"	1-$\frac{1}{32}$"	1-$\frac{1}{8}$" & Up
	Good Middling			
	Strict Middling			
	Middling plus			
	Middling			
	Strict Low Mid. plus			
	Strict Low Middling			
	Low Middling plus			
	Low Middling			
	Good Mid. Lt. Spotted			
	Strict Mid. Lt. Spotted			
	Middling Lt. Spotted			
	NON-RAIN-GROWN			
	Good Middling			
	Strict Middling			
	Middling plus			
	Middling			
	Strict Low Mid. plus			
	Strict Low Middling			
	Low Middling plus			
	Low Middling			
	Good Mid. Lt. Spotted			
	Strict Mid. Lt. Spotted			
	Middling Lt. Spotted			

Non-Rain-Grown Cotton_____B/C

Deliverer's Class_____B/C By_____

Accepted		Transferred to
By	Time	

FIGURE 4-1(b) Nontransferable Soybean Meal Delivery Notice

No._____

SOYBEAN MEAL DELIVERY NOTICE

BROKER & CO.
INCORPORATED

NEW YORK, N. Y. 10011

_____19_____

BOARD OF TRADE CLEARING CORPORATION

We have on hand ready for delivery the following described Soybean Meal Shipping Certificate, and hereby made tender to you for the same, in fulfillment of contract of sale to you of 100 tons (2,000 pounds each) of Soybean Meal of Standard of Board of Trade of the City of Chicago at_____44% Protein Soybean Meal.

Soybean Meal Shipping Certificate, Registrar's Number_____

registered on_____, 19_____, issued by Shipping plant of

_____Located at_____

_____, 100 tons at Delivery Price_____

per ton $_____, Less premium_____days @_____

cents per ton per day $_____
ETL Certificate (delivery price)
Semi-Unrestricted Certificate, premium of $3.25 per ton - $....................................
 Amount due upon surrender of Soybean Meal Shipping Certificate

$ _____
 BROKER & CO.
 INCORPORATED

By _____

Premium charge paid to and including_____, 19_____
Number of days from date of registration or date to which premium paid to date of delivery (not counting date of registration or date of payment of charges but counting day delivery made)

_____days.
 E. & O.E.

Delivery Responsibilities

One way or the other, once a long accepts the delivery notice—or *stops* it—the clearinghouse's obligation is ended. The seller is informed of the buyer's identity, and then the two parties make all the arrangements from that point. They may also make certain adjustments, if necessary, in accordance with the certified grade and weight of the commodity.

The delivery is considered complete and the contract closed when the buyer accepts a warehouse receipt (indicating the storage of the commodity) from the seller and, in turn, pays in full with a certified check. Payment is not made through the clearinghouse. The only link the clearinghouse maintains with the contract is that it retains the margins on account until the actual delivery is made.

Financial Protection

The clearinghouse has ample protection against default as a result of its original and variation margin requirements. Margin deposits, however, form only the foundation for the resources that make it possible for the clearinghouse to guarantee all cleared contracts for both delivery and payment. As a further safeguard and as a condition of membership, a clearing member contributes to the *guarantee fund* of the clearinghouse.

Another source of financial guarantee is the charge of a small fee for the clearing member's trades. This source of revenue helps to cover costs and accumulates to become the *surplus fund*. Money in this fund is invested in U.S. government bonds and the interest earned is applied to the operating expenses of the clearinghouse.

Even though the clearinghouse has taken many precautions to protect itself against the risk of default by a member, it follows certain procedures during just such an occasion:

1. It will close out all of a member's contracts by purchase and sale on the exchange floor.
2. The deficit owed to the clearinghouse is first paid for from the margin account.
3. Should the margin account be insufficient, then the member's contribution to the guarantee fund is used.

4. The next step to cover a deficit is to draw on the surplus fund to an extent determined by the board of directors.

5. If the surplus fund is exhausted, the general guarantee fund stands as an additional reserve. Once the guarantee fund is drawn upon, the balance must be restored by assessing all clearing members. Clearing members may be jointly liable to the full extent of their capital.

TRY THIS

If a member firm goes bankrupt and cannot meet its obligations to a clearinghouse, a customer's accounts are protected by:

a. The CFTC
b. The exchange
c. SIPC
d. The guarantee fund

HERE'S WHY

The answer is (d). In effect, all the other clearinghouse members are liable not just for their contributions to the fund, but also for contributions to emergency assessments if necessary. Note that the Securities Investor Protection Corporation (SIPC) in choice (c) covers only securities accounts, even if a bankrupt member also carried futures positions.

5

Market Analysis

Investors who trade in commodities, whether as their main occupation or as an investment sideline, usually use one of two basic approaches to forecast prices and to decide whether to buy or sell. These two approaches are:

1. the fundamental analysis approach, and
2. the technical approach, or price movement analysis.

The principles underlying these two basic approaches to price forecasting must first be understood and then the commodity trader can learn how to apply them to actual markets.

Since the two basic approaches are founded on two entirely different concepts, traders are usually inclined to be strongly in favor of either one approach or the other. However, exclusive use of either approach is not wise. Common sense advises that to obtain the best possible trading results with the least amount of risk you should combine the good points of both approaches. How much of a combination is practicable depends on the market situation and also, to some extent, on the circumstances and objectives of the individual trader. After reading about the merits and drawbacks of each approach, you can decide which aspects of each are best for you.

Fundamental Analysis

The fundamental analysis of futures markets is based on a study of the underlying supply-and-demand factors that are likely to shape the trend of prices. The pure technical analyst, on the other hand, is concerned exclusively with the behavior of prices themselves and not with the factors that cause price movement. The fundamental analyst devotes his or her attention to such influences as the relationship between supply and demand, government programs, international commodity agreements, political developments, inflation, and so on.

The theory behind this approach to futures trading is that supply and demand interact to determine prices. A supply scarcity results in a higher average price level than a supply surplus, all other factors being equal. However, "all other factors" can also have a significant impact on the supply, the demand, and the price of any commodity or financial instrument. The fundamentalist evaluates the existing and probable supply/demand balance, takes into account identifiable external factors that affect it, and then assumes a market position that is based on his price forecast. Fundamentally based forecasts, as well as their resulting market positions, tend to be long term.

The fundamental analysis approach to commodity trading is actually tied closely with normal seasonal price tendencies. For example, the fundamental market analyst knows that Chicago December wheat usually reaches a summer low sometime in July or August—possibly even as early as June—and that from this low a seasonal price advance normally extends into at least November or December. The fundamental market analyst also knows that Chicago July corn normally stages an advance from a fall or winter low to a May, June, or July high, and that Chicago November soybeans usually stage a decline from a spring or summer high to a fall harvest-time low. By knowing these seasonal tendencies and by fully understanding the factors and the particular situations responsible for each, the fundamental analyst is likely to fall into a normal seasonal price pattern or run an irregular path.

In either event, the fundamental trader is usually able to take full advantage of the major price moves. Actually the fundamentalist is in a better position to do so than the technical trader. The technical trader, who is not so concerned with such factors, does not take a position until after the market itself confirms that a move

is underway. Furthermore, during periods of erratic or indecisive market action, the technical trader, depending on the particular system being used, may be forced to change positions several times. Conversely, the fundamental trader, who has studied and understands the factors involved in the situation, is less likely to lose perspective and abandon a position that is actually sound and that, if maintained, will prove profitable *in the long run*.

The fundamental market analyst may also, along with an appraisal of market factors, give some consideration to the behavior of the market itself. By doing so, he or she is actually using some of the techniques used by the technical analyst. But this practice is not incompatible with fundamental market analysis. As a matter of fact, the good fundamental market analyst continuously observes and interprets market action. Market action often provides an actual checkpoint as to whether the market is performing as expected; it is used to double check the analysis. By giving consideration to price movement, the fundamental trader often improves the timing of purchases and sales based mainly on the original fundamental analysis.

The fundamental approach to commodity trading appeals to many traders for many reasons.

1. It permits a trader interested only in longer-term price swings to take a position and maintain it with a minimum of attention to day-to-day market action. Without a long-term perspective, short-term price jolts will often knock a trader out of an otherwise good position.

2. It provides many traders with an understanding of why prices move higher or lower.

3. The trader is able to understand such movements by studying the factors that cause such price changes.

4. Most traders like to have a "reason" for making a trading decision. Many traders find it psychologically difficult to establish a market position that is based on the turn of a moving average or the violation of a trend line. A rationale for a trade that is based on a serious study of supply-and-demand data often provides the strength of commitment necessary to stay with a particular trade.

Briefly, the principal difference between the technical and fundamental approaches is that the technical trader makes no attempt

to study fundamental factors. The price-movement analyst is content to follow the moves as they occur, relying on the action of the market itself to determine when to buy and sell. The fundamental trader, on the other hand, studies market factors in detail. By appraising situations and by studying all factors, this trader determines in advance whether prices are likely to move higher or lower and then takes a position in the market accordingly.

Fundamental analysis does have a number of weaknesses when looked at as the *sole* basis for trading decisions. These weaknesses include the following:

1. It is imprecise. The best fundamental forecast will predict an "average" high or low or a probable "range" of prices. It is difficult to be more precise than this. Thus, when markets are near their fundamental price objectives, it is difficult to know how to react. Will prices stagnate, will they shoot beyond all objectives because of speculative excess, or will they reverse? Fundamental analysis provides no easy answers. In addition, the imprecision of fundamental analysis makes trade timing difficult. If prices are expected to reach a peak six months from now, when should we get long? Will prices rise gradually over the next half year or will they erode for 5½ months before skyrocketing to new highs?

2. Fundamental analysis cannot take into account all the many variables that currently influence price nor those factors that may not be of influence now but that will be in the future. This, critics say, leaves fundamental forecasts vulnerable to the "surprise factor."

3. Modern futures markets tend to be extremely price-efficient. This means that their prices tend to reflect, or *discount*, known fundamentals very quickly, even before any formal analysis is conducted. As a result, fundamental analysis may tell us why prices are at present levels rather than where they are likely to go.

4. The fundamental approach, in and of itself, does not incorporate any risk-control safeguards. It is possible for fundamentals to undergo no apparent change while prices move against a trader's position and wipe out his entire equity. In fact, one of the strengths of fundamental trading—that it gives traders more persistence in long-term price trends—is a major weakness when prices are moving adversely for no apparent reason.

Sometimes the fundamental reasons for a price move come to light only after a trader's equity has disappeared.

Even though fundamental analysis has its weaknesses, it still is an important element in good futures trading programs. Used in combination with technical trading signals and money management protection, it provides the basis for trading those major price swings that have made futures markets—and some of their traders—famous.

TRY THIS

A fundamental futures trader is more likely to be interested in long-term price moves than is the technical trader. True or False?

HERE'S WHY

The answer is True. The general assumption is that the evolving of the supply/demand figures necessary to make major trend predictions is a long-term proposition. Short-term fluctuations are too rapid and "emotional" to respond to the same kind of information that fundamental analysts find most useful.

Market Factors

Your success in applying the fundamental analysis approach to your trading technique depends primarily on your ability to evaluate the basic market factors. Which factors? What statistics are used in figuring supply-and-demand balances? What are the seasonal price tendencies for various commodities, and what causes them? What do you look for when comparing current and past price levels? Are there government programs that impact on the demand or on the *available* (not removed from the market) supply?

You must be able to separate the important factors from the vast amount of day-to-day market information that is important only as it relates to and affects these factors. We'll explain how that's done.

Supply and Demand

The most influential factor in determining the price of a commodity is the supply-and-demand balance—the amount of a commodity that is available in relation to requirements. This relationship is the central focus of all fundamental analysis.

The Nature of Demand

The demand for a specific commodity is defined as the quantity of that commodity that consumers are willing to purchase at different prices during a particular time period. It is obvious that consumers are willing to buy more at lower prices than at higher prices. The amount that is demanded increases as prices decline, and it declines as prices increase. For this reason, we say that demand is inversely related to price. Figure 5-1 graphically depicts the relationship between the quantity demanded and price.

The line shown in Figure 5-1 is called a *demand curve*. The exact shape and slope of the demand curve are determined by conditions at a particular time, but the general slope is always downward to reflect the inverse relationship between quantity demanded and price. Why? First, at a lower price you can afford to buy more of something out of a given amount of income. Second, at a

FIGURE 5-1 **Typical Demand Curve**

As price increases, demand decreases, and as price decreases, demand increases.

lower price you are likely to want to buy more of something because it becomes more attractive compared with other things on which you might spend your money. Finally, lower prices will encourage the development of alternative uses for a commodity.

Changing conditions (other than price) will alter the shape and slope of the demand curve during a period of time. Either a part or all of the demand curve will steepen or flatten as changes occur in the factors that influence demand. There are four main factors that influence demand and, therefore, the shape of the demand curve.

1. Consumer income affects demand. An increase in income causes consumers to demand more of some commodities. Beef is a good example. For other commodities an increase in income causes consumers to demand less at each price. Potatoes are often a good example of this because higher incomes can cause consumers to eat more meat and fewer potatoes.

2. An increase in the prices of competing commodities will tend to increase the demand for a product. If beef prices increase, demand for pork and chicken will probably increase if their prices remain constant.

3. Changing tastes and values can bring about shifts in demand. Demand for frozen concentrated orange juice (at a given price) increased tremendously during the 1950s as the product gained wide consumer acceptance. Shifts in demand for this product continue to occur as consumer preferences shift between the fresh and the frozen product. Per-capita consumption of beef in the United States declined in recent years due to changing tastes and health considerations.

4. Consumer expectations affect demand. If consumers expect the price of a particular commodity to rise, their demand for that commodity will also rise in anticipation. On the other hand, expectations of falling prices will cause some purchases to be postponed. Expectations of coffee shortages and higher prices have led to consumer hoarding a number of times since the 1970s.

The degree to which the quantity demanded responds to a change in price is called the *price elasticity of demand*. Economists classify demand as elastic or inelastic on the basis of the relative responsiveness of quantity demanded to changes in price. The

demand for a commodity is said to be *price inelastic* if a large change in price is required to bring about a relatively small change in the quantity demanded. For example, if a 50% drop in coffee or gasoline prices would bring about a 10% increase in the quantity demanded, coffee and gasoline demand would be said to be relatively price inelastic.

Demand for a commodity is likely to be inelastic when:

1. there are few good substitutes,
2. consumer outlays for the commodity are small,
3. the commodity is a necessity or the demand for it is urgent, and
4. the demand for the commodity stems from the demand for a related product (the demand for tires will be more a function of the demand for cars than of the price of tires).

The elasticity of demand is an important issue for many of the commodities that are traded on futures exchanges. In comparison to such items as televisions, jewelry, or home computers, the demand for most commodities that are traded on futures exchanges is relatively price inelastic. Farm products are a good example. In periods of surplus production, prices must often drop drastically to increase consumer demand and absorb excess supply. Why? Because demand is relatively unresponsive to changes in price. People can eat only so much bread and pork, and animals can consume only so much corn or soybean meal. Very large changes in price are required to bring about very small changes in overall demand. In periods of shortage, very large increases in price are necessary to bring demand down and avert a total depletion of the commodity. (Export competitiveness, in which price changes can have great effects on demand, also enters into the supply/demand balance.)

In a sense, price elasticity of demand is one of the many factors that account for the excitement of futures trading in certain commodities. Relatively small and seemingly unimportant changes in a market's supply/demand balance produce large and important changes in price where there is a close supply/demand balance. Because of leverage, even larger changes in traders' equities result. A 5% change in the supply of corn might produce a 10% or 15% change in its price; a 10% or 15% change in the price of corn can be enough to more than double or wipe out the equity in a corn trader's account.

The Nature of Supply

Supply is defined as the quantity that producers will offer for sale at different prices. Like demand, supply can be plotted on a graph, as shown in Figure 5-2, with "Supply" on the vertical axis and "Price" on the horizontal axis. Unlike the demand curve, the supply curve slopes upward, signifying that suppliers will make more of a product available as the prices they receive increase.

Among the factors that influence the shape and the slope of the supply curve are:

1. the cost of the factors of production,
2. the state of relevant production technology, and
3. the prices of competing products.

Supply-and-Demand Balance

To figure supply-and-demand balances, you rely mainly on government statistics. With government statistics continuously available, figuring supply and demand is a lot easier. With few exceptions these statistics, both with respect to supply and utilization,

FIGURE 5-2 Typical Supply Curve

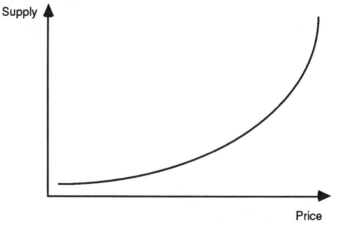

As price increases, supply increases, and as price decreases, supply decreases.

are issued by the U.S. Department of Agriculture (USDA) and are commonly referred to as official estimates. Sometimes you may feel that a government estimate is too high or too low. In such cases, the procedure is not to ignore the estimate but rather to adjust it in making supply-and-demand computations.

In domestically produced agricultural commodities, such as corn, cotton, soybeans, wheat, and cattle, preliminary government crop estimates are issued well ahead of the actual harvest. These, plus private reports and perhaps a personal record of crop conditions, make it possible to forecast probable supply-and-demand balances well in advance. You can obtain a complete list of the various government reports available on both supply and utilization by writing to the U.S. Department of Agriculture in Washington, D.C. The Food and Agriculture Organization also produces useful statistics.

Supply-and-demand balances are statistics based on a crop year or marketing period, not a calendar year. A crop season begins on the first of the month closest to the harvest period. For statistical purposes, a new crop is assumed to be fully available at the start of the new crop season.

In figuring the *total supply* of a commodity for a particular season, three categories of supply must be taken into account:

1. the new crop,
2. the old crop carryover, and
3. probable imports.

The old crop carryover consists of all unused stocks (from either the previous or earlier crops) that remain at the end of the immediately preceding season; these unused stocks are sometimes referred to as *reserve stocks*. Since the supply of a commodity is made up of inventories plus current production, nonstorable commodities have no inventories and therefore current production is the sole supply: live cattle and hogs, and iced broilers for example. The supplies of other commodities that are byproducts, while they may or may not be storable, depend on the production of raw materials from which they are processed. The marketable supply of soymeal, plywood and lumber, and eggs is considered the current production, and their prices may be influenced by the supply and price of the "parent" commodity. Frozen pork bellies (raw bacon) and frozen concentrated orange juice are storable, and

inventories must therefore be considered. However, they too rely on the production of "parent" commodities.

Seasonal production and price patterns also appear in commodities other than grains. Hog production (pig births), for example, is the largest during the spring months of March, April, and May. These newborn pigs are brought to market during the period of August through December. Cattle also go through a production cycle inasmuch as heifers are not bred until they are approximately three years old. The "fattening" process of a yearling calf runs six to nine months. The length of time required from breeding to the "finished product" has a large impact on supply and price cycles. One of the most important fundamental factors that influences production and supply—particularly in livestock—is the feeding cost. This ratio is expressed as the number of units of corn *equal* in value to 100 pounds of pork or beef. The ratio expressed is high when the value of corn is low relative to the sales value of beef. In other words, a ratio of 20 to 1 (20/1) indicates that corn is inexpensive relative to the sales value of livestock and that feeding is profitable. These ratios are calculated and released monthly by the USDA.

In calculating supply, it is necessary to be aware of any carryover supplies "locked away" in government price support programs or made newly available because of any changes in such programs.

TRY THIS

What does a supply-and-demand balance include?

HERE'S WHY

Three categories of supply must be taken into account when figuring the total supply of a commodity for a particular season. They are the new crop, the old crop carryover, and any probable imports.

TRY THIS

If the hog/corn ratio is high, a farmer would probably do which of the following?

a. increase corn acreage
b. decrease corn acreage
c. decrease breeding and feeding of hogs
d. increase breeding and feeding of hogs

HERE'S WHY

The correct answer is (d). A high ratio means corn is cheap relative to the pork produced by feeding it to hogs. In other words, it pays to feed the corn to the hogs and fatten them, so a farmer profits most by increasing hog production.

Price Levels

An extremely important factor to the fundamental market analyst is the price level. In fact, in fundamental market analysis, the level at which a commodity is selling is a constant consideration. After all other considerations, selling price is often the deciding factor regarding a bullish or bearish status.

Four types of price comparisons are made to determine whether the price of a commodity is too high or too low:

1. Observe the price level at which a commodity is selling in relation to the current (or anticipated) government loan rate.
2. Mark the selling level compared to prices in past seasons when similar conditions prevailed.
3. Note whether the price of a commodity appears to be too high or too low compared to the price of competing commodities.
4. Look at how foreign prices for the same commodity compare to domestic prices.

The price that brings supply and demand into balance is known as the *equilibrium price*. In theory, at least, it is found by combining the supply curve and the demand curve, which we discussed earlier, and is shown in Figure 5-3.

The fundamental analyst constructs the expected supply and demand curves for an item and then estimates the equilibrium

FIGURE 5-3 Typical Supply/Demand Graph

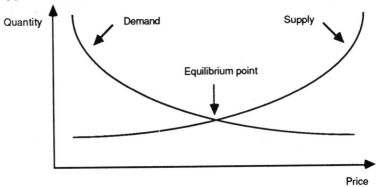

The equilibrium point is the price level at which supply equals demand.

prices that will bring market forces into a state of rest. In effect, prices fluctuate in an effort to find their equilibrium. Prices that are too high increase supply, decrease demand, and lead to lower prices. Prices that are too low increase demand, decrease supply, and lead to higher prices. Prices that are "just right" keep supply and demand in balance.

Seasonal Price Tendencies

There is a tendency, more pronounced in some commodities than in others, for prices to follow an established seasonal pattern. The tendency in wheat, for example, is for prices to go through two cycles of advance and one of decline, all in a 12-month crop season. These seasonal price cycles move as follows: a moderate to broad advance from the July-August low to the following November-December high; a moderate to substantial decline from the November-December high to the following February low; a recovery from the February low to the March-May high; and then a decline to the July-August low, thus completing the full 12-month cycle. Corn and soybean prices tend to reach a seasonal low some time in the October-December period, with seasonal highs reached sometime between May and July. Pork bellies run up from a March low to a July peak and resume the slide to a November low with a gradual recovery in December.

Some market analysts consider the *separate* influences that

cause seasonal price tendencies as basic factors rather than regard this overall tendency as a basic factor by itself.

Other considerations that affect seasonal price patterns include external forces such as unusual export demand (Russian wheat sales), abnormal weather, and labor disruption.

Obviously, seasonal price tendencies should not be relied on alone as a basis for making purchases and sales. They should serve as a guide only and be considered in conjunction with other factors. If an average supply-and-demand balance exists, you would expect prices to probably follow a normal seasonal pattern. On the other hand, if the fundamental supply-and-demand situation is either extremely bullish or extremely bearish, or if some unusual special influence is affecting the situation, you can reasonably assume that the seasonal price pattern will be distorted.

Also to be considered in conjunction with seasonal price tendencies is the prevailing price level, both in relation to the level that has existed in past seasons when conditions have been similar and in relation to the government loan rate. If, for example, the price of a commodity appears to be unusually depressed at the time of the year when a seasonal low is normally reached, you could expect that prices might undergo a broader than average seasonal advance. On the other hand, if the market appears to be overpriced at the time when a seasonal low is normally reached, you would logically anticipate a smaller-than-average seasonal price advance. In fact, if the market appears to be sufficiently overpriced, you might conclude that prices should actually decline during the period of normal seasonal advance.

You should not attempt to lay down a hard-and-fast rule that will apply in all cases. But a good general rule for the fundamental trader is that you should avoid being long during periods of the year when seasonal price declines usually occur, and you should avoid being short during periods of the year when seasonal price advances usually occur, unless you have a particularly good reason for doing so.

How Market Factors Influence Prices

The basic market factors, or their various combinations, normally lead to definite types of market situations. Actually, what the fundamental market analyst must do is evaluate the basic factors that exist and then decide what type of situation will likely result.

Total Supply Scarcity

A total supply scarcity is basically the most bullish of all situations. In such a circumstance, you don't turn bearish, or sell, until prices have become high enough to discount the bullish supply situation. How far prices advance before leveling off depends, of course, on how acute the scarcity is. Bullishness also depends on whether commodity prices, as a whole, are advancing or declining. Even with all these considerations taken into account, you will find that predicting the peak is still extremely difficult in a scarcity situation.

In fact, predicting the level at which the bull market will top out is probably tougher in a total supply scarcity situation than in any other. There is no reserve supply that will become available "at a price." The market has no ceiling, no top. In such a market, the fundamental trader should rely more on price movement analysis to determine when the bull move has topped out. In other words, follow the market rather than try to outguess it.

When estimates indicate that demand during a particular season may be in excess of available supply, prices tend to advance and thereby curtail purchases for demands of lesser importance, so that the available grain satisfies the more urgent requirements. As prices move higher, buyers become more reluctant to purchase; instead, they seek substitutes where feasible, postpone buying, or purchase only requirements necessary to maintain a working inventory.

TRY THIS

A total supply scarcity is bearish. True or False?

HERE'S WHY

False. On the contrary, it is the most bullish of all situations. Longs benefit when they control contracts on limited supplies, so that those who wish to obtain the commodity must bid up the prices. With a total scarcity, price rises are steep and very fast, making the market far more responsive to technical, rather than fundamental, forces.

Total Supply Surplus

When production is substantially in excess of requirements, resulting in a total supply surplus, prices generally decline to, and average out at, a relatively low level during the entire crop season. In such situations, a wider-than-average discount below the loan rate, preferably during the early part of the crop season, is needed to lay the groundwork for a sizable and extended advance.

Free Supply Scarcity

A free supply scarcity is an artificially created scarcity that results from the federal government's program aimed at stabilizing farm prices. Under a program authorized by Congress, the U.S. Department of Agriculture can make loans to farmers at a designated loan rate, taking the farmers' surplus inventory as collateral. (The government farm policy was a major factor in controlling prices and supplies through the loan programs, acreage diversion, and price supports until world shortages began to appear, principally in wheat and corn.) In this way, in times of great surplus, the government can in effect hold back some of the surplus until prices rise enough to warrant selling it on the open market. The loans are available only on certain commodities and only for a limited time after the harvest (called the *impounding deadline*). The loans are called *nonrecourse loans*, because they give farmers the choice of default without penalty or of paying off the loan prior to maturity and redeeming the commodity.

Since it is artificial, the free supply scarcity is not as bullish as a total supply scarcity. An adequate supply exists, but not all of it is immediately available; part of that supply is owned by the government and some of the current crop may have been placed under loan (impoundings). The bullishness is limited to a certain price range. The top of the range is the premium of the market price over the loan value necessary to make paying off the loans profitable and placing the grain into supply channels. The lower limit is the discount necessary to draw the surplus portion of the supply under loan. Obviously, the USDA carefully regulates the resale or other disposition of these surplus stocks, so as not to unfairly suppress free market prices. This situation is encountered very

often in markets heavily dominated by surpluses and government support programs.

> EXAMPLE: In a certain commodity, the total supply for the season—carryover, imports, and production—is 1,500 million bushels. But the estimated requirements are only 800 million bushels. From a total supply standpoint, the supply far exceeds probable needs. From a free supply standpoint, however, the picture is a little different. The government owns 500 million bushels of the carryover, reducing the free supply to 1,000 million bushels. Of the total requirements, probably 50 million bushels will be filled from government stocks, leaving 750 million to be filled from free stocks. Therefore, where the total supply exceeds requirements by 700 million bushels, the free supply exceeds free requirements by only 200 million bushels. This 200 million bushels is the free supply margin. If more than this margin is placed under loan, thus reducing the free supply, a shortage of free stocks will occur in relation to free requirements. Hence, the free supply scarcity.

TRY THIS

What does this artificial scarcity result in?

HERE'S WHY

This artificial scarcity results in a bullish situation, because in order for requirements to be met, prices must move up to where the free supply is increased either by stocks coming back out from under loan (redemption) or by Commodity Credit Corp. (CCC) sales for unrestricted use.

Free Supply Surplus

This is the most bearish supply-and-demand situation, because a free supply surplus usually means an even larger total supply surplus. In other words, even after allowing for all that is owned by the government and all that is under loan, there is still a sizable surplus on the basis of free supply calculations. How bearish a free supply surplus is depends on the size of the surplus. When an

indicated free supply surplus exists, prices will always have to sell at a sufficiently wide discount under the government loan price to draw the free surplus, or at least most of it, under loan. A small discount should be enough to cause a small free surplus to be impounded, but if the free surplus is large, you may be reasonably certain that a wider-than-average discount is required.

Now that you know about the basic factors regarding fundamental analysis, perhaps a quick summary of its use is in order. Table 5-1 lists guidelines to follow.

TABLE 5-1 Basic Guide for Applying Fundamental Market Analysis

1. Calculate the total supply-and-demand balance:
 a. Increase or decrease in carryover stocks.
 b. Price patterns from similar situations in the past.

2. Calculate the free supply-and-demand balance:
 a. Free surplus or artificial scarcity.
 b. Amount impounded to absorb surplus/redeemed to alleviate scarcity.
 c. Discount under/premium over the loan in the past.

3. Consider seasonal tendencies:
 a. Prices follow tendency—immediate or delayed position.
 b. Trade with established tendency.

4. Observe price level:
 a. Prices too high or too low. (See 1b above.)
 b. Look/allow for possible counter-seasonal move.

5. Consider any existing factor of a special nature.

Macroeconomic Influences

Fundamental analysis has two important components. One is the supply/demand balance of the particular item being studied, as you have just read. The other is the macroeconomic background

against which these fundamentals must be evaluated. Factors such as inflation, currency fluctuations, and monetary and fiscal policies affect overall price levels and should be incorporated into any fundamental analysis. Some of these macroeconomic forces are discussed in the following pages.

Inflation

During periods of extreme inflation a commodity normally sells at a higher price than ordinarily warranted on the basis of supply-and-demand statistics. During periods of extreme deflation the reverse is true. In forecasting highs and lows and in forecasting a logical price level for a commodity, you have to consider the general commodity price level and the general commodity price trend.

There is a general consensus among economists that dramatic increases in a nation's money supply are likely to produce inflation. This is logical because money can be thought of as a commodity like any other. If more of it is produced, it will be less valuable, which is the definition of inflation. Thus, traders often follow the various money supply numbers that are released by the Federal Reserve as likely indicators of future inflation rates. The level of inflation is crucial because an inflationary environment will cause prices to rise more or to decline less than an analysis of supply/demand balances alone might suggest.

The most widely followed indicators of inflation are the *Producer Price Index* (PPI, formerly the *Wholesale Price Index*), the *Consumer Price Index* (CPI), and the Commodity Research Bureau's (CRB) *Futures Price Index*. The PPI and the CPI are released monthly by the U.S. Department of Commerce. The CRB Index is calculated and published daily by Commodity Research Bureau, Inc. of Jersey City, New Jersey. The New York Futures Exchange (NYFE) lists a futures contract based on the CRB Index.

Monetary Policy

The government exerts a powerful influence on the overall level of economic activity through its control of the nation's money supply. The management of the U.S. money supply is the province of the

Federal Reserve and is known as monetary policy. In theory, an expansion in the money supply increases the availability of credit and hence should tend to lower interest rates and to raise the level of economic activity. Conversely, a reduction in the money supply should tend to raise interest rates and to restrain overall economic activity.

A restrictive monetary policy, which raises interest rates, tends to push commodity prices lower. Conversely, an accommodative monetary policy tends to lower interest rates and to support futures prices. The reasoning is straightforward. Higher interest rates raise the opportunity cost of owning commodities, which pay no interest, so the overall demand for commodities will tend to fall. Lower interest rates reduce the opportunity costs of owning non-interest-bearing items and therefore tend to bolster demand.

Fiscal Policy

Fiscal policy is the term used to describe a nation's taxation and government spending initiatives. Such policies have become much more prominent in economic analysis since the early 1970s because of the large and persistent imbalance between U.S. federal government income (primarily taxes) and federal government expenditures. The excess of spending over revenues is known as the federal budget deficit and is considered by most economists to be a key macroeconomic force.

Exchange Rates

The increasing interdependence of the world's major economies has made currency exchange rates an important factor in price analysis. All else being equal, a nation whose currency declines in value relative to the currencies of its trading partners will be able to import less and to export more. Conversely, a nation whose currency increases in value will be able to import more but to export less. This is important to remember when analyzing futures markets for items that enjoy significant international trade. For example, the sharp rise in the value of the U.S. dollar during the early 1980s made many U.S. agricultural products such as soybeans more expensive to foreign importers. This contributed to the slump in demand for agricultural products during that period.

Government Commodity Agreements

Government commodity agreements influence many markets. The most obvious example of such an agreement is in oil, where OPEC often plays a dominant role in pricing.

Other commodities are also affected to varying degrees by international commodity agreements. Many of the agricultural markets, for example, can react to decisions adopted by the European Community (EC). EC decisions on sugar and feedgrain output and sales sometimes affect futures in these items. The cocoa, coffee, and sugar markets are periodically influenced by these international agreements or cartels between producers and consumers. These agreements have seldom proven effective for long periods, but traders should remember that they can have an important short-term influence on prices.

Trade Policy

Tariffs, quotas, import restrictions, and bilateral and multilateral trading agreements can significantly affect the flow of internationally traded products. Governments sometimes use trade policy to further political agendas or to protect certain industries within a country from foreign competition. Such policies can radically affect supply/demand fundamentals. One such example follows.

The United States has long subsidized domestic sugar producers whose production costs, on the whole, far exceed those of most other sugar producers. The government accomplishes this through a combination of subsidies and import restrictions on foreign sugars. The net effect is that sugar prices in the United States are artificially high, which naturally tends to restrict usage.

Technical Analysis

Fundamental analysis, as we just discussed, focuses on the supply-and-demand factors that underlie price movements. In farm product futures, for example, the fundamentalist considers the effect of such things as bumper crops and blights. In financial futures, the concern might be for the current level of interest rates

or trade deficits. The fundamental approach is therefore said to study the *causes* of price movements.

By contrast, technical analysis studies the *effects* of supply and demand—that is, the price movements themselves. The most prominent form of technical analysis is also called *charting* because it is essentially the charting of actual price changes as they occur. The charting approach reflects the basic assumption of the technician that all influences on market action—from natural catastrophes to trading psychology—are automatically accounted for or *discounted* in price activity.

Given this reasoning, charting can be used for at least three purposes.

1. *Price forecasting.* The technician can project price movements either in tandem with a fundamental approach or solely on the basis of charted movements.
2. *Market timing.* Chart analysis is much better suited than is the fundamental approach for determining exactly when to enter and exit a position.
3. *Leading indicator.* If market action discounts all the influences on it, then price movement may be considered as a leading indicator, and it may be used in two ways. First, the chartist may—without regard for why prices are moving in one direction or the other—open or close a position. Second, an unusual price movement can be taken as a signal that some influence on the market has not been accounted for in the fundamentalist's analysis and that further study is required.

Volume and Open Interest

If chartists typically regard price as a primary indicator, they view volume and open interest as secondary indicators.

Volume is the number of contracts traded in a given period. Every time a trade occurs during the day, volume goes up. It can stay the same as long as no trading takes place, but it cannot decrease.

As a general rule, volume is a gauge of the "pressure" behind a price movement. High volume generally indicates that the current trend had momentum and should persist. A lack of volume might be a sign that the trend is "losing steam."

Open interest is the total number of outstanding or unliquidated contracts at the end of the day. A transaction can cause open interest to go up, down, or stay the same, according to the following summary:

Buyer	Seller	Change in Open Interest
Buys new long	Sells new short	Increases
Buys new long	Sells old long	No change
Buys old short	Sells new short	No change
Buys old short	Sells old long	Decreases

Open interest therefore measures the flow of money into and out of the market. When it is increasing, money is flowing into the market: New longs are opening positions with new shorts. This enhances the likelihood that the present trend will continue. Decreasing open interest reflects a liquidating market and perhaps a nearing reversal.

When interpreting open interest, you must acknowledge its seasonality. In any futures market, open interest will increase or decline depending on the nature of the underlying commodity or financial instrument. So all changes in open interest have to be compared against foreseeable seasonal moves before giving them weight as indicators of trend.

Volume and open interest are generally regarded as strong secondary indicators after price. Following is a chart that summarizes the interpretations of price, volume, and open interest:

Price	Volume	Open Interest	Interpretation of Market
Rising	Up	Up	Strong
Rising	Down	Down	Weakening
Declining	Up	Up	Weak
Declining	Down	Down	Strengthening

This table summarizes a number of useful principles:

- Volume tends to increase when prices are moving in the direction of the trend. In an uptrend, volume will increase on the up-swings and taper off on the dips. The opposite is true of a downtrend.
- "Unseasonally" rising open interest in an uptrend is bullish: new longs—with "fresh" money—are entering the market. In a downtrend, increasing open interest is bearish; "short" money is coming into the market.
- In an uptrend, declining open interest is bearish because longs are closing positions and taking money out of the market. Shorts are being forced to cover their positions; when all the shorts are out of the market, the price uptrend will likely turn downward.
- In a downtrend, diminishing open interest is bullish. Losing longs are getting out of the market. Once they are all out, the downtrend should come to a halt.

These are by no means all the possible interpretations of volume and open interest. The intention is simply to introduce the most basic ones.

The Use of Charts in Market Analysis

Most analysts use two working assumptions: (1) markets move in trends, and (2) trends persist. Identifying the trend at an early-enough stage enables the trader to take the appropriate positions. The tool used to track price movements and thus to identify trends is the chart.

Two basic types of charts available to the technician are the bar chart and the point-and-figure chart. Through the use of charts, analysts can observe how commodity prices *really* act, rather than how economists *think* they should act, and the trader can acquire a new grasp on market strategy.

The Bar Chart

A *bar chart*, also referred to as a *vertical line chart*, shows the daily trading range (the high, low, and close) for a particular day's trading. The price scale is placed on the vertical axis. The time sequence (days, weeks, months) is placed on the horizontal axis, as shown in Figure 5-4.

On a daily bar chart, every five-day period (a trading week) is usually marked by a vertical line that is heavier than the others. For each day, the high, the low, and the closing (or settlement) prices are plotted. A vertical line, or bar, connects the high and the low prices. A horizontal tick to the right of the bar indicates the closing price. (A tick on the left side of the bar marks the opening price for the day.)

By plotting the daily range of prices in the way shown in Figure 5-4, you can obtain a graphic picture of the trend of the market and the movement of prices over a period of time, which is helpful in determining the probable future course of prices. However, with so many chart services available, plotting one's own charts is often an unnecessary and unprofitable way to spend time.

The Point-and-Figure (P&F) Chart

Another type of chart is called a *point-and-figure chart*, which shows the intraday movement rather than just the overall range. Unlike bar charts, P&F charts record only price movements: If no price

FIGURE 5-4 Daily Trading Range Expressed in a Bar Chart

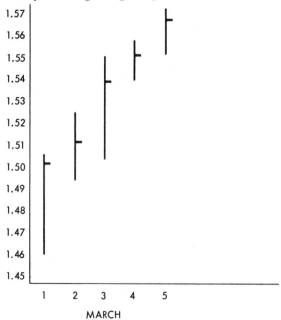

change occurs, the chart remains the same. Time is not reflected on a P&F chart, although time-reference points, such as a "10:00" for ten o'clock, are sometimes used. Volume is indicated only by the number of recorded price changes, not as a separate entity. Although traditionally ignored, gaps may be represented by empty boxes.

Point-and-figure charts have at least two major advantages over bar charts: First, they can be used on an intraday basis to identify support, resistance, and other price-related data—particularly congestion areas (no clear trend in sight)—that bar charts can miss completely. Second, P&F charts are more flexible than bar charts in that the analyst can vary the size of the box and the reversal criterion, either of which can drastically change the appearance of the formation.

On a P&F chart, the analyst moves one row of boxes to the right each time the market reverses. The next question is, what constitutes a reversal? Is a one-box change in direction a reversal? Or is it three boxes worth of movement?

TRY THIS

Perhaps the best way to explain the elements of a P&F chart is to construct one. Following are the actual price changes in an hour or so of cotton trading:

8515	8515	8510
8525	8505	8516
8510	8515	8510
8515	8512	8515
8510	8515	8506

Now let's construct a P&F chart using a piece of graph paper, with each box equal to one point and a three-box reversal criterion, that is called a "1 × 3" chart. Start by placing a dot in the 8515 box in row 1: A dot is used because the chartist does not know whether this is an up or down move. Still in column 1, the chartist places X's in all the boxes up to and including box 8525, representing the

upward price change from 8515 to 8525. The next price, 8510, represents a 15-box reversal and certainly qualifies as a reversal on this chart. Shift to the next column to the right and one box down, to reflect the change in direction. Then place O's in column 2 down to and including 8510. The rest of the price changes are plotted in the same up and down, X and O, manner.

When completed, compare your chart with the chart in Figure 5-5 to see how accurate your charting skills are.

Using Long-term Charts

Technical analysis techniques can be used to review any time period. They apply not only to daily charts, but also to weekly charts (that contain up to five years of data) and to monthly charts (that can offer up to 20 years of price movements). In fact, no

FIGURE 5-5 Plotting the Point-and-Figure Chart

analyst could get a broad-enough picture of a market without referring first (and often) to longer-term charts.

Herewith is a reasonable approach to follow:

1. Consult a chart that reflects the general environment of the futures market to be charted.
2. Next, turn to long-term charts of the individual market to determine the scope of past price movements. Looking for large-scale patterns in these charts prepares the analyst to properly interpret the day-to-day price action.

Trends in the Market:
The Effect of Buying Power and Selling Pressure

Although many claim that price movements can be predicted from a chart, charts are best used as a method of *following* the market. By recording price movements as they develop, charts provide a continuous picture of the internal forces causing commodity price movements. Therefore, they enable you to promptly detect and evaluate any significant changes taking place. For example, if buying power and selling pressures are about equal at a particular price level, prices move *sideways*—a situation referred to as a *congestion area* or *trading range.* The market tends to meet support on *dips* (declines) but encounters resistance on *rallies* (advances). In other words, if buyers are no more aggressive than sellers, prices fluctuate within a limited range horizontally. On the other hand, if buying power is stronger than selling pressure at a particular price level, prices rise. As long as buying power (demand) continues in excess of selling pressure (supply), prices proceed in an upward trend. If selling pressure becomes stronger than buying power at a particular level, prices decline. Uptrends indicate that at a given price level, buyers are being more aggressive than sellers; a downtrend indicates that sellers are more aggressive than buyers at a particular price level.

> EXAMPLE: Fifty lots are being offered for sale, and several buyers are bidding for quantities totaling 150 lots. Obviously all the buyers cannot be satisfied. In competing with one another to obtain what is being offered, the buyers begin to bid the price up. Some buyers are willing to pay a higher price than other buyers in order to get the lots

being offered. As the price goes higher, some buyers become less inclined to make a purchase.

Conversely, as the price rises, some sellers are stimulated to offer larger quantities. When buyers become reluctant to pay higher prices and sellers become more willing to sell, sellers become more aggressive than buyers at a particular price level, and the prices begin to decline. If 150 lots are offered for sale, but buyers are bidding for only 50 lots and the sellers are anxious to sell, they will reduce their asking price in an effort to dispose of their lots.

TRY THIS

What would happen if the price in the above example became lower?

HERE'S WHY

Sellers would become more reluctant to offer, and the buyers would become more willing to buy. Thus the trend of prices reverses itself once again. As this tug of war between buyers and sellers takes place, this constant shifting process (either from down to up or up to down) is reflectd in the price movement itself.

Although a trend can come to an end at any time without warning, it must first reveal itself in the price movement, which the alert trader observes. In short, the object of chart analysis is to attempt to follow a trend until it is concluded and to ascertain when such a trend has changed.

Uptrend

An *uptrend* in the price of a commodity is characterized by a series of highs and lows that attain levels generally higher than previous highs and lows. This is illustrated in Figure 5-6.

Drawing a line connecting the low points of several moves to determine the trend is usually helpful. The trend line points in the

FIGURE 5-6 Uptrend

direction in which prices are moving. Prices that continue above the upward trend line constitute an indication that buying power is more aggressive than selling pressure, and you should maintain a long position. As a general rule, your chances of success are usually better if you trade from the long side when the trend is up.

The end of an uptrend is indicated when a high fails to exceed the peak of the previous high. This indicator does not necessarily mean that a downtrend is imminent, but it does suggest that a considerable amount of sideward activity may be needed for supply and demand to adjust to the new price level. In due course, either a new uptrend will start, or else a downside breakout will occur. If a break in the uptrend is followed by a succession of lower highs and lower lows, a downtrend has been established. When the uptrend is broken, it is an indication that selling pressure is overtaking buying power. If you are long, this trend is your cue to liquidate your position. If you had been bearish on this commodity, based on your fundamental analysis, but had hesitated in initiating a short position (because prices were in an uptrend), this may also be your cue to establish your short position.

Downtrend

A market is in a *downtrend* when the highs and lows of the move get progressively lower. When each price decline reaches a lower level than the previous decline and each rally falls short of the previous high, the market is considered to be in a downtrend. A line should be drawn connecting high points of several moves to determine

the downtrend. As long as prices continue below the downtrend line, the trend may be considered to be down, indicating that selling pressure is more aggressive than buying power. You would thus maintain a short position. An example of a downtrend line is shown in Figure 5-7.

The end of a downtrend is indicated when a low fails to penetrate a previous low. This failure does not of itself indicate that a trend reversal is an early prospect. The downtrend may be resumed or a new uptrend started, but a new trend will not occur until either buying power or selling pressure dominates and determines the direction of the new trend. When the downtrend is broken, it can be a sign that an uptrend is beginning.

If you are short, this penetration should be your signal to cover your position. If you had been fundamentally bullish on this commodity but had hesitated in establishing a long position because prices were in a downtrend, this may be your cue to initiate your long position.

Congestion Area

At times, buying power just about equals selling pressure. This temporary balance of buying and selling pressure is also referred to as a *trading range*, and prices are said to be moving *sideways*. An interesting rule of thumb of traders is that, generally, the longer the duration of the sideways or horizontal market, the more extensive the trend that will follow. An example is shown in Figure 5-8.

FIGURE 5-7 Downtrend

FIGURE 5-8 Sideways/Congestion Area

Support Level

A support level is the point of a trend at which buyers become more aggressive than sellers. The result is to halt a decline. A support area is not difficult to find on a chart. (One is shown in Figure 5-9.) When the market is in an uptrend, the congested area previously established is the support level. This is so because when prices are fluctuating in a narrow range, moving sideways, buying power and selling pressure are about equal. When prices break out of the congestion area on the topside, the longs—the people who bought—are making money, but the shorts—the people who sold—are losing money. As a natural, although quite often damaging, reaction, the shorts maintain their positions in the hope that the market will react and decline again to the price at which they sold. But more often than not, sellers are happy just to break even. Consequently, if (after advancing) prices return to a previous congestion area, people who had sold in that area are inclined to buy back the contracts—just to "get out." If enough sellers feel this way, a considerable amount of buying power may develop as prices recede to that level. As prices draw closer to this level they are stemmed more and more. The decline grinds to a halt at this, the "support," level. Another possible source of increased buying power consists of people who regretted not going long during the original congestion period after watching the breakout and subsequent advance. When prices return to the level at which they had wanted to buy, they are not going to "miss the boat" again.

FIGURE 5-9 Support Levels

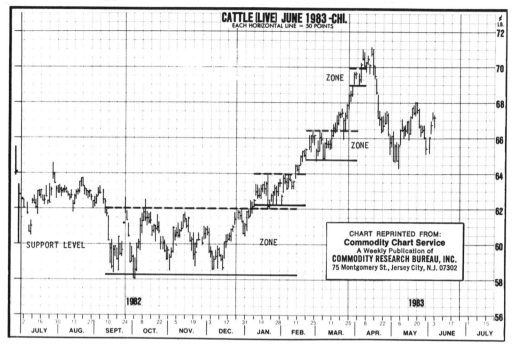

TRY THIS

What should you do if you are fundamentally bearish on a commodity and prices are right on top of a support area?

HERE'S WHY

You should wait for prices to penetrate a support level on the downside before establishing a short position. If a support area is penetrated, buying power at that price level is not sufficient to stem the decline. The market will probably decline to the next support area, wherever that may be. In planning your positions, always consider the nearest area of support, and then the next, and so on. Usually, the wider areas of support provide more buying power and more support.

Resistance Level

Resistance level is the point in a market that tends to level off advances. If the market is in a downtrend, the previously established congestion area in that downtrend is an area of resistance. Pretty much the same psychology applies to resistance levels as applies to support areas, only the shorts and the longs are reversed in their roles. Once a resistance area is penetrated in an uptrend, it then becomes the area of support to the following decline.

Pattern Identification

Among other things, analysts are able to identify a number of *price patterns*. These are price movements that, when charted, describe a predictable pattern. Some price patterns indicate a trend reversal; others reflect pauses or temporary reverses in an existing trend and usually form more quickly than reversal patterns.

Trends will always have a top or a bottom. A top occurs when selling pressure outweighs buying power. A bottom occurs when buying power overcomes selling pressure. These tops and bottoms usually follow one of a number of patterns. Some of these are described below.

Double Top (or M) Formation

A trader will see two peaks in relatively close proximity after an upward trend has been underway. This is an indication that a reversal of the uptrend may be about to begin—that the uptrend is leveling off and a downtrend is beginning. Refer to Figure 5-10.

FIGURE 5-10 Double Top Formation

Double Bottom

This is the opposite of the "M," or double top formation. The chartist will note two low points in the shape of a "W." This W formation, also called a *fulcrum*, usually signals the end of a downtrend and the beginning of an uptrend. See Figure 5-11.

Head and Shoulders

This pattern is a triple top formation similar to an M formation but with three points instead of two. The three peaks are very clearly shown in Figure 5-12, with the middle peak (head, D) higher than the ones before and after it (the shoulders, B and F). This situation usually occurs after an extensive advance and can mean that a major decline is forthcoming. The longer the formation takes to develop, the greater the decline anticipated. Let's examine further the details involved in the head and shoulders formation.

The first sign that a head and shoulders formation may be developing is a sharp rally followed by an extended advance and a subsequent reaction. The market usually reacts somewhat to the influence of a lot of profit taking after a sustained advance (points A to B in Figure 5-12); when an uptrend is drawn out, traders start closing out positions to cash in. If enough of them do so, the market starts turning downward a bit as a result of this sudden tendency to liquidate (B to C). Other traders, sensing a top, sell in order to "short the market," that is, sell at a top price and buy in at a lower price on the decline to come.

Of course, a certain amount of buying power develops in reaction to this decline. Some traders may wish to use this opportunity to add to their existing long positions, and others, who failed to take advantage of the advance earlier, may establish new long positions. The downward reaction (or correction) is thus arrested, and the market moves upward again (C to D).

The renewed advance exceeds the high of the previous move,

FIGURE 5-11 Double Bottom Formation

FIGURE 5-12 Head and Shoulders, or Triple Top, Formation

gaining momentum as previous short sellers (who are losers at this point) begin to cover (buy back their contracts) and thereby accelerate the upswing. But, as the market moves upward again, it encounters renewed profit taking as well as new selling, which induces another reaction (D to E).

This reaction carries below the uptrend line. At this point longs start selling again, and possibly new sellers give the downward swing an extra push. Prices usually carry to the most recent support level, which in this case is the low of the previous move (E).

Traders, recalling that this was a support area before, begin to buy again; recent sellers, realizing that the downward reaction is not following through (even though the uptrend was broken), begin to buy back their short positions. The market subsequently begins to rally (E to F) but falls short of the previous high and eases under increased selling pressure.

This time the price breaks through the support level, because the selling pressure has become so much greater than the buying power.

A major reversal follows. When prices penetrate the level of the two previous lows, the horizontal line on the graph defined by points C and E (often referred to as the *neckline)*, the market is reversing itself from up to down. The neckline is the trendline drawn to connect the two troughs between the peaks. A close below the neckline signals the completion of the pattern and an important market reversal. If your position is long, you should liquidate. If you were contemplating a short position but had hesitated because the market was in an upward swing, this is your cue to establish short positions and place a stop order to buy above F, or perhaps D, to minimize your loss.

Following a penetration of the neckline, an approximation of the possible extent of the downside move may be made by measuring the distance between the high of the head (D) and the neckline below the top of the head. Then extending this distance from the point at which the neckline was penetrated should lead you to the downside objective.

Inverse Head and Shoulders

As the name indicates, the opposite of a head and shoulders pattern is the inverse head and shoulders. This formation occurs at the bottom of a decline and indicates a major advance.

Simply picture the head and shoulders pattern upside down. Instead of an uptrend line, this pattern occurs during a downtrend. The same principles apply here as with the head and shoulders pattern.

The first sign that an inverse head and shoulders formation may be in the making is a sharp sell-off. After a sustained decline, a market usually rallies somewhat under the influence of profit taking (points B to C in Figure 5-13). The market rallies as the shorts buy in their contracts, taking profits, and as other traders, sniffing a bottom, buy. The rally picks up speed as demand increases and as buying power begins to absorb all the selling.

But as the market rallies, some traders use the opportunity to add to their existing short positions; others who failed to take advantage of the earlier decline establish new short positions. The upward rally or correction is arrested, and the market begins to move downward again (C to D). The market drops below the low of the previous move, gaining momentum as previous longs (who are losers at this point) begin to liquidate—sell back their contracts—thereby accelerating the downswing.

As the market moves downward, it again encounters renewed profit taking as well as new buying that causes another rally (D to E), which carries above the downtrend line. At this point new buyers enter the market, and short sellers again start to buy back their contracts.

Prices usually carry to the most recent resistance level (E), the high of the previous move. Traders who recall that this point offered resistance before begin to sell again. Recent buyers who realize that the upward reaction is not following through (even

FIGURE 5-13 Inverse Head and Shoulders Formation

though the downtrend was broken) begin to sell their long positions. The market subsequently begins to react (E to F) but falls short of the previous low. Instead, it rallies under increased buying power, this time carrying above the previous highs of the move. At this point buying power is more than enough to absorb all the selling.

Again, a major reversal follows. When the market advances above the neckline, the formation has been completed. The breakthrough is your signal that an uptrend is beginning. If you are short, you should cover your position. If you had considered taking long positions but were reluctant to do so because the market was in a downward tendency, establish your long positions at this point and place a stop order to sell just below the previous low point, either F or D. Figure 5-14 shows the charting of an actual inverse head and shoulders market situation.

TRY THIS

An inverse head and shoulders indicates the reversal of an advancing trend. True or False?

HERE'S WHY

False. An inverse, or inverted head and shoulders, is the mirror-image of a head and shoulders top. It indicates the bottoming out of a downtrend with a rally to follow.

Descending Triangle

A *descending triangle,* usually indicative of a decline, is a saw-tooth pattern (see Figure 5-15) in which the highs encounter successively stronger selling pressure, while the lows encounter consistently strong support at a particular price level. In this type of pattern, the support or buying power is limiting the decline to a certain price level, but offerings or selling pressure is cutting off rallies progressively lower; consequently, each subsequent rally falls short of the

FIGURE 5-14 Inverse Head and Shoulders Chart

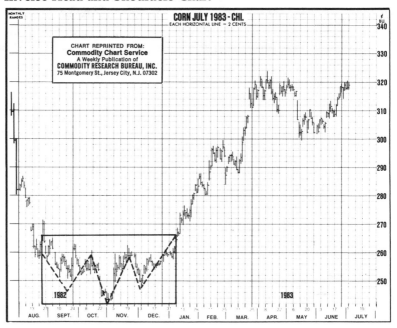

previous rally. Descending triangles are always considered bearish situations.

Figure 5-15 shows the market reaching a high for the current move (B). It then declines to C before selling pressure becomes weaker than buying power at B. However, the market encounters support at C, rallies to D [which is a lower high than the previous one (B)], and declines to E. Buying power once again exceeds selling pressure, and prices rally to F but cannot advance above the previous high (D). Again they decline. This time the market fails to meet support at the C and E level, as it had on two previous occasions. When this level is penetrated, the market has topped out, and the downtrend is beginning.

FIGURE 5-15 Descending Triangle

TRY THIS

What would happen if your position was long?

HERE'S WHY

If you were long, it would be prudent to liquidate your position when C and E are penetrated on the downside. If you had considered a short position but refrained because the trend was up, this penetration is your signal to start selling. Then place a stop order to buy above point F to protect your sale.

Ascending Triangle

An *ascending triangle* is a pattern in which the lows move progressively higher, while the highs encounter resistance at one price level. In this kind of pattern, overhead resistance or selling pressure limits the advance at certain price levels, but demand or buying power gets progressively stronger on each dip. Consequently, subsequent dips do not carry as far as previous reactions. An ascending triangle pattern is always considered bullish and is looked upon as a continuation in an uptrend but as a reversal in a downtrend. Likewise, the descending triangle acts as a continuation pattern in a downtrend but as a reversal formation in an uptrend. An example is shown in Figure 5-16.

TRY THIS

Referring to Figure 5-16, the ascending triangle, what is happening to the pattern?

FIGURE 5-16 Ascending Triangle

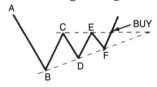

HERE'S WHY

In such a pattern where buying power is getting progressively stronger, the breakout is on the upside. As the lows get higher, a minor uptrend usually can be drawn connecting the lows (as shown by the dashed line in Figure 5-16). If the lows continue to get progressively higher and continue above the trend line, a wise trader should wait for the upside to break out into a new high ground before buying. Very often an extended advance follows.

Symmetrical Triangle

A combination of an ascending triangle and a descending triangle is known as a *symmetrical triangle* (see Figure 5-17). In this pattern, the highs get progressively lower as the lows of the moves get progressively higher. Each rally falls short of the previous high of the rally, because on each rally, selling pressure or offerings intensify. On the other hand, each dip falls short of the previous low of the reaction, because on each subsequent dip, buying power gets stronger. In a sense, this is a congestion area—a sideways movement without any clear trend evident. Sooner or later one of these groups (buyers or sellers) predominates and a new trend is established.

Flags

After a major trend has been underway, minor interruptions of the trend may occur and cause a pattern of up and down movements within a range. There is a point at which the major trend will resume. These points are *flags* (either upward or downward) and merely indicate readjustments to a new price level after a sharp run up or a decline.

FIGURE 5-17 Symmetrical Triangle

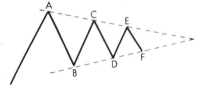

FIGURE 5-18 Upward Flag

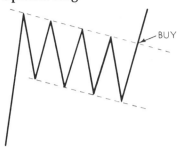

The upward flag, shown in Figure 5-18, usually develops in a major upward trend. Generally, it is not the end of a major move, merely a temporary interruption of it before the upward move resumes. Traders who wish to add to existing long positions or put on new longs should wait for the completion of the flag pattern and the subsequent upward breakout—that is, for a penetration of the minor downtrend line.

The downward flag, shown in Figure 5-19, develops in a major downtrend. The flag is usually a readjustment to the new price level after an extended sharp decline. It is not the end of a move, just a temporary interruption before the subsequent downtrend continues. The flag develops a minor uptrend channel within a major downtrend. Traders who wish to add to existing short positions or to put on new shorts should await the completion of the flag pattern and the downward breakout to confirm the resumption of the downtrend. The more congested the pattern, the more reliable the signal.

FIGURE 5-19 Downward Flag

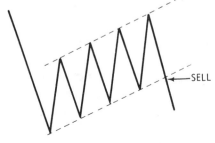

6

Volume of Trading and Open Interest

Volume of trading and open interest figures are two statistical areas that many investors prefer to leave to the technical analyst, who is generally more concerned with a market's strength or weakness than is a fundamentalist. If you are a fundamental market analyst, however, you are (or should be) just as concerned, because these figures frequently have a bearing on your findings. If open interest and trading volume numbers confirm a conclusion formed on the basis of your fundamental analysis, you have added reason to assume your analysis is sound. On the other hand, if these figures contradict your conclusions, you might want to carefully reexamine your appraisal of the fundamental factors. You may or may not change your opinion, but you will be alerted to a possible market risk that was not apparent on the basis of a straightforward fundamental analysis. These figures, therefore, can be of use to any commodity futures user.

It should be fairly obvious to you by now that the chartist typically regards price as a primary indicator, with volume and open interest as secondary indicators. To understand the significance of these two elements, let's define them.

Volume of Trading

Volume is the number of contracts traded in a given time period. That is, volume of trading is the total of purchases *or* of sales, not of purchases and sales combined. Since two must be party to each futures contract (the seller and the buyer), the total of all purchases is equal to the total of all sales.

> EXAMPLE: Mr. Able buys one contract of March sugar from Mrs. Baker. The volume of trading is one contract, not two contracts. Although Mr. Able buys one contract of sugar for future delivery and Mrs. B sells one contract, only one contract unit of sugar is involved.

The volume of trading in a commodity is compiled from data required in daily reports from exchange clearing members. It is commonly included in daily bar charts, sometimes on weekly charts, but usually not on monthly charts. Each clearing member of each exchange makes a daily report of all purchases and sales of commodity futures that it clears. A compilation of these reports gives the volume of trading in each commodity, for each market, and for each day. Every time a trade occurs during the day, volume goes up. It can stay the same as long as no trading takes place, but it cannot decrease.

TRY THIS

If a customer of Firm A buys 20 contracts of heating oil from a customer of Firm B, what will the reported trading volume be?

a. 10 c. 40
b. 20 d. 80

HERE'S WHY

The correct answer is (b). Only one side of each trade counts as volume. When the broker buys for a customer, the firm does not report a trade for its own account—only for the customer's.

As a general rule, volume is a gauge of the "pressure" behind a price movement. High volume generally indicates that the current trend had momentum and should persist. A lack of volume might be a sign that the trend is "losing steam."

Open Interest

A futures contract is said to be *open* when it has been neither liquidated by an offsetting transaction nor fulfilled by delivery. Open contracts are collectively referred to as *open interest*. A transaction can cause open interest to go up, down, or stay the same, according to the following summary:

Buyer	Seller	Change in Open Interest
Buys new long	Sells new short	Increases
Buys new long	Sells old long	No change
Buys old short	Sells new short	No change
Buys old short	Sells old long	Decreases

The amount of open interest for each commodity and contract market is tabulated every business day by exchange clearing members. The total of all long open contracts equals the total of all short open contracts that are reported. The open contract figures shown in the daily reports are for *one side only* (e.g., only the longs or the shorts), not for the long and short sides combined.

When trading in a new delivery month begins, no contracts exist. For example, when trading in the May 1986 corn delivery began in March 1985, there were no May 1986 contracts in existence. A commodity is unlike a "new issue" of stock in this respect. But as soon as someone executes an order to buy and someone else executes an order to sell short, one contract has been created. As other new buyers and other new sellers consummate trades, other contracts are created. This process of contract creation can go on to infinity.

EXAMPLE: Mr. Able establishes a long position by buying one contract of December cattle from Mrs. Baker, who sells short one con-

tract of December cattle; one contract is thus created. The open interest is now one contract. Then, another trader, Ms. Chillingsworth establishes a long position by buying one contract of December cattle from Mr. Dimlit, who is selling short; thus the open interest increases to two contracts, and the volume of trading totals two contracts for the day. Still another new buyer, Mr. Earner, and another new seller, Mrs. Flax, consummate a trade—and another contract is created. The open interest amounts to three contracts, and the volume of trading follows by exactly the same amount—three contracts. Mr. Able, Ms. Chillingsworth, and Mr. Earner are each long one contract for a total of three contracts, and Mrs. Baker, Mr. Dimlit, and Mrs. Flax are all short the same amount—one contract each for a total of three contracts.

Buys	Sells
Able	Baker
Chillingsworth	Dimlit
Earner	Flax
Three contracts	Three contracts

If Mr. Able decides to liquidate his long position by a subsequent sale on the same day, and if Mr. Gloo, a new buyer, purchases the contract that Mr. Able is selling, the open interest remains unchanged at three contracts. Mr. Able merely transfers his contractual obligation to Mr. Gloo. Thus, Mr. Gloo replaces Mr. Able on the long side of the market.

Buys	Sells
Chillingsworth	Baker
Earner	Dimlit
Gloo	Flax
Three contracts	Three contracts

Mr. Able, who originally bought and then sold, satisfies his contractual obligations. He has to neither take nor make delivery. The difference between his purchase and sales prices comprises his profit or loss. The open interest remains unchanged at three contracts.

But the volume of trading now totals four contracts.

On the other hand, however, if the contract that Mr. Able is liquidating is purchased by Mrs. Flax, a previous short who is covering her contract, the open interest would decrease to two contracts. The volume of trading, however, would still total four contracts. Both Mr. Able and Mrs. Flax are closing out their previously established contracts.

Buys	Sells
Chillingsworth	Baker
Earner	Dimlit
Two contracts	Two contracts

Ms. Chillingsworth and Mr. Earner are each still long one contract for a total of two contracts, and Mrs. Baker and Mr. Dimlit are still short one contract—each side for a total of two contracts.

TRY THIS

Customer A is long 10 contracts and Customers B and C are short 5 contracts each. If Customer A sells three of his contracts to Customer B, what is the change in open interest as a result of this transaction?

a. unchanged
b. −3
c. +3
d. +6

HERE'S WHY

The correct answer is (b). The open interest has declined by 3 as Customer A is now long 7 contracts, while Customer C remains short 5, with Customer B's position now short only 2.

Open interest therefore measures the flow of money into and out of the market. It increases when money is flowing into the market—that is, when a new purchase and a new sale are consummated. It decreases when a buyer and seller mutually close out their positions. Open interest also decreases when a short makes delivery and a long accepts it. By taking delivery, a long closes out the futures positions and initiates a cash position. And by making delivery, the short fulfills the contractual obligations and no longer has a position in futures.

TRY THIS

The open interest is the sum of open long *and* short positions. True or False?

HERE'S WHY

False. It represents *either* long *or* short positions which, by definition, must be equal. It may also be thought of as the number of open contracts that may be closed out by offsetting trades.

When interpreting open interest, the chartist must acknowledge its seasonality in agricultural futures. In any futures market, open interest will increase or decline for reasons associated with the nature of the underlying commodity or financial instrument. So all changes in open interest have to be compared against foreseeable seasonal moves before giving them weight as indicators of a trend. This is discussed later in this chapter.

The Statistics

The Commodity Futures Trading Commission issues open interest and volume of trading statistics for the commodities it regulates. These figures are expressed in standard units of trading. Both

types of figures are published daily in the financial sections of most large newspapers. And, of course, they are always available from a brokerage firm. Because of the time needed for data compilation, open interest and volume figures reflect the transactions two days before the date line of the newspaper. Usually the figures are broken down by commodity and then again by delivery month; for each month, the volume, the open interest, and the net change in open interest are listed.

An example of such a listing is shown in Table 6-1. The "volume" column represents the total of all purchases or of all sales for a particular day (day X). Total volume of trading on that day was 45,495,000 bushels, which means that 45,495,000 bushels were purchased and 45,495,000 bushels were sold.

The "open interest" column, 265,200,000 bushels, indicates that the total number of corn contracts outstanding as of the end of trading day X amounted to 265,200,000 bushels (265,200,000 bushels were held by longs and 265,200,000 bushels were held by shorts). The open interest in the March delivery was 75,370,000 bushels, the open interest in the May delivery was 85,490,000 bushels, and so on.

The figures under the column "net change open interest" reflect the change in open interest from the previous trading session for each delivery. For example, the open interest in the March delivery at the close of trading on day X was 75,370,000 bushels, which was down 5,290,000 bushels from the previous session. The open interest in the May delivery increased 30,000 bushels from the previous session. Although the open interest in all the deliveries (except the March delivery) increased on that day, the total open interest decreased by 3,620,000 bushels because the decrease in the March delivery was larger than the increase in all other deliveries combined.

TABLE 6-1 **Volume and Open Interest Report for Corn**

	Volume (1,000 bushels)	Open Interest (1,000 bushels)	Net Change Open Interest
March	22,455	75,370	−5,290
May	11,380	85,490	+ 30
July	10,030	81,120	+1,090
September	840	17,635	+ 75
December	790	5,585	+ 475
Total	45,495	265,200	−3,620

Since open interest figures represent contracts outstanding as of the close of trading each day, day trades (which are offset intraday) are, obviously, not included in the open interest tabulations. These day trades (both purchase and sales), however, are included in volume of trading figures.

Seasonal Influences

The open interest in agricultural commodities tends to increase and decrease in a more or less fixed seasonal pattern. This seasonal change follows the same general pattern as seasonal changes in the visible supply of a commodity—that is, in the amount in commercial storage. In the case of wheat and oats, for example, the open interest and the visible supply tend to be at a seasonal low just ahead of the new crop harvest in June and July; then both increase to a peak sometime in September or October. This peak coincides with the time that commercial warehouse stocks are largest and with the time that it becomes necessary to start using these stocks to meet domestic and export requirements. From this peak the open interest and the visible supply then decline seasonally to a low that is reached just ahead of the new crop movement. In corn and soybeans, the open interest and the visible supply reach a low in late August or September, increase to a peak in December or January, and seasonally decline into late August or September again.

These purely seasonal changes in the open interest are relatively unimportant in detecting technical market strength or weakness. However, the changes in the open interest that are most important in such deductions are the net changes after allowance is made for seasonal trends. There is no way to measure these net changes precisely, but you can usually determine whether open interest changes are greater or less than would be expected from just the seasonal phases. You can also tell if the change from the usual seasonal tendency is substantial or if it is relatively small.

Volume of trading has no seasonal tendency—at least none of importance. Trading volume tends to increase slightly during the period of heaviest new crop movement, but this is not pronounced enough to be of much concern to the trader.

Interpreting Changes

You know that the total open interest figures for a particular commodity—not the figures for individual futures months—are the ones used in determining probable price trends. Well, the same rule holds true for volume of trading. Changes in open interest and in volume of trading have forecasting value only when considered secondarily in connection with price change. Analysts who chart daily open interest and volume of trading figures usually do so at the bottom of a price chart showing daily high, low, and closing prices. Volume of trading is shown by vertical bars extending up from the base of the chart, and open interest is shown by dots (usually connected by a continuous line) extending across the chart from left to right on a separate scale just above the volume scale and below the price scale. Figure 6-1 illustrates how this chart looks.

FIGURE 6-1 Typical Chart Showing the Open Interest and Volume of Trading

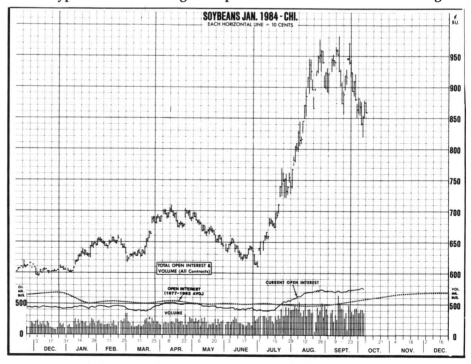

TABLE 6-2 Significance of Open Interest Changes

Volume	Open Interest	Prices	Activity	Market
Up	Up	Rising	New buying	Technically strong
Up	Up	Declining	New selling	Technically weak
Down	Down	Declining	Long liquidation	Strengthening
Down	Down	Rising	Short covering	Weakening

Some guidelines for forecasting probable market action on the basis of open interest and volume of trading figures are listed below and shown in Table 6-2.

1. If open interest and prices are both up: this is a sign of new buying and a technically strong market.
2. If open interest is up and prices are down: this indicates short selling or hedging and a technically weak market.
3. If open interest and prices are both down: this indicates long liquidation and a technically strong market.
4. If open interest is down and prices are up: this indicates short covering and a technically weak market.
5. If volume of trading expands on price strength and declines on price weakness: this indicates the market is in a technically strong position and should sell higher.
6. If volume of trading expands on price weakness and declines on price strength: this indicates the market is in a technically weak position and should sell lower.

These are by no means all the possible interpretations of volume and open interest but merely some of the more basic ones.

TRY THIS

Which of the following markets would be considered technically strong?

I. open interest up—prices up

II. open interest up—prices down

III. open interest down—prices up

IV. open interest down—prices down

 a. I and III only

 b. I and IV only

 c. II and III only

 d. II and IV only

HERE'S WHY

The correct answer is (b). Market (I) indicates technical strength because new buyers (and new short sellers) create an increased open interest. As prices are rising, it indicates that the new longs are more aggressive than the new (or existing shorts). Market (IV) is bullish because it indicates that the open interest tends to shrink on the downside, implying no pressure of new selling to replace those shorts taking profits on the declining market.

Sometimes at the end of a long advance or decline, sudden and dramatic market action will lead to a sharp reversal. When this occurs at the end of a prolonged uptrend, it consists of a great deal of buying, which causes prices to rise quickly, and is called a *blowoff*. In the case of a downtrend, it is called a *selling climax*, which is accompanied by much selling and, of course, sharp declines in prices. In either case, as volume picks up, open interest drops off. Under these conditions, be on the lookout for an abrupt reversal.

7
Hedging

In a very general sense, *hedging* is the counterbalancing of market commitments or positions to avoid or to lessen financial loss. In commodities, a natural hedging opportunity is built into the relationship between the futures market and the cash market. Since the prices in either tend to rise or fall more or less together, their parallel behavior can be used by a dealer to decrease the risk in commodities.

Hedging, like the futures contract, was born of risk. Anyone who has to grow, process, or in any way handle a commodity for eventual sale runs a risk as long as the materials are in his or her possession. If, during the period of possession, the market price declines sharply, the eventual sale could be at a price far lower than anticipated—lower perhaps than the total of the purchase and handling costs. In a word, the eventual sale could be a clear-cut loss.

The Concept of Hedging

To qualify as a hedger, both the cash market presence and the risk-reduction motive must be present. Let us consider several examples.

- A corn farmer who sells corn futures to protect the value of his crop prior to harvest. As a corn producer, the farmer is active in the underlying cash market. As an owner of this growing corn, the farmer is vulnerable to a price decline. His sale of corn futures protects against such a decline and therefore reduces his exposure to price fluctuations.

- A commercial bank that uses interest rate futures to reduce the maturity mismatch between its assets and its liabilities. As both a borrower and a lender of funds, the bank is clearly in the interest rate business. Depending on whether its loans have a shorter or a longer average maturity than do its deposits, the bank might need either to buy or to sell interest rate futures to reduce its exposure to interest rate fluctuations.

- A United States importer who buys Deutsche mark futures in connection with a forthcoming payment to his German supplier in the latter's currency. The importer will be paying for his supplies with Deutsche marks, so if this currency increases in value relative to the U.S. dollar, the importer would have to pay more for his Deutsche marks (and thus for his supplies). Therefore, the purchase of Deutsche mark futures reduces the importer's exposure to currency fluctuations.

The important point to note is that the central figure in each case meets both criteria for being deemed a hedger. These criteria are (1) a presence in the underlying cash market *and* (2) the use of futures in a manner that reduces risk. If the bank had sold soybean futures, it would not be considered a hedger because it has no involvement in the cash soybean market. If the corn farmer had *bought* corn futures, he would not be a hedger because he would be using futures to *increase* his exposure to price changes. This latter approach, which is essentially the opposite of true hedging, is sometimes called a "Texas Hedge." As the foregoing suggests, it is possible to be a hedger in some transactions and a speculator in others.

Without hedgers there would be no economic justification for futures and options. Hedgers provide actual goods and services to the economy. Futures and options enable them to provide these goods and services more efficiently.

Anyone whose business relies on a steady supply of commodities at a fairly steady price runs a risk, even though they do not

actually possess the materials. If a manufacturer, for instance, can inventory only so much of a raw material at one time, then every so often—say, every quarter—the manufacturer will have to purchase more raw materials. The company's budget, then, is based on a predetermined cost of raw material. If radical market price changes drastically alter the costs of these materials over a quarter of a year, the company could face costs that would either eat into its profits or drive the company's prices up, especially if there were forward sales of manufactured product at a fixed price.

Both parties may prefer to avoid the speculative risk and to simply take a normal service charge or markup on the goods. If so, both can protect themselves by taking a position in the futures market opposite to their positions in the cash market by either:

1. *Selling hedge:* Anyone who owns a commodity in the actual market and who is considered long (a buyer) simply sells a contract in the futures market (that is, becomes a short).

2. *Buying hedge:* Anyone who is expecting to purchase an actual commodity or who is committed to perform on a forward sale simply goes long (that is, buys a contract) in the futures market.

Because the actual cash price of a given commodity usually runs roughly side-by-side, up or down, with its counterpart price in the futures contract market, the commodity user can rely on this rule of thumb: *A loss in one market means a profit in the other, as long as opposite positions are maintained, one in each market.* Prices in both markets run parallel because both respond to the same stimuli of supply and demand. If the commodity owner sells the goods for a cash market loss, the futures position can probably be closed out for a profit. Likewise, the manufacturer who has to pay high cash prices for raw materials keeps the commercial deal profitable by closing out the futures position for a gain. The rule of thumb is rooted in the relationship of cash-to-futures prices called the "basis." The basis widens or narrows as the cash and futures prices fluctuate independently. It is this change that provides the foundation for hedging.

To a certain extent, selling hedges are matched one-for-one by buying hedges. However, in actual practice, seldom are two parties ready at precisely the same moment to initiate a futures contract. And to further complicate the trading, the quantities of the

two parties may differ. Or both may want to sell or to buy at the same time. Some hedgers therefore may not find others whose interests are in hedging. This is where the speculator comes in.

For the most part, the speculator carries the hedging load by assuming the risk and taking the opposite side of the contract. The speculator bridges the gap between the buying and selling hedgers. Further, a hedger uses the many speculators in the market as underwriters and the contract as an insurance policy. The risk is shifted from one person's shoulders and distributed in smaller parts among the many speculators.

EXAMPLE: A wheat dealer is long 5,000 bushels in his inventory. He sells an equivalent quantity, 5,000 bushels, in the futures market. He is now long and short at the same time—long in the cash market and short in the futures market.

Prices decline in both markets, just when the dealer is ready to sell. He sells the wheat for a cash market loss but then closes out the futures position for a corresponding gain. His inventory has been sold and his futures position closed out.

EXAMPLE: Shutterbug Films Company sells a large order of photographic film on a contract; it will take the company roughly nine months to fill the whole order.

Mr. Shutterbug, however, is worried about the increasing cost of silver and wants to make sure that when he buys the silver necessary to make the film, the cost will be within the range on which the contract was estimated and ultimately awarded. He, therefore, authorizes his financial officer to buy enough silver futures contracts (spread out over the nine months) to cover the needs of all outstanding production estimates.

Should the price of silver keep going up—out of the range of profitability for Mr. Shutterbug—the profits from the closed-out futures can make up for the losses in the cash market.

Selling Hedge

Most business persons are not in business to speculate on the rise or fall of commodity prices. Their profit is derived from some

service they provide that requires the handling of a commodity: To protect their profit margin, therefore, against a decline in the price of the actual commodity while it is in their possession, they hedge by selling the number of futures contracts approximately equivalent to the amount of actuals held. *Selling hedges* are used for basically three purposes:

1. *To protect inventories of commodities not covered by actual sales or by sales of its products.* The great bulk of the farmer's surplus grain moves through the country elevator on its way from the farm to the processor and then ultimately to the consumer. Unless the grain has been contracted for before delivery, the elevator buys the grain upon its arrival or receives it from the farmer for storage, with the sale to take place at a later date. As soon as title to the grain passes to the elevator, the elevator is exposed to risks of adverse price changes.

2. *To protect, or to earn, an expected carrying charge on commodities stored.* A country elevator operator with adequate storage space and grain of a grade deliverable on futures contracts may decide against selling immediately. Instead the operator stores the grain and sells a futures contract roughly equivalent to the grain stored. The contract is supposed to earn a carrying charge, that is, a reasonable return for storage, for certain costs in carrying the grain, and for interest, insurance, and shrinkage. The carrying charge is earned, of course, only if the futures contract price is far enough above the actual purchase price of the grain. Also, the hedge would ordinarily be placed in the deferred futures of the same crop year, as opposed to the nearby delivery. The deferred futures contract, under normal conditions, sells at a premium over both the near future and spot grain prices, and the price difference normally approximates the cost of carrying the grain to the deferred delivery month.

 The object of this kind of hedge is to cover the carrying charge anticipated at the time the hedge is placed. Although in some instances the actual grain is delivered against the futures contract to close out the hedge, in most cases delivery is not intended at all when the hedge is placed. For as soon as the elevator operator can find a profitable deal, he or she sells the grain and simultaneously buys back (or takes off) the hedge.

3. *To protect, or to ensure, a given price for prospective or estimated production of commodities.* Agricultural producers, or farmers, are exposed to rapid changes in demand for their products, and they are hard put to increase or decrease production to conform with changing economic conditions. Unlike manufacturers, who may slow down in periods of depression, farmers must continue to produce. At best, they may shift from one crop to another.

Risks are inherent in farming, and producers often look toward the futures market for price insurance on their prospective crops. Grain prices, for example, are higher on the average near the end of the crop year than immediately after the harvest. In late August, a farmer, estimating the upcoming crop to yield 20,000 bushels and satisfied with the prevailing price at that time for the December corn futures, can insure the value of the crop—approximately—by selling 20,000 bushels of this futures. When the crop is harvested and delivered for sale to the local elevator, the farmer removes the hedge by buying in the futures.

TRY THIS

Which of the following is NOT a purpose of a selling hedge?

a. To protect inventories acquired against a prior decline.
b. To earn carrying charges on commodities stored.
c. To ensure a given price for estimated production.
d. To earn a speculative profit on an anticipated price decline.

HERE'S WHY

The correct answer is (d). The hedger is essentially not a "speculator." However, a hedge may produce an overall profit, although it is incidental to the protective nature of position. For example, a wheat farmer places a selling hedge when cash is $4.00 and futures are at $4.20. If cash declines by $0.05 but futures drop by $0.08, the hedge will show a $0.03 basis gain (from -20 to -17). This would not only hedge the inventory loss but produce a $150 profit in addition.

Buying Hedge

A buying hedge is intended to protect against an advance in the price of the cash commodity (or its products) that has already been sold at a specific price but not yet purchased. Exporters and manufacturers commonly sell commodities or their products at an agreed-upon price for forward delivery. The forward delivery is said to be *uncovered* if the commodity is not on hand. The secret of success in a buying hedge is that initiating a futures position should coincide as closely as possible with the signing of a contract for actual forward sales. Timing is very important.

Insofar as buying hedges allow firms to make long-term commitments without having to carry large inventories, they prevent the tie-up of working capital for long periods of time and thus free these funds for other productive uses. Interest charges are also lower, because a firm needs to borrow less to meet its everyday needs. Buying hedges can, therefore, be considered a healthful stimulus to the economy as a whole.

Buying hedges are used, basically, for three purposes: to protect uncovered forward sales of a commodity or its products; to replace inventory at a lower cost; and to maintain prices on stable-price products. Each of these is discussed below.

1. *To protect uncovered forward sales of a commodity or its products.* The demand on manufacturers and processors often requires them to enter into contracts for the forward sales of their products, that is, sales in advance of actual production. A copper fabricator, who makes forward sales of rolled sheets, finds that he lacks the required inventory for production needed for the forward sale. To ensure a supply of copper at the price estimated in the sale, he hedges by buying futures contracts equivalent to the required amount of actual copper. Here's a good example to illustrate this premise.

 EXAMPLE: On June 15, Mr. Coprola obtains an order for a quantity of rolled sheets to be delivered on September 15. Based on the current price of merchant copper and his processing costs, he quotes a fixed price for the copper sheets and signs a contract for the delivery.

 However, the actual price of copper on June 15—the cash price— will not, in all probability, be the same three months later. In the

interim, demand may improve, or labor or political problems may curtail delivery of copper. Any number of events could raise the price of copper between June 15 and September 15. Enough of an increase could wipe out the profit margin. The forward sale that once looked so profitable could become a substantial loss.

Of course, the fabricator could purchase the copper when he first makes the contract, but he would have to tie up considerable working capital or pay interest charges for a bank loan; he would also have to pay insurance costs for three months and arrange to store the metal. Naturally, these costs would have to be included in the price of the sheets and would therefore raise the price of the finished consumer product.

The fabricator might also decide to speculate: He may have reason to believe that the price of copper will decline before the commodity is needed. In that case, he would decide not to hedge. If prices decline, he would make a windfall speculative profit. However, if prices advance, he could suffer a sizable loss.

In this case, however, the mill holds only two months' worth of production and the fabricator is not the speculative type. So he looks for price protection in the purchase of futures. Mr. Coprola utilizes the futures market and buys futures contracts in the amounts necessary to fill the order. Therefore, on June 15, he instructs his broker to buy 5 contracts of September copper at the market. He pays a price of 61.50 cents per pound for the futures contract, and the fabricator uses this price to establish a cost for the delivery of the rolled sheets in September. The fabricator, an experienced hedger, knows that the grade of copper he uses is one of the basic grades in the futures contract and the futures price will fluctuate with the cash price. The fabricator knows that the charges associated with a futures contract usually make acceptance of delivery uneconomical. More important, he cannot be sure that delivery against the futures contract will be in time for his production, since delivery of futures contracts is at the seller's option during the delivery period.

On August 4, one of his suppliers of copper offers him an attractive price of 64 cents per pound for the quality and quantity he requires. He accepts the offer and simultaneously sells his 5 contracts of September futures at 64.50, the going price. Copper prices rose during this period and the results of his hedge proved to be profitable. Although he loses 2½ cents on the forward sale transaction, this loss is more than offset by a 3-cent gain in the futures.

If the price of copper had declined instead of advancing, the fabricator still would not lose. He incurs a loss on his long position in futures, but he can buy the actual copper at a lower price. The gain in cash offsets the loss in futures. Not all hedges work out this perfectly, but they all protect manufacturers against major price moves.

	Cash	*Futures*
June 15	Sells rolled sheets that equate to 5 contracts of copper futures based on a price of 61.50	Buys 5 contracts of September futures at 61.50
August 4	Buys 125,000 lbs. of merchant copper at 64.00	Sells 5 contracts of September futures at 64.50
	Loss 2.50 ($3125)	**Gain** 3.00 ($3750)

The net profit is $625, less commissions.

2. *To replace inventory at a lower cost.* When distant-month futures are selling below the spot or below the nearby futures price, the merchant can sell off inventories at the relatively high spot price and replace them with lower-cost futures contracts for more remote deliveries, assuming he has no immediate need for the merchandise.

3. *To maintain prices on stable-price products.* Certain breakfast cereals, for example, show little price variation at the retail level. If distant deliveries are selling at discounts, producers can purchase their future raw material needs at levels that guarantee their normal business profit. In other words, futures trading allows processors to cover their raw material needs at their convenience and to their advantage instead of being forced to make purchases only at the particular time the actual commodities are available. This type of hedge also avoids storage costs and ties up only a minimum of working capital, because of the relatively small margin outlay required for futures transactions.

TRY THIS

Each of the following is a purpose for a buying hedge EXCEPT:

a. To protect uncovered forward sales.

b. To ensure inventory against adverse price action.

c. To replace inventory at a lower cost than current prices.

d. To maintain prices on stable-price products.

HERE'S WHY

The correct answer is (b). Inventories already acquired are endangered by price *declines* and are protected by short, or selling, hedges. Buying hedges are useful to offset price increases *before* the inventory is acquired.

The Advantages of Hedging

Hedging in the futures market can provide businesses with a number of important advantages. Most important among these are that hedging substantially reduces the price risks in dealing with commodities or financial instruments, does not interfere with normal business operations, allows greater flexibility in planning, and permits easier and greater financing. A more detailed discussion of each of these advantages follows.

1. *It substantially reduces the price risks that are involved in dealing with commodities or financial instruments.* Although it is not possible to completely eliminate risk, a properly executed hedge in a market that has a relatively stable basis eliminates much of the danger. Along these lines, hedging usually produces much greater stability in the financial performance of businesses. It tends to minimize the significant swings in profit that can be caused by fluctuating raw material prices, interest rates, or foreign exchange rates.

2. *Hedging does not interfere with normal business operations.* It allows for substantial price protection without the need for change in inventory policy or for engaging in inflexible principal-to-principal forward purchase or sale commitments.

3. *Hedging allows greater flexibility in planning.* Because futures contracts are available for many delivery months in the future, businesses can plan ahead and adjust schedules with greater

ease. A soybean crusher (someone in the business of buying soybeans and crushing them into the end products of soybean oil and soybean meal) can buy actual soybeans only when a farmer or a grain merchant is willing and able to sell. He or she might have to hold these beans until someone else is ready to buy one or both of the end products. It is rare that these two events would occur simultaneously. With futures, however, the crusher is able to manage financial exposure by the substitution of transactions in the futures market for opportunities that may not be available in the cash market. This helps make more efficient use of inventory excess or shortage.

4. *Hedging permits easier and greater financing.* In businesses where it is common to collateralize loans with commodity inventory, hedging plays a very important role. For unhedged commodity inventories, banks typically accept about 50% of the present value of the inventory as collateral for financing. In cases where the inventory is hedged in the futures market, financing can exceed 90% of the inventory's present value. This makes a big difference. For example, assume that a company has $1 million for inventory purchases. It could buy $2 million worth of unhedged inventory. The bank would be willing to lend $1 million, with the remainder coming from the company's own funds. If that same company committed itself to a hedging program in futures, the result could be enormously different. It might be able to buy $10 million of inventory—90% financed by the bank and the remaining $1 million coming from its own funds. It should be clear what effect this increased leverage would have on the potential for business expansion. A corollary benefit is, of course, that banks themselves have greater confidence in loans that are made against commitments hedged in futures.

The Risks of Hedging

Before deciding whether or how much to hedge, every business must first determine the sources and the sizes of the risks to which it is exposed. Price risks develop in a variety of ways, and price increases or decreases can jeopardize the profits expected from a business's inventory, both basic and modified, its anticipated pro-

duction, as well as the profits expected from any agreements the business has entered into to purchase or sell at a fixed price. Also, a business's future borrowing or lending requirements can expose it to interest rate risk, either up or down. Following is a brief review of each of these potential risk areas.

1. *Basic inventory.* This includes present holdings of physical commodities or financial instruments that have not been committed for future sale at a fixed price. These assets, such as copper in a warehouse or an inventory of bonds that are held by a government securities dealer, are subject to losses in value if prices decline. The assets may conform exactly to the specifications of the futures contract or they may not. In this latter category, copper of a somewhat different grade from that called for in the futures contract could still be hedged in the futures contract.

2. *Modified inventory.* This category includes physical commodities that have been transformed by processing or manufacturing, rendering them significantly different from the specifications of the futures contract. Examples might include pipeline inventories and work-in-process or finished goods inventories. The extent to which a commodity has been processed and separated from the standard delivery grade makes hedging in the futures market a less certain means of reducing risk.

3. *Anticipated production.* Future farm or mine output that has not been contracted for forward sale and that will be added to inventories once it is available falls into this category. In this case, the risk is that a price decline will undermine the profitability of the producing facility. In the extreme case, a decline in price to levels below the cost of production would actually result in a loss for every unit produced.

4. *Purchase agreements at a fixed price.* These include all forward contracts that commit the holder to take delivery of a commodity or a financial instrument at a fixed price. Such commitments are as vulnerable to price declines as are actual inventories.

5. *Future borrowing requirements.* Most businesses are subject to interest rate risk. This risk might take the form of the expected rollover of a loan or the need to borrow funds for expansion. Here a decline in the value of interest-bearing instruments (an increase in interest rates) would expose the business to risk.

In all the above cases, the potential hazard is a decline in prices. Each represents, in one form or another, a current or anticipated long position in the cash market that can be offset by the sale of futures contracts. Now consider two examples in which the risk is that prices might rise.

6. *Agreements to sell at a fixed price.* These are contracts that bind the holder to make delivery of a commodity, a commodity product, or a financial instrument at a future date at a predetermined price. For example, an importer of packaging machines from West Germany agrees to pay his supplier 50,000 Deutsche marks when delivery occurs three months in the future. During that time, should the Deutsche mark rise in value relative to the dollar, this cost in dollars will be greater than planned and would cut into whatever profit was expected from the purchase and the sale of the machine. In other words, the importer is short Deutsche marks.

7. *Future lending requirements.* This category covers expected cash inflows that will be lent out to cover interest costs. A drop in interest rates (a rise in the price of interest-bearing or discount instruments) results in reduced earnings. An example might be a portfolio manager who plans to roll over a $10 million investment in Treasury bonds that mature three months later. A decline in interest rates will cause the investment to be rolled over at a lower rate of return.

These are seven basic ways that risks arise in the cash market. Although there are many variations, most forms of risk fall into one or another of these. In the first five categories, the danger is that the prices of financial instruments or raw materials will fall. Each of those situations represents a long position in the cash market because it is a form of ownership, either present or future, to which the business is committed. In the last two categories, price increases are the danger. These categories represent short positions in the cash market because they entail commitments to make delivery of something that is not presently in inventory.

From this list of sources, it is obvious that a commitment in any of the first five categories could be offset, at least theoretically, by a commitment in one of the last two categories, without ever having to resort to the futures market.

For instance, the risk of holding inventory (category 1) in a climate of weakening prices can be offset by (a) actually selling off the inventory, or (b) arranging to sell the inventory directly to a user for future delivery at a fixed price. The risk of making forward sales at a fixed price (category 6) can be offset either by acquiring inventory now or by arranging for forward purchases from a producer at a fixed price.

Basis Risks in Hedging

As noted earlier, hedgers substitute one risk for another. They eliminate the price risks that are entailed in owning the actual commodity or financial instrument and accept the risk that is entailed in "owning" the basis. Hedging is useful if—and only if—the latter risk is meaningfully smaller than the former.

A *perfect hedge,* as it is known in the trade, is one that involves no change in basis. For example, a business buys 10 units of a commodity at $2.50 on October 15. It immediately establishes a hedge by selling 10 units of December futures at $2.75. Thus, the basis at the time the hedge is placed is 25 cents. One month later, the business sells all 10 units at $2.00, incurring a loss on the cash market position of 50 cents. If futures also have fallen 50 cents, the cash market loss is offset precisely by the futures market profit. Figure 7-1 helps to illustrate.

Because the basis did not change, the futures market provided perfect protection in this selling hedge. Needless to say, the real world provides few such perfect opportunities.

If the futures market had declined more than the cash market, the outcome might look as shown in Figure 7-2.

FIGURE 7-1 No Basis Change

Date	Cash Market Transactions	Futures Market Transactions	Basis
October 15	Buy 10 Dec. @$2.50	Sell 10 Dec. @$2.75	+ $0.25
November 15	Sell 10 Dec. @$2.00	Buy 10 Dec. @$2.25	+ $0.25
Result:	− $5.00	+ $5.00	
Net Result: $0			

FIGURE 7-2 Favorable Basis Change

Date	Cash Market Transactions	Futures Market Transactions	Basis
October 15	Buy 10 Dec. @$2.50	Sell 10 Dec. @$2.75	+ $0.25
November 15	Sell 10 Dec. @$2.00	Buy 10 Dec. @$2.20	+ $0.20
Result:	− $5.00	+ $5.50	

Net Result: $0.50

In this case, the 5-cent change in the basis produced a bonus. Not only did the hedge provide protection against the $5.00 loss that would have been incurred in the cash market, but the hedger actually made an additional 50 cents because futures declined faster than cash.

A widening of the basis would have had the opposite effect, as shown in Figure 7-3.

In the case of Figure 7-3, hedging provided substantial but incomplete protection against the loss in the cash market.

The outcome of any hedge can be determined simply by measuring the change in basis between the time the hedge is put on and when it is taken off. [To avoid confusion we have adopted the convention of using a plus sign (+) to signify that futures are above cash and a minus sign (−) to signify that futures are below cash. We also refer to a market in which futures are over cash as a *normal market*. One in which cash is above futures is referred to as an *inverted market*.] In Figure 7-2, the narrowing of the basis by 5 cents resulted in that amount of profit to the hedger.

FIGURE 7-3 Unfavorable Basis Change

Date	Cash Market Transactions	Futures Market Transactions	Basis
October 15	Buy 10 Dec. @$2.50	Sell 10 Dec. @$2.75	+ $0.25
November 15	Sell 10 Dec. @$2.00	Buy 10 Dec. @$2.30	+ $0.30
Result:	− $5.00	+ $4.50	

Net Result: − $0.50

Disadvantages of Hedging

Risks are often a part of margining futures in a volatile market. To better understand this, imagine a precious metals dealer with a 500-contract inventory of gold (50,000 ounces) and an offsetting position of 500 short futures contracts. If prices rise dramatically, say from $400 per ounce to $500 per ounce, the dealer will be faced with enormous variation margin calls that must be met with cash. No interest is earned on the cash that is used to meet these calls, and the inventory holdings generate no offsetting cash flow even though their value increases as prices rise. In this case, margin calls would approximate $5 million. The real interest or opportunity cost of this cash outflow would be $600,000 annually if the dealer could otherwise earn 12% on his capital. To minimize this cost, sophisticated hedgers make use of a practice known as *variation margin hedging* or *underhedging*. If the short position in futures is slightly smaller than the inventory, then rising prices will generate a net profit on the unhedged portion of the inventory. If this unhedged position is the correct size, this profit will come close to offsetting the variation margin interest loss in a climbing market. In a failing market, the interest gain from variation margin receipts will offset the loss in value of the unhedged portion of inventory.

Futures markets also have a number of other disadvantages, involving basis risk, costs, incompatibility of cash and futures, and limit moves, that should be understood. They are summarized here.

1. *Basis risk.* Because of basis changes, futures may not provide full protection against adverse price changes in the cash market. Basis risk increases the more the cash article differs from specifications of the futures contract.

2. *Costs.* Every futures transaction involves execution and clearing costs. Even when they are small, these fees can add up over time and should be monitored. There is, also, interest on the margins.

3. *Incompatibility of cash and futures.* Because futures contracts are standardized, they do not always match precisely the particular terms of a cash market commitment. Quantities may be larger or smaller than what the futures contract calls for, and quality may differ also.

4. *Limit moves.* Because futures trading can be restricted by daily trading limits, it may be impossible to establish or to liquidate hedges on particular days. This occurrence is rare but can cause considerable unease when it occurs.

Hedging Applications

The examples we've presented so far have turned out quite well. Not surprisingly, then, these examples are called *perfect hedges*—perfect in the sense that the cash and futures prices moved up and down by exactly the same amount, thus providing complete protection regardless of how high or low prices moved. The difference between cash and future prices, the *basis*, remained constant. However, the basis does change from time to time and from one location to another. Consequently, the changing relationship between cash and futures prices may at times result in additional profits or losses, depending on whether the basis changes in or against the hedger's favor.

Though the basis is variable, it is generally predictable. Cash and futures prices have a tendency to adjust to each other during the delivery period at the delivery point, because of the pressure caused by deliveries in the expiring futures.

The effectiveness of the hedge is governed by the cash-futures relationship at the time the hedge is established and by the subsequent narrowing or widening in the basis during the life of the hedge. How the basis affects hedging is best demonstrated by examples. Following are two such examples.

Selling Hedge in a Normal Market Followed by a Narrowing in the Basis

EXAMPLE: On October 1, a cotton spot merchant buys 100 bales (50,000 pounds) of cotton from a farmer at 60.00 cents a pound based on prices at a futures delivery point. He sells one contract of December futures at 62.00 cents a pound. The equivalent amount in the futures unit of trading is 100 bales of 500 pounds each. In grading the cotton the merchant determines it should be worth 75 points off (under) the December futures. The merchant's buying basis is said to be 200 points (2 cents) off December. He is unable to sell the cotton at his estimate of 75 points off at this time. By November 1,

the merchant finds a buyer at his price of 75 points off December
futures, which is now selling at 60.00 cents. The cash transaction is
therefore priced at 59.25 cents per pound. He "buys in," or covers,
his short hedge at the current futures price of 60.00 cents. Calcula-
tions for the transactions are:

	Cash	*Futures*
October 1	Buys 50,000 pounds cotton at 60.00 cents a pound $30,000.00	Sells 1 contract December futures 62.00 cents
November 1	Sells 50,000 pounds cotton at 59.25 cents a pound 29,625.00	Buys 1 contract December futures 60.00 cents
		2.00 cents
		(2 cents = 200 points with each point = $5)
	Loss $375.00	**Gain** $1000

Net profit is $625, less futures commissions.

The merchant fairly predicted what his profit would be because
he bought at 200 points off and sold at 75 points off the basis, or 125
points at $5 a point equals $625.

In actual business conditions, considerations of delivery point
differentials and detailed costs would apply.

The merchant's profit developed as a result of a narrowing in
the basis, that is, a narrowing in the difference between the cash
and futures prices. Although both the cash and futures prices
declined, the cash price did not decline as much as the futures
price. The cash market (in which he was long) declined 75 points
(75/100 of a cent), while the futures market (in which he was short)
declined 200 points (2 cents). He bought spot cotton and sold
futures when cash was 200 points or 2 cents off (under) futures;
then he sold cash and bought futures when cash was 75 points off
the futures. The basis narrowed from 200 points to 75 points. The
difference between his buying and selling basis is his profit, 125
points.

Thus, even though he sold the actual cotton for less than the purchase price, he made a profit because he used the futures market. If he had not hedged, he would have incurred a straight $375 loss on the cash transaction.

If cash and futures prices advance instead of decline, the results are basically the same, as long as the basis narrows.

Buying Hedge in a Normal Market Followed by a Narrowing in the Basis

If an elevator operator purchases futures as a hedge against a forward cash sale when futures are at a full carrying charge premium to cash, the hedge provides only partial protection against a price advance. The difference between the cash and futures prices must narrow by the amount of the carrying charges as the delivery period approaches. However, in this instance the basis movement is less important than the hedger's ability to anticipate basis when cash grain is acquired. Futures cannot maintain their premium above cash over the long run: Either they must move down into line with the cash prices, or the cash prices must advance to the futures prices. And the adjustment between cash and futures can take place in an advancing or declining market: If the market advances, cash prices must advance further than futures because they began from a lower level; conversely, if the market declines, futures must decline more than cash.

EXAMPLE: A miller buys March corn futures as a hedge on November 1, when futures are 20 cents above the cash price. The most that March futures can be at a premium to cash on December 1 is 15 cents, which is the cost of carrying from December to March. The price of cash advances from $2.10 to $2.20 by December 1, and the most that March futures can advance is from $2.30 to $2.35. The miller's buying basis is 20 cents under March futures and his selling basis is 15 cents under March futures, which results in a 5-cent loss in the basis. The loss in the basis develops because the cash price advances more than the futures price. Thus, as time passes, the buy hedger loses the equivalent of carrying charges. The purchase of futures protects the miller against 5 cents of the 10-cent advance in the cash price, but it does not protect him against the 5-cent change in basis. Despite the 5-cent loss on the hedge, his profit margin on the forward cash sale may be large enough to absorb this loss, and he may still make a profitable sale. At any rate, a 5-cent loss is better

than a 10-cent loss, which is what he would have encountered if he
had not hedged by buying futures.

	Cash	Futures	Basis
Nov 1	Sells 5,000 bushels No. 2 corn @$2.10	Buys 5,000 bushels March corn @$2.30	20 cents under March
Dec 1	Buys 5,000 bushels No. 2 corn @$2.20	Sells 5,000 bushels March corn @$2.35	15 cents under March
	− $0.10	+ $0.05	

Net loss is 5 cents per bushel, which is equivalent to $250, plus
commission.

The results are the same even if prices decline.

EXAMPLE: The miller buys March corn futures at $2.30 against a
forward sale at a price of $2.10, and the market subsequently de-
clines. The futures price has to decline farther than the cash price,
because the premium on the futures above the cash must decrease
by the equivalent of carrying charges as time passes. Thus, the price
of cash corn declines 10 cents to $2.00 by December 1, and the price
of futures declines 15 cents to $2.15. The 15-cent difference repre-
sents the full carrying charges between December and March.

	Cash	Futures	Basis
Nov 1	Sells 5,000 bushels No. 2 corn @$2.10	Buys 5,000 bushels March corn @$2.30	20 cents under March
Dec 1	Buys 5,000 bushels No. 2 corn @$2.00	Sells 5,000 bushels March corn @$2.15	15 cents under March
	+ $0.10	− $0.15	

Net loss is 5 cents per bushel, which is equivalent to $250, less
commission.

Although a buying hedge in a normal market protects against a price advance, it cannot give full protection over the long run because of the tendency for cash and futures prices to converge as the delivery period approaches. Large premiums on futures over cash spell potentially large losses. In addition, the longer the hedge is held, the more unprofitable it will be.

Other Hedging Applications

The outcome of hedges varies according to the circumstances. Other combinations of buying and selling hedges in an environment of widening and narrowing basis include:

- *Selling hedge in a normal market followed by a widening of the basis.* In this case the futures leg produces a smaller profit (or a greater loss) than does the cash leg.
- *Selling hedge in an inverted market followed by a narrowing of the basis.* In this case the futures leg once again produces a smaller profit (or greater loss) than does the cash leg.
- *Selling hedge in an inverted market followed by a widening of the basis.* In this case the futures leg yields a greater profit (or a smaller loss) than that of the cash leg.
- *Buying hedge in a normal market followed by a narrowing of the basis.* In this case the futures leg yields a smaller profit (or a greater loss) than the cash leg.
- *Buying hedge in a normal market followed by a widening of the basis.* This case will show a greater profit (or a smaller loss) in the futures leg.
- *Buying hedge in an inverted market followed by a narrowing of the basis.* In this case the profit (loss) in the futures position is larger (smaller) than that in the cash position.
- *Buying hedge in an inverted market followed by a widening of the basis.* Here the futures leg will produce a greater loss (or a smaller profit) than that of the cash leg.

TRY THIS

If the market is inverted, a short hedger profits when the basis widens. True or False?

HERE'S WHY

True. Suppose cash is at 53.45 and futures are at 52.00. The market is thus "inverted" as cash is over futures. A hedger shorts futures and is long cash at those prices, a basis of +1.45 or "1.45 over." If futures drop by 0.50 and cash drops by only 0.25, the basis has widened to +1.70 and the hedger has made more on the short futures than was lost on the long inventory.

Dealer Requirements

To understand some of the hedging requirements facing dealers in the futures market, we must first understand their role in this market.

Dealers are the intermediaries between producers and consumers. They play key roles in a market economy and are particularly important participants in the futures markets. A dealer is an organization (or person) that stands ready to buy or sell the items in which it deals whenever one of its customers requests. Dealers differ from brokers in that they act as principals in transactions and therefore use their own capital. Brokers act as intermediaries who match buyers with sellers but do not themselves take market positions. In a futures trading ring, the floor broker who executes an order on behalf of an FCM is acting as a broker. The local who takes the opposite side of the transaction into his own account is, in effect, acting as a dealer.

To understand the role that is played by dealers in the cash markets, let us begin by visiting an imaginary world in which there are only a producer and a consumer. Assume that we have Corporation A in California that wants to issue 10-year debt and we have pension fund Manager B in Houston who is considering buying 10-year corporate debt. If the two are in regular contact, or if they happen to stumble across one another at exactly the right moment, then the corporation might place its 10-year paper directly with the investor. In the real world, however, this is not likely. Corporation A probably does not have the staff to monitor the capital markets continuously for prospective investors, and Manager B in Houston may have no direct access to information from the California corporate arena.

This is basically a problem of communications and information flow. The two parties simply do not know about each other. If this is the only problem, a broker could provide the solution because a broker's job is to monitor both sides of a market continuously so as to bring together seller and buyer (or, in this case, issuer and investor). In real life, though, communications are often not the only obstacle. Corporation A may need funding this week, whereas Investor B may not have funds that are available until existing investments mature in two weeks. We have seen how Corporation A could use the futures markets to hedge against a rise in interest rates prior to the issuance of this debt. But what if its cash flow requirements are such that it needs actual funds rather than merely protection against rate increases? Neither a cash market broker nor a position in the futures markets can address this problem. This is a job for a cash market dealer.

A dealer would be prepared to use its own capital to purchase Corporation A's debt. In doing so, it would be acting as financial intermediary rather than as end-investor. If Investor B had indicated a willingness to pay $1,000 for $1,000 face value of Corporation A's debt, then the dealer might bid $990 as principal in the hope of reselling the paper to Investor B in two weeks at a $10 profit. The dealer is, in effect, making a two-sided market in Corporation A's 10-year debt: $990 bid/$1,000 offered. The dealer differs from an investor in that he is not buying the paper because he perceives it to be an attractive long-term investment. Rather, he believes that he can earn a profit by quickly reselling the debt issue. The dealer differs from a broker because he is committing his own capital rather than simply matching issuer and investor.

The dealer's $10 profit (or dealing spread) represents compensation for the service of providing liquidity by bridging the time gap between the need for funds by the issuer and the availability of funds from the investor. This service is of value, though, only if the dealer is willing to bid for debt when Corporation A wants to issue debt. If our dealer bids only when he himself wants to, he will soon find himself going out of business. Issuers will either find another dealer who is more responsive to their timing needs or turn to the less costly broker market if dealers are not providing sufficient added value in the form of timing flexibility. If either of these things happened, our original dealer would quickly lose ground among investors as well because he would tend to have a smaller inventory of products from which investors could select at any given time.

This need to be responsive to their customer's timing requirements puts dealers in a position of only limited control over their cash market positions and exposures. Returning to the example above, if the dealer feels that Investor B may change his mind about buying Corporation A's 10-year debt then he, the dealer, might lower his own bid to $985 or $980 because of the perceived additional risk. But if he wants to maintain his relationship with Corporation A, he will not often withdraw his bid entirely nor lower it to a level that would seem frivolous or insulting. This means that in the course of servicing his issuing client, our dealer will sometimes find himself owning inventory that he does not really want and is not particularly confident about being able to resell quickly at a profit.

The basic concept to keep in mind is this: A dealer must be responsive to customers on both sides of his market, and this responsiveness will often force him into long or short positions that he does not really want. What we have discussed applies to dealers in a wide variety of markets. Though we have focused on the specific example of a bond dealer, the same concepts apply as well to dealers in any other market. An international bank must be prepared to give its customers bids and offers for the major currencies. A grain merchant must stand ready to buy from farmers and must also maintain sufficient inventory at various locations to meet unexpected export demand. The specifics vary from business to business, but in every case a dealer must develop and maintain relationships with producers and consumers. At any point in time the dealer's cash market exposure—long, short, or neutral—is determined, in good measure, by his attempts to service his customer base.

The nature of a dealer's cash market business flow creates specialized futures requirements. Two of these requirements deserve particular attention. First, a dealer shares with producers and consumers the desire to reduce his exposure to price fluctuations. However, a dealer's exposures are likely to fluctuate more rapidly as he buys from producers and sells to consumers. An active dealer might make several dozen or more cash market transactions each day. If he wants to keep his futures hedges current, he will need to adjust them at least several times daily and perhaps even after each cash market trade. This contrasts with the hedging requirements of nondealers, whose futures positions tend to change much less frequently. Again, the reason is the more varied cash market

activities of dealers relative to other market participants. Dealers are forced to consider many more cash market items and basis relationships than are most producers and consumers.

EXAMPLE: A fixed-income portfolio manager might typically confine his attention in the corporate bond sector to one or two dozen issues that he either already owns or is considering buying. However, a corporate bond dealer must be prepared to quote markets in any of the hundreds of issues that are followed by one or more of his customers. Both the manager and the dealer will likely use the highly liquid futures on U.S. Treasury securities to hedge their cash market positions, so each cash market corporate security corresponds to a basis relationship that should be understood and monitored.

EXAMPLE: A copper mining company need concern itself only with the basis relationships that involve the grades and locations of the ores that it produces. On the other hand, a copper dealer purchases many different grades and locations. Each physical market grade/location combination is another basis relationship that the dealer must follow.

An understanding of basis relationships is important to dealers for another reason as well. Dealers' profit margins are narrow relative to those of other hedgers, so basis mishaps can have especially bad consequences. Consider these examples:

EXAMPLE: Corn farmers typically expect average selling prices to exceed production costs by 50 cents per bushel or more. (This does not always happen but is a reasonable average over many seasons.) Grain dealers, on the other hand, expect average net profit margins of 1 cent per bushel or less. Consistently leaving ½ cent to ¾ cent per bushel on the table through ill-timed basis positions would probably go unnoticed by the farmer but would be devastating for the dealer.

EXAMPLE: An investor in over-the-counter securities probably expects to make at least several dollars per share and perhaps much more when he buys a $40- or $50-per-share stock. The over-the-counter dealer who sells him the stock would be delighted to realize a 50-cent-per-share margin on the purchase and resale of the security. Clearly, the dealer needs a much keener understanding of the relationship between the stock and the particular equity futures index in which it is hedged.

The unique hedging requirements of dealers create the need for special futures trading capabilities. Dealers need to understand these in order to operate profitably.

TRY THIS

Which of the following is ordinarily true of hedging margin requirements?

a. They are the same as regular (speculation) margins.
b. They are greater than regular margins.
c. They are less than regular margins.
d. There are no margins required for bona fide hedge accounts.

HERE'S WHY

The correct answer is (c). Hedging margins are generally lower than speculative, or "regular," margins because of the hedgers' involvement in the cash markets—that is, they are capable of making or taking delivery—and also because the hedger's financial position is normally perceived as being more substantial than that of the typical speculator. Furthermore, hedgers usually have a position approaching neutral, while speculators are net long or short—a riskier position.

Strategy Summary

In hedging, these are important points to remember:

1. When hedges are placed in a normal market and the spread narrows, the selling hedger gains and the buying hedger loses.
2. When hedges are placed in a normal market and the spread widens, the selling hedger loses and the buying hedger gains.
3. When hedges are placed in an inverted market and the spread narrows, the selling hedger loses and the buying hedger gains.

4. When hedges are placed in an inverted market and the spread widens, the selling hedger gains and the buying hedger loses.

TRY THIS

Each of the following is correct EXCEPT:

a. In an inverted market, a widening basis profits a short hedger.
b. In a normal market, a narrowing basis profits a short hedger.
c. In an inverted market, a narrowing basis profits a long hedger.
d. In a normal market, a narrowing basis profits a long hedger.

HERE'S WHY

The correct answer is (d). In a normal market (futures over cash), a narrowing basis profits the *short hedger* because cash rises faster than futures.

8

Trading Techniques: Speculation and Spreading

As we have discussed in the previous chapter, a hedger is someone who trades futures with the intent of providing a type of price insurance to reduce risk associated with a cash position, long or short.

A speculator, on the other hand, is someone willing to trade in the futures market, taking on the risk that the hedger has passed on, with the intent of making a profit.

Speculators provide the futures market with a great deal of liquidity, thus enabling hedgers to spread their risk over a number of willing speculators.

Speculators put up what is called *risk money* in anticipation of a profit. Attractive profits can be made by investing in the commodities market. One reason for this is that commodity markets require a relatively small margin. Instead of the 50% margin required to trade in stocks, a commodity trader is usually required to put up no more than 5% to 10%. Such low margins give trades tremendous leverage. The other side of this coin, of course, is that small fluctuations can wipe out a trader's equity, and large fluctuations can generate terrible losses.

A more sophisticated type of speculation is called *spreading*. This is the purchase of one commodity future and the simultaneous sale of another. A spreader buys the delivery that appears relatively underpriced and at the same time sells the delivery that appears relatively overpriced. Traders engage in spreading when they feel the price relationship will either narrow or widen. As time passes, they hope the futures assume a relationship that will create a profit. But, more about spreading later on. Let's concentrate first on the concept of speculation.

Speculation

The relationship between hedgers and speculators often typifies the purpose of futures trading—the shifting of risk to those who are willing to assume it.

Speculators have good reason to look to commodities trading for expectation of profits. Commodity trading offers unique opportunities for quickly making more money than does almost any other investment venture.

And, contrary to popular beliefs, these profit opportunities are open not only to professional traders and to those with a lot of money, but also to those with limited risk capital and to those with no special knowledge of commodity markets. The commodity trader who follows sound trading practices (even an amateur who devotes relatively little time to trading) can realize an average annual return that is considerably better than what you can expect from most capital ventures.

Making such large profits possible, of course, is the relatively small margin required to trade in commodities.

Commodities become particularly attractive when you consider the many ways in which risk can be curbed and controlled. Usually such high returns are associated with high risks. But don't be fooled: The risks connected with commodity trading are not small, nor should you expect to make money in commodities unless you understand how to evaluate and limit the existing risks. The truth of the matter is that commodity trading is a high-risk field—necessarily so. The potential for large profits implies that potential for large losses as well.

But the risks that exist in commodity trading are not constant; while they may be large or small in a particular trade, depending

on the situation and the timing of market commitments, they do average out over time. Because of this, knowledgeable traders—who follow sound trading practices—are able to lessen their risk potential by averaging it out over a sufficient number of trades; at the same time their increasing knowledge and experience in the market enable them to maintain a sound profit margin.

Commodity trading can never be reduced to an exact science because prices are influenced by so many factors that cannot be measured precisely. As a consequence, no single method or combination of methods guarantees a profit on every trade. Such a guarantee is impossible, and the experienced trader is well aware of it.

All you can do, therefore, is carefully evaluate and limit risks—and follow sound trading practices. Not even the practices discussed in this book will enable you always to be right on the market. *Nothing will.* But, if followed, they will prevent you from being subjected to serious losses on those occasions when the market does not perform as you expect. At the same time, they should enable you to be right a large enough percentage of the time to make trading commodities profitable.

Considerations Before Entering the Market

Four basic rules observed by successful speculators that will help you to trade successfully are:

1. *Adopt and follow a definite trading plan.* It is best to decide on a plan, be it a fundamental or technical approach (as discussed in Chapter 5), or a combination of the two.
2. *Trade conservatively with money you can afford to risk.* When trading in futures, you should have trading capital equal to or at least double the minimum margin required by a broker. This additional capital does not have to go into the account, but it should be available and set aside for trading when needed.
3. *Never risk all the trading capital on any one situation.* To be a successful trader you must spread or diversify risk by participating in various situations over a period of time.
4. *Never make demands on trading profits to meet regular expenses.* In order to remain an objective trader, you must not require a certain amount of profit from trading for living expenses.

Getting Started

When initiating a futures position the following guidelines may prove helpful.

1. *Make a careful analysis of the fundamentals.* See which situation has the best profit potential. Refer to Chapter 5 to better understand the fundamental approach when analyzing the direction of the market trend.
2. *Then, project the extent of the market trend.* Refer to Chapter 5 again for technical forecasting. Keep in mind areas of support and resistance.
3. *Weigh risk versus profit potential and transaction cost.* It does not make sense to take on a high-risk situation in the hopes of a modest profit.

 EXAMPLE: You anticipate that the extent of an upward move could result in a $600 gain. The nearest logical place to put a sell-stop order is below the area at which you contemplate buying. That point allows for a $200 loss, and your profit potential is three times your risk. On the other hand, if the profit potential appears to be $200 and the nearest area to place a sell stop results in a $200 loss, your risk versus your profit potential makes the transaction hardly worth undertaking.

4. *Determine that the timing is right for entry into the market.* Refer here to the section on technical/chart analysis in Chapter 5.
5. *Don't undertake either a long or short position until you have a clear-cut view of the market trend.*
6. *Don't anticipate a trend.* Wait until a trend has started before initiating a position.

After Establishing a Position

Once you have established a position in the market, try to keep in mind the following.

1. Stop orders and stop-loss orders can be used to minimize a loss in the event the market moves against a position.
2. You should maintain a position as long as the market trend continues to be favorable to your position.

3. Don't let a position influence your decision to stay or to get out. Should a trend develop that is against your position, don't hesitate to sell or buy to get out of your position. Don't be stubborn.

4. Don't attempt to pick tops or bottoms. When a position begins to work, traders should alter stop protection to protect profits or to minimize losses. Use a *trailing stop*—that is, when long, keep moving the sell stop to a higher level to keep up with the market's advance in order to protect profits. The reverse would be appropriate when short.

EXAMPLE: Refer to Figure 8-1. You buy soybeans at $5.90 (B) and place a protective sell stop at $5.87 (SS). The price of soybeans subsequently advances to $6.00 (B1), but you feel prices will move higher and want to hold your position. At the same time, you do not want to lose your profit. To protect your profit, you cancel your original sell stop at $5.87 and raise it to (SS1)—just below the market at $5.97. You are willing to risk 3 cents of your profit against the possibility of additional profits.

If the market drops to $5.97 (your stop price), your stop order to

FIGURE 8-1 Stop Protection

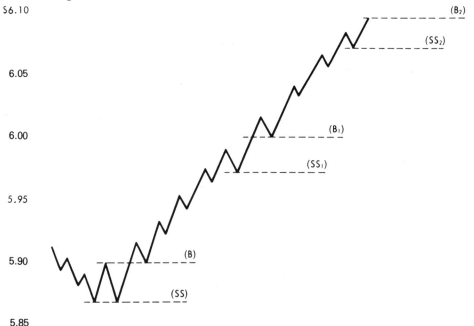

sell immediately becomes a market order to sell and your broker must sell at the best price he can get. You would be stopped out of your position with approximately a 7-cent profit.

Prices continue to advance from $6.00 (B1) to $6.10 (B2) and they do not activate your stop price. You cancel your sell-stop order at $5.97 (SS1) and raise it again to $6.07 (SS2) to protect your profit, thus keeping pace with the market's advances.

Although raising a sell-stop order to protect a profit on a long position is justified as the market continues to move in your favor, you should not cancel or lower your stop when the market moves against you and approaches your stop price. This policy disregards the very protection that stops are supposed to provide.

TRY THIS

A trader established a long Eurodollar deposit position at 87.97. If the market is now at 90.25, where should a sell-stop order be placed to protect the profit and continue participation in an uptrend?

a. 87.97

b. 89.95

c. 90.24

d. 90.50

HERE'S WHY

The correct answer is (b). A sell stop must be far enough under the market not to be touched off by a minor reversal, but not so far under as to give back the profit already achieved. The stop at 89.95 locks in 198 ticks, or thereabouts. The stop at 90.24 obviously locks in another 29, but is so close to the market it is virtually a market order. Any trade just one tick down will trigger the order and preclude further upside participation.

Trading Techniques for the Speculator

Different trading techniques are commonly used by the speculator. Some of them are discussed in the following paragraphs.

Averaging Down (or Up)

When a market moves contrary to an established position, some people tend to add to their long positions. They hope to obtain a lower average price so that when the market recovers, they will break even at a lower price. This is known as *averaging down*. The same principle applies to *averaging up*, but in reverse: Shorts sell more in an upward trend to break even.

Many traders feel that averaging down allows them to escape unharmed at a lower level. In actuality, averaging down is increasing the risk of a situation that is not working. This concept is illustrated in Figure 8-2.

> EXAMPLE: You buy one contract of May potatoes at $4.50. The market goes down to $4.40, and you feel that buying a second contract at $4.40 would give you a lower average price. Your rationale is really, "The deal is bad, so now I'll be able to break even if the price gets back up to $4.45." The danger, however, is that if the market continues to decline to $4.30, you are then losing 15 cents on each of the two contracts, instead of 20 cents on one.

Usually, adding to your position is logical only after your first commitment shows a profit.

Pyramiding

When the market is moving in your favor, you may at times want to add to your position. This practice is known as *pyramiding*. This can be a highly successful operation, if conducted according to a sound trading plan. Most successful traders generally follow two rules in adding to their positions:

1. Don't add to your position unless your existing position is showing a profit.
2. The number of contracts added to your position should be no larger than your base (generally your initial position), and it should become proportionately smaller as the market continues to move in your favor.

FIGURE 8-2 Averaging Down

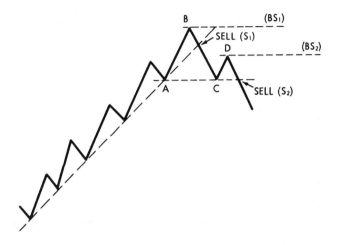

EXAMPLE: By pyramiding, according to these two rules, you increase your commitment, as shown in Figure 8-3. You initiate your position by buying five contracts at $4.40. The market advances to $4.45, and you buy an additional four contracts, bringing your total position to nine contracts. Your average price on nine contracts is now $4.42 + . The market advances to $4.50, and you buy another three contracts, bringing your cumulative total position to twelve contracts and your average price to $4.44 + . As the market advances to $4.55, you buy another two contracts, bringing your total to fourteen contracts and the average price to about $4.46. Again the market gains, this time to $4.60, and you pick up one more contract for a total of fifteen. Your final average price on fifteen contracts is now around $4.47.

FIGURE 8-3 Pyramiding

		Average
$4.60	x	4.46⅝
$4.55	x x	4.45¾
$4.50	x x x	4.44⅛
$4.45	x x x x	4.42¼
$4.40	x x x x x	4.40

By pyramiding in this manner, the average price of all your contracts will be at a level well below the prevailing market. If the market moves against the position, you are not seriously affected and are given ample time to liquidate at a profit.

Another version of pyramiding is to establish a position in small and increasing increments. Once you have established the desired base (the maximum number of contracts to be bought at a particular price level), further additions should be no larger than the base.

TRY THIS

The practice of adding new long positions at prices lower than an initially established position is best described as:

a. pyramiding
b. averaging down
c. trailing stops
d. none of these

HERE'S WHY

The correct answer is (b). This is often regarded as throwing good money after bad. In any event, it lowers the break-even point if the market rebounds. For example, a trader buys gold at $350 whereupon it dips to $340. By buying another at $340, he now breaks even at $345, and a return to the original purchase price shows a profit of $10 overall (+ $10 on the $340 purchase and even on the $350 purchase).

TRY THIS

Pyramiding involves adding to an existing position in *increasing* increments. True or False?

HERE'S WHY

False. Such pyramiding is inherently unstable. Rather, the trader should add in *decreasing* increments, which leaves the bulk of the position in profitable status in the event of temporary reverses. The base of the pyramid needs to be wider than the apex.

Buying and Selling: Premiums vs. Discounts

Once you have decided to be either long or short, you must decide *which delivery month*—a near month or a month with an extended delivery. Different strategies regarding delivery in both normal markets and in inverted markets are summarized below.

1. In an inverted market, the near maturity is trading at a *premium* to the distant maturity. Should you wish to initiate a *long position*, it is usually more advantageous to buy a more distant month, which is selling at a discount to the closer month. If you wish to initiate a *short position*, you should sell the near month rather than the distant.

2. In a normal (carrying charge) market, the near contract month is trading at a *discount* to the distant maturity. Should you wish to establish a *long position*, you should buy a relatively near month rather than the distant month. To buy the distant maturity would mean also paying for the premium at the time. If you wish to establish a *short position*, however, sell the distant delivery, which is at a premium to the shorter-term deliveries.

In both strategies, if you anticipate that the position will take some time to work out, it would be inappropriate to take a position in a near month where you would soon be faced with the question of delivery.

Spreading

As we mentioned earlier, spreading is the purchase of one commodity future against the simultaneous sale of another. A spreader buys the delivery that appears relatively underpriced and simultaneously sells the delivery that appears relatively overpriced. A trader undertakes this dual transaction when he or she feels that the prices of the two futures contracts are not in line with one another and expects that the *spread relationship*—the difference in price between the two "legs"—will change. When it changes, the trader realizes a profit or suffers a loss because of the adjustment in the relative prices of the two contracts.

Spread vs. Price Levels

When spreading, traders are often not concerned with the overall direction of the market. Rather, their interest is only in the narrowing or widening of the price difference between the two contracts. So, when a spreader enters an order, prices at which the contracts are to be executed are not specified. Only the *price difference* between the two contracts is specified.

Types of Spreads

There are four basic types of spreads: interdelivery spreads, intermarket spreads, intercommodity spreads, and commodity product spreads.

1. *Interdelivery spreads.* This type of spreading operation involves the purchase and sale of *different delivery months* in the same commodity in the same market: for example, the purchase of October cotton and the sale of December cotton.

 This spread takes advantage of deviations in the price difference between different delivery months. In this case the trader purchases the contract that is relatively undervalued and sells the contract that appears to be relatively overpriced. The profit is made when the price difference adjusts itself and the trader closes his positions.

 Depending on whether the market is normal or inverted, there are different types of spread situations. In some cases, the risk and profit potential can be defined.

 In a *normal market*, the nearby maturity sells at a discount to the distant delivery. The trader buys the nearby maturity and sells the distant maturity in anticipation of a *narrowing* in the spread difference.

 EXAMPLE: On October 19 the price of the March corn delivery is 9 cents below the July delivery—March is $2.16½ and July is $2.25½ per bushel. You feel that the price of the March delivery is underpriced in relationship to the July—or that the July is overpriced compared to the March delivery—and you expect the spread difference to narrow. In other words, you feel that either the March delivery will gain relative to the July delivery or the July will decline relative to the March delivery. You simultaneously buy the March delivery and sell the July delivery.

After establishing the spread transaction at a 9-cent difference, the price difference between the two contracts narrows to 4 cents by December 9, and you decide to take profits. You simultaneously liquidate both contracts (called *unwinding* the spread) and realize a profit of 5 cents. When you liquidate, or close out, the spread, you do just the opposite of what you did originally. Since you originally bought 5,000 bushels of March corn and sold 5,000 bushels of July corn, now you sell 5,000 bushels of March corn and buy 5,000 bushels of July corn. Your profit is calculated as follows:

October 19	Buy 5,000 bushels March corn @ ...$2.16½	Sell 5,000 bushels July corn @.............$2.25½
December 9	Sell 5,000 bushels March corn @ ...$2.25½	Buy 5,000 bushels July corn @.............$2.29½
	Profit +$0.09	**Loss** −$0.04

Net return is 5 cents per bushel, which is the equivalent of $250, less commission.

In this case, the *risk is limited* to the difference between the current spread difference and full carrying charges of the distant delivery. On the other hand, the *profit potential is unlimited*.

As time passes, the nearby delivery may gain on the distant delivery and may even move to a premium over the price of the distant month. It is, however, rare for this to happen. If, on the other hand, the spreader expects the relationship to widen, he should sell the nearer contract and buy the more deferred. The profit is potentially great, limited only by the carrying charges.

In an *inverted market*, the nearby delivery sells at a premium to the distant delivery. The trader sells a nearby delivery and buys a distant delivery when anticipating a narrowing in the spread. *Risk is unlimited.*

EXAMPLE: The March delivery is at a 5-cent premium to the July delivery. You think that the March delivery will widen its premium above the July, so you decide to buy the March and sell the July. If March advances relative to July, you will make a profit.

You buy the March delivery at $2.16½ on October 19, then sell it at $2.25½ on December 9, realizing a profit of 9 cents per bushel. On these same dates, you sell July at $2.11½ and cover your position at

$2.16½, resulting in a 5-cent loss. Despite this 5-cent loss on your short position in the July delivery, your profit of 9 cents on the long March is more than enough to produce a net profit. Your overall profit on the transaction is 4 cents, less commission.

October 19	Buy 5,000 bushels March corn @ ... $2.16½	Sell 5,000 bushels July corn @ $2.11½
December 9	Sell 5,000 bushels March corn @ ... $2.25½	Buy 5,000 bushels July corn @ $2.16½
	Profit + $0.09	**Loss** − $0.05

Net profit is 4 cents per bushel, which is the equivalent to $200, less commission.

The trader sells a nearby delivery and buys a distant delivery in anticipation of a narrowing in the spread difference, or even elimination of the premium. *Profit potential is limited* to the original spread plus the maximum carrying charge. The *risk is unlimited* because the nearby delivery, which the trader is short, can go to any price above the distant delivery.

2. *Intermarket spreads.* This spreading operation involves the purchase and sale of the same commodity in the same or different delivery months but in two *different markets:* for example, the purchase of September wheat on the Kansas City Board of Trade and the sale of September (or any other delivery month) wheat on the Chicago Board of Trade. In this case, the trader uses the price relationships between exchanges rather than the price differences between months on the same exchange.

However, when using different exchanges, the intermarket spreader must consider several additional factors in analyzing spread possibilities. Four things to consider before engaging in intermarket spreads are:

a. *Transportation costs between the markets.* Grain normally moves from west to east. In other words, wheat moves from the major surplus-producing areas of the West, either Kansas City or Minneapolis, to the deficit-producing areas of the

East. Consequently, the price of wheat in Chicago is usually higher than the price of wheat in Kansas City or Minneapolis because of the transportation cost. This may, of course, vary.

b. *Different deliverable grades.* Each market tends to reflect the price of the type of wheat grown most abundantly in that particular area. The Kansas City Market is primarily a hard red winter wheat market, whereas Minneapolis is a spring wheat market and Chicago is a soft red winter wheat market. More specifically, the futures market in each area tends to reflect the price of grades of wheat deliverable on its particular exchange. For example, hard winter wheat that is deliverable on the Kansas City Board of Trade cannot be delivered on the Minneapolis Grain Exchange, which calls for delivery of spring wheat. Both classes of wheat—winter and spring—are deliverable on the CBOT.

c. *Local supply-and-demand conditions.* Although wheat is produced in many parts of the country, growing conditions may be altered within the same season by the vagaries of weather. While the Southwest may produce a bumper crop, the crop in the Midwest around Chicago may be relatively poor because of unfavorable weather. Similarly, the crop in the Northwest around Minneapolis may be good, and the crops in either (or both) the Southwest and the Midwest may be poor.

d. *Liquidity of each market.*

3. *Intercommodity spreads.* This spreading operation involves the purchase and sale of *different, but related, commodities* in the same or different markets and in the same or different delivery months: for example, the purchase of March corn on the CBOT and the sale of March oats on the CBOT. Another example is the purchase of March wheat on the Minneapolis Grain Exchange and the sale of May corn on the CBOT.

For instance, since corn and oats are interchangeable animal feeds, their respective prices should reflect this relationship. When corn prices are higher than oat prices, the use of corn in livestock feeding tends to slacken, and the use of oats tends to increase. This shift in utilization causes the price of oats to gain on the price of corn, moving toward a more normal price relationship.

EXAMPLE: A bushel of oats weighs 32 pounds, whereas a bushel of corn weighs 56 pounds. Therefore, on a strictly weight basis, a bushel of oats should be worth approximately 57% of the value of a bushel of corn. However, the feeding value of oats per pound is about 3% better than that of corn. Consequently, the price of oats is normally about 60% of the price of corn on a bushel basis. Therefore, when the price of oats is 60 cents per bushel, the price of corn should be about $1 per bushel.

4. *Commodity product spreads.* This type of spread involves the purchase of the raw material and the sale of the derived processed products, or vice versa; for example, the purchase of March soybeans on the CBOT and the sale of March soybean oil and March soybean meal on the CBOT; or the sale of March soybeans and the purchase of March soybean oil and March soybean meal on the CBOT.

When the value of the processed products widens or narrows in relationship to the raw material, it may present an arbitrage, or spread, opportunity. The relationship between the raw material and the value of the product is called *gross processing margin*. The gross processing margin is either plus (or positive) if the value of the products is larger than the price of the raw material, or minus (or negative) if the value of the product is less.

If the trader anticipates a decline in the value of the products relative to the price of the commodity, he will buy the raw material future and sell the product future. In soybeans, this is called a *crush spread*. If the trader thinks that the value of the products will gain relative to the commodity, he will buy the products and sell the commodity. This transaction is referred to as a *reverse crush spread*.

In a *crack spread*, the trader buys an energy commodity, such as crude oil, and takes the reverse action in the product, such as a refinery product. The number of commodity contracts is proportionate to the number of product contracts.

TRY THIS

In an inverted market, if the trader expects the spread to narrow, she should buy the deferred contract and sell the near. True or False?

HERE'S WHY

True. When the spread in an inverted market is expected to narrow, the spreader follows exactly the opposite course of a spreader in a normal market.

TRY THIS

Which of the following is an *interdelivery* spread?

a. long September Kansas City wheat—short September Minneapolis wheat
b. long August soybeans—short October soybean meal
c. short September wheat—short March wheat
d. long March GNMA—short September GNMA

HERE'S WHY

The correct answer is (d). "Interdelivery" spreads deal with the same commodity and the same exchange but with different *delivery* months. Note that while (c) has different delivery months, it involves *two short* positions, not one long and one short, which is what a spread is.

TRY THIS

A reverse crush is a product spread in which the trader is long soybeans and short soybean meal and oil. True or False?

HERE'S WHY

False. Reverse crush is a product spread in which the trader is short soybeans and long soybean meal and oil. An improvement in the gross processing margin is anticipated.

9

Futures
Markets

From its beginnings in the mid-1800s, formalized futures trading
has grown to encompass a large family of commodities and finan-
cial instruments. Today's domestic futures industry encompasses
major U.S. exchanges that provide the setting for active trading in
futures contracts on approximately 80 different commodities and
financial instruments. There are new contracts being added con-
stantly and some being dropped for lack of activity. In recent years,
trading on these exchanges has exceeded 100 million contracts
annually, with a still growing value of more than $10 trillion.
Outside the United States, futures trading takes place in exchanges
located in a variety of cities including London, Hong Kong, Tokyo,
Paris, Singapore, Sydney, Sao Paulo, and Winnipeg, to mention
the more important ones.

Figures 9-1 through 9-5 provide some perspective on the
growth of futures trading in recent years and on the distribution of
this trading among the various products and exchanges. This
information covers U.S. futures markets only.

FIGURE 9-1 Volume of Futures Trading

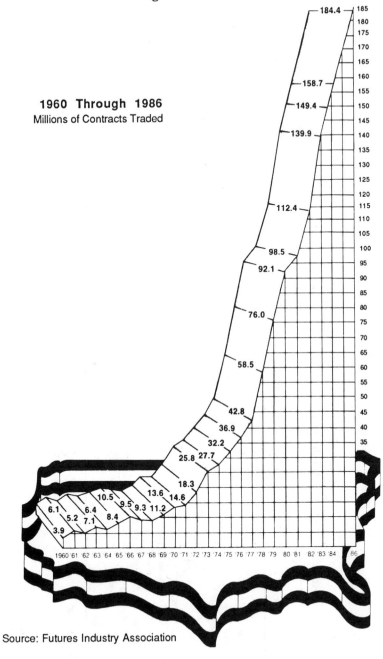

1960 Through 1986
Millions of Contracts Traded

Source: Futures Industry Association

FIGURE 9-2 Futures Volume Highlights—1986 Compared with 1985

Rank	Exchange	1986		1985		Rank
		Contracts	%	Contracts	%	
1.	Chicago Board of Trade	81,135,634	44.01%	70,553,897	44.46%	(1)
2.	Chicago Mercantile Exchange	59,831,171	32.45%	52,115,247	32.84%	(2)
3.	New York Mercantile Exchange	14,644,413	7.94%	7,831,765	4.94%	(4)
4.	Commodity Exchange, Inc.	14,174,698	7.69%	15,116,655	9.53%	(3)
5.	Coffee, Sugar & Cocoa Exchange	5,535,081	3.00%	4,582,878	2.89%	(5)
6.	New York Futures Exchange	3,182,992	1.73%	2,833,614	1.79%	(6)
7.	MidAmerica Commodity Exchange	2,368,547	1.28%	2,485,166	1.57%	(7)
8.	Kansas City Board of Trade	1,716,686	0.93%	1,959,138	1.23%	(8)
9.	New York Cotton & Citrus Exchange	1,477,590	0.80%	915,547	0.58%	(9)
10.	Minneapolis Grain Exchange	284,586	0.15%	300,911	0.19%	(10)
11.	Chicago Rice & Cotton Exchange	3,098	.00%	1,760	0.00%	(11)
	TOTAL	184,354,496	100.00%	158,696,578	100.00%	

Source: Futures Industry Association

FIGURE 9-3 Futures Contracts Traded by Commodity Group

Rank	Commodity Group	Contracts	Percentage
1986			
(1)	Interest Rate	70,202,183	38.08%
(2)	Ag Commodities	38,276,714	20.76%
(3)	Equity Indices	26,462,813	14.35%
(4)	Foreign Currency	19,352,161	10.50%
(5)	Precious Metals	14,692,890	7.97%
(6)	Petroleum Products	12,869,624	6.98%
(7)	NonPrecious Metals	1,927,481	1.05%
(8)	Other	570,630	0.31%
	TOTAL	184,354,496	100.00%
1984			
(2)	Interest Rate	41,221,424	27.60%
(1)	Ag Commodities	48,860,126	32.71%
(4)	Equity Indices	18,442,464	12.35%
(5)	Foreign Currency	14,000,857	9.37%
(3)	Precious Metals	18,880,269	12.64%
(7)	Petroleum Products	4,619,533	3.09%
(6)	NonPrecious Metals	2,589,518	1.73%
(8)	Other	758,034	0.51%
	TOTAL	149,372,225	100.00%
1982			
(2)	Interest Rate	28,825,112	25.64%
(1)	Ag Commodities	46,310,209	41.20%
(5)	Equity Indices	4,911,121	4.37%
(4)	Foreign Currency	8,690,285	7.73%
(3)	Precious Metals	18,809,458	16.73%
(7)	Petroleum Products	1,875,414	1.67%
(6)	NonPrecious Metals	2,362,625	2.10%
(8)	Other	616,655	0.55%
	TOTAL	112,400,879	100.00%

Source: Futures Industry Association

FIGURE 9-4 Futures Volume Highlights—1986 Compared with 1985

Rank	Contracts With Volume Over 100,000	1986		1985		
		Contracts	%	Contracts	%	Rank
1.	T-Bonds, CBT	52,598,811	28.53%	40,448,357	25.49%	(1)
2.	S&P 500 Index, CME	19,505,273	10.58%	15,055,955	9.49%	(2)
3.	Eurodollar, CME	10,824,914	5.87%	8,900,528	5.61%	(3)
4.	Gold, COMEX	8,400,175	4.56%	7,773,834	4.90%	(4)
5.	Crude Oil, NYMEX	8,313,529	4.51%	3,980,867	2.51%	(11)
6.	Deutsche Mark, CME	6,582,145	3.57%	6,449,384	4.06%	(6)
7.	Corn, CBT	6,160,298	3.34%	6,392,812	4.03%	(7)
8.	Soybeans, CBT	6,133,668	3.33%	7,392,128	4.66%	(5)
9.	Swiss Franc, CME	4,998,430	2.71%	4,758,159	3.00%	(9)
10.	Live Cattle, CME	4,690,538	2.54%	4,437,327	2.80%	(10)
11.	T-Notes (6½-10 yr), CBT	4,426,476	2.40%	2,860,432	1.80%	(15)
12.	Japanese Yen, CME	3,969,777	2.15%	2,415,094	1.52%	(19)
13.	Silver (5,000 oz), COMEX	3,849,687	2.09%	4,821,206	3.04%	(8)
14.	Sugar #11, CSC	3,583,814	1.94%	3,012,929	1.90%	(14)
15.	No. 2 Heating Oil, NY, NYMEX	3,275,044	1.78%	2,207,733	1.39%	(21)
16.	Soybean Oil, CBT	3,182,963	1.73%	3,647,408	2.30%	(12)
17.	NYSE Composite Index, NYFE	3,123,668	1.69%	2,833,614	1.79%	(16)
18.	Soybean Meal, CBT	3,049,005	1.65%	3,339,268	2.10%	(13)
19.	British Pound, CME	2,701,330	1.47%	2,799,024	1.76%	(17)
20.	Wheat, CBT	2,090,316	1.13%	2,127,962	1.34%	(22)
21.	Live Hogs, CME	1,936,864	1.05%	1,719,861	1.08%	(24)
22.	Copper, COMEX	1,872,209	1.02%	2,444,552	1.54%	(18)
23.	T-Bills (90-day), CME	1,815,162	0.98%	2,413,338	1.52%	(20)
24.	MMI Maxi, CBT	1,738,916	0.94%	422,091	0.27%	(39)
25.	Platinum, NYMEX	1,624,635	0.88%	693,256	0.44%	(31)
26.	Pork Bellies (frozen), CME	1,100,339	0.60%	1,457,386	0.92%	(25)
27.	Coffee "C", CSC	1,073,142	0.58%	650,768	0.41%	(33)

	Contracts With Volume Over 100,000	1986		1985		
Rank		Contracts	%	Contracts	%	Rank
28.	Cotton #2, NYCE	1,015,392	0.55%	636,492	0.40%	(34)
29.	Value Line Index, KCBOT	953,985	0.52%	1,204,659	0.76%	(26)
30.	Municipal Bond Index, CBT	906,980	0.49%	334,691	0.21%	(41)
31.	Leaded Reg. Gasoline, NY, NYMEX	829,733	0.45%	667,172	0.42%	(32)
32.	Cocoa, CSC	777,765	0.42%	800,573	0.50%	(29)
33.	Wheat, KCBOT	744,023	0.40%	735,447	0.46%	(30)
34.	Canadian Dollar, CME	734,071	0.40%	468,996	0.30%	(36)
35.	Soybeans, MIDAM	680,156	0.37%	843,231	0.53%	(28)
36.	Silver (1,000 oz), CBT	511,239	0.28%	1,034,830	0.65%	(27)
37.	Lumber, CME	502,530	0.27%	581,548	0.37%	(35)
38.	T-Bonds, MIDAM	467,639	0.25%	297,033	0.19%	(43)
39.	Unleaded Gasoline, NY, NYMEX	439,352	0.24%	132,611	0.08%	(48)
40.	Feeder Cattle, CME	411,441	0.22%	455,881	0.29%	(38)
41.	Corn, MIDAM	406,694	0.22%	456,661	0.29%	(37)
42.	Wheat, MIDAM	344,749	0.19%	347,355	0.22%	(40)
43.	Wheat, MGE	283,900	0.15%	297,509	0.19%	(42)
44.	Orange Juice (frozen, conc.), NYCE	211,543	0.11%	190,758	0.12%	(44)
45.	Dollar Index, NYCE	166,494	0.09%			
46.	Palladium, NYMEX	145,562	0.08%	133,223	0.08%	(47)
47.	Oats, CBT	140,952	0.08%			
48.	Gold (Kilo), CBT	124,546	0.07%	168,527	0.11%	(45)
49.	Swiss Franc, MIDAM	102,019	0.06%	110,047	0.07%	(49)
	Contracts with Volume Over 100,000 Contracts*			2,201,971	1.38%	
	Contracts with Volume Under 100,000 Contracts	832,603	0.45%	1,142,090	0.72%	
	TOTAL	184,354,496	100.00%	158,696,578	100.00%	

*Contracts over 100,000 traded in 1985 but not over 100,000 in 1986.
Source: Futures Industry Association

FIGURE 9-5 Commodity Futures Contracts Traded 1982–1986, by Exchange

	Contract Unit	1986	1985	1984	1983	1982
Wheat	5,000 bu	2,090,316	2,127,962	2,974,886	3,886,914	4,031,584
Corn	5,000 bu	6,160,298	6,392,812	9,108,526	11,924,576	7,948,257
Oats	5,000 bu	140,952	99,024	155,110	359,825	424,595
Soybeans	5,000 bu	6,133,668	7,392,128	11,362,691	13,680,324	9,165,520
Soybean Oil	60,000 lb	3,182,963	3,647,408	4,009,548	3,858,558	3,049,313
Soybean Meal	100 tons	3,049,005	3,339,268	3,822,179	3,872,453	2,784,423
Plywood	76,032 sq. ft.			4,466	50,424	100,001
Silver	5,000 oz				21,470	77,682
Silver	1,000 oz	511,239	1,034,830	1,887,257	2,643,166	775,136
Gold	100 oz				4,133	19,515
Gold	Kilo	124,546	168,527	302,717	302,745	
GNMA Mrtges, CDR	$100,000	24,078	84,396	862,450	1,692,017	2,055,648
GNMA II	$100,000			37,615		
Cash Settle GNMA	$100,000	7,351				
T-Bonds	$100,000	52,598,811	40,448,357	29,963,280	19,550,535	16,739,695
T-Notes (2-year)	$100,000				562	
T-Notes (6½-10 yr)	$100,000	4,426,476	2,860,432	1,661,862	814,505	881,325
Domestic CD (90-day)	$1,000,000					145,360
Unleaded Reg. Gasoline	1,000 bbl				51,573	8,736
Crude Oil	1,000 bbl			628	94,591	
Heating Oil	1,000 bbl				3,152	
Municipal Bond Index	$1,000 x Index	906,980	334,691			
Major Market Index	$100 x Index	36,292	2,062,083	1,514,737		
MMI Maxi	$250 x Index	1,738,916	422,091			
NASDAQ-10C	$250 x Index	3,743	139,888			
Chicago Board of Trade		81,135,634	70,553,897	67,667,952	62,811,523	48,206,790

Currency Futures

The Foreign Exchange Market

The foreign exchange (FX) market is a vast global activity encompassing all transactions in which the currency of one country is exchanged for that of another. An American tourist exchanging dollar bills for local currency at a hotel or a store is a small participant in a market whose players include exporters and importers, multinational corporations, central banks, and all financial and nonfinancial institutions that, in the course of their activities, receive or disburse a variety of currencies. Each day more than $300 billion flow between the major bank and nonbank dealers of Europe, the Far East, and the United States.

Historically, most foreign exchange transactions were trade-related. For example, if a Swiss exporter sells a machine to an American buyer, the American's dollars must be changed into Swiss francs, because this is the currency sought by the supplier of

FIGURE 9-5 (continued)

	Contract Unit	1986	1985	1984	1983	1982
Fresh Eggs	22,500 dz					18
Potatoes	80,000 lb					9
Live Hogs	30,000 #	1,936,864	1,719,861	2,169,030	2,790,746	3,560,974
Pork Bellies, Frozen	38,000 lb	1,100,339	1,457,386	1,908,045	2,403,277	2,811,674
Live Cattle	40,000 #	4,690,538	4,437,327	3,553,270	4,248,152	4,440,992
Feeder Cattle	42,000 lb	411,441	455,881	316,985	537,173	603,769
Broilers	30,000 lb					2,118
Lumber	130,000 bd. ft.	502,530	581,548	753,568	731,003	516,619
Plywood	152,064 sq. ft.					35
Gold	100 oz		7	8,841	994,132	1,533,466
Leaded Regular Gas	1,000 barrels			4,045		
No. 2 Fuel Oil	1,000 barrels			4,601		
T-Bills (90-day)	$1,000,000	1,815,162	2,413,338	3,292,817	3,789,864	6,598,848
Domestic CD (90-day)	$1,000,000	3,062	84,106	928,662	1,079,580	1,556,327
Eurodollar (3-month)	$1,000,000	10,824,914	8,900,528	4,192,952	891,066	323,619
European Currency Unit	125,000	43,826				
British Pound	25,000	2,701,330	2,799,024	1,444,492	1,614,993	1,321,701
Canadian Dollar	100,000	734,071	468,996	345,875	558,741	1,078,467
Deutsche Mark	125,000	6,582,145	6,449,384	5,508,308	2,423,508	1,792,901
Japanese Yen	12,500,000	3,969,777	2,415,094	2,334,764	3,442,262	1,762,246
Mexican Peso	1,000,000		12,737	15,364	40,308	65,036
Swiss Franc	125,000	4,998,430	4,758,159	4,129,881	3,766,130	2,653,332
Dutch Guilder	125,000				162	128
U.S. Silver Coins	$5,000					1
French Franc	250,000	2,685	9,335	8,388	26,348	16,474
S&P 500 Index	$500 x Index	19,505,273	15,055,955	12,363,592	8,101,697	2,935,532
S&P 100 Index	$200 x Index	3,514	1,662	166,202	390,902	
S&P OTC 250	$500 x Index	5,270	94,919			
Chicago Mercantile Ex.		59,831,171	52,115,247	43,449,682	37,830,044	33,574,286

the machine. Traditionally, therefore, the growth of foreign exchange activity was tied to the growth of international trade.

Major participants in this exchange include commercial and investment banks, central banks, the trade sector, and the capital sector.

The commercial and investment banks are equipped to buy or to sell foreign currencies for their commercial customers and correspondent banks, as well as for the international banking activities of their own institutions. They also trade foreign exchange as a profit-making activity. The activities of these major dealers help even out the temporary excesses of supply and demand that inevitably emerge from thousands upon thousands of individual transactions each day.

Central bank operations encompass government transactions, transactions with other central banks and various international organizations, and intervention that is intended to influence exchange rates. The latter is one of the most important factors in

FIGURE 9-5 (continued)

	Contract Unit	1986	1985	1984	1983	1982
Rice, Milled	120,000 lb				275	5,262
Rice, Rough Old	200,000 lb		9	2,978	11,964	11,253
Rice, Rough New		3,095				
Cotton	50,000 lb				1,004	8,388
Cotton Short Staple	50,000 lb	3	1,751			
Soybeans	5,000 bu				197	1,998
Corn	5,000 bu				102	971
Chic. Rice & Cotton Ex.		3,098	1,760	2,978	13,542	27,872
Coffee "C"	37,500 lb	1,073,142	650,768	499,133	427,441	556,435
Sugar #11	112,000 lb	3,583,814	3,012,929	2,449,549	3,201,968	2,037,020
Sugar #12	112,000 lb	19,058	99,851	109,448	84,120	51,093
Sugar #14	112,000 lb	72,526	17,433			
Cocoa	10 M tons	777,765	800,573	1,127,752	1,162,540	607,964
CPI-W	$1,000 x Index	8,776	1,324			
Coffee, Sugar & Cocoa		5,535,081	4,582,878	4,185,882	4,876,069	3,252,512
Copper	25,000 lb	1,872,209	2,444,552	2,506,365	3,186,914	2,362,625
Silver	5,000 oz	3,849,687	4,821,206	6,742,508	6,432,982	2,868,639
Gold	100 oz	8,400,175	7,773,834	9,115,504	10,382,805	12,289,448
Aluminum	40,000 lb	52,627	77,063	82,661	11,896	
Commodity Exchange		14,174,698	15,116,655	18,447,038	20,014,597	17,520,712
Wheat (5,000 bu)	5,000 bu	744,023	735,447	956,668	942,971	964,815
Value Line Index	$500 x Index	953,985	1,204,659	910,956	724,979	528,743
Mini Value Line	$100 x Index	18,678	19,032	30,179	25,092	
Kansas City Bd. of Trd.		1,716,686	1,959,138	1,897,803	1,693,042	1,493,558

determining both short-term and, arguably, long-term currency exchange rates.

Transactions made by the trade sector are, usually, made in connection with the purchase or sale of a product, service, or financial asset across country lines.

The capital sector includes investors and speculators. These transactions differ from those of the trade sector in one major way: They relate to investment rather than to the purchase or sale of a product or service.

Fundamentals of Price Determinants

Since money is the most important commodity, exchange rates between the currencies of different countries are determined by the interaction of supply and demand. Increase the supply of a

FIGURE 9-5 (continued)

	Contract Unit	1986	1985	1984	1983	1982
Wheat	1,000 bu	344,749	347,355	404,508	334,413	243,640
Corn	1,000 bu	406,694	456,661	604,992	629,678	274,324
Oats	1,000 bu	2,169	1,746	7,067	11,797	12,981
Soybeans	1,000 bu	680,156	843,231	1,301,916	1,171,294	527,411
Soybean Meal Old	20 tons	3,231	10,981			
Soybean Meal New		2,256				
Live Cattle	20,000 #	58,752	64,510	81,112	88,349	107,329
Live Hogs	15,000 #	80,818	74,388	112,877	108,069	175,624
Refined Sugar	40,000 lb			24	3,306	24,000
Silver	1,000 oz	649	4,510	19,497	96,611	125,409
New York Silver	1,000 oz	9,342	57,886	12,611	30,833	3,810
Gold	33.2 oz	0	76	41,690	349,044	383,499
New York Gold	33.2 oz	21,111	31,467	19,285		
Platinum	25 oz	5,944	1,368	213		
Copper	12,500 lb	892	4,043	492		
Copper High Grade		1,753				
T-Bonds	$50,000	467,639	297,033	251,300	267,259	419,277
T-Bills	$500,000	34,690	36,904	30,486	37,755	100,417
British Pound	12,500	17,270	21,239	8,901	884	
Swiss Franc	62,500	102,019	110,047	99,385	19,632	
Deutsche Mark	62,500	74,662	85,439	67,507	6,607	
Japanese Yen	6,250,000	47,601	32,912	34,677	10,835	
Canadian Dollar	$50,000	6,150	3,370	3,315	171	
MidAmerica Commodity Ex.		2,368,547	2,485,166	3,101,855	3,166,537	2,397,721
Wheat	5,000 bu	283,900	297,509	338,487	379,603	346,226
White Wheat	5,000 bu	686	3,402	2,245		
Sunflower Seeds	100,000 bu				4	38
Minneapolis Grain Ex.		284,586	300,911	340,732	379,607	346,264

currency, and its price will drop; decrease the supply, and its price will rise. Here, we will discuss the major factors that determine the supply and demand of currencies in the foreign exchange market.

Balance of Payments

Basic to a country's exchange rate are all the commercial and financial transactions between it, its people, and the rest of the world. The sum of these transactions is the country's *balance of payments*. These transactions include such things as exports and imports of goods and services, foreign investments, and foreign aid transactions.

A country's balance of payments includes all payments made to or received from other countries. Another term, *balance of trade*, refers to just the purchases and sales of goods and services between individuals and businesses in different countries—imports

FIGURE 9-5 (continued)

	Contract Unit	1986	1985	1984	1983	1982
Cotton #2	50,000 lb	1,015,392	636,492	1,137,141	1,550,117	1,255,792
Orange Juice (frozen, conc.)	15,000 lb	211,543	190,758	317,364	124,267	207,070
Propane	100,000 gal	11,966	13,724	22,005	28,721	16,919
European Currency Unit	100,000	72,195				
Dollar Index	$500 x Index	166,494	74,573			
NY Cotton & Citrus		1,477,590	915,547	1,476,510	1,703,105	1,479,781
T-Bonds	$100,000				18	4,464
Domestic CD (90-day)	$1,000,000					132
NYSE Composite Index	$500 x Index	3,123,668	2,833,614	3,456,798	3,506,439	1,432,913
NYSE Financial Index	$1,000 x Index				3,828	13,933
Cmdty Rsrch Bureau Index	$500 x Index	59,324				
New York Futures Ex.		3,182,992	2,833,614	3,456,798	3,510,285	1,451,442
Palladium	100 oz	145,562	133,223	159,019	241,224	63,829
Platinum	50 oz	1,624,635	693,256	571,127	1,053,282	669,024
Imported Lean Beef	36,000 lb					7
Potatoes	50,000 lb				17,115	67,322
Potatoes (Cash Settlement)	100,000 lb	16,558	16,903	26,595	16,650	
No. 2 Heating Oil, NY	1,000 bbl	3,275,044	2,207,733	2,091,546	1,868,322	1,745,526
No. 2 Heating Oil, Gulf	1,000 bbl					74
Leaded Reg. Gasoline, NY	1,000 bbl	829,733	667,172	653,630	406,843	104,082
Leaded Reg. Gasoline, Gulf	1,000 bbl					77
Unleaded Gasoline, NY	1,000 bbl	439,352	132,611	2,736		
Crude Oil	1,000 bbl	8,313,529	3,980,867	1,840,342	323,153	
New York Mercantile Ex.		14,644,413	7,831,765	5,344,995	3,926,589	2,649,941
Total Futures		184,354,496	158,696,578	149,372,225	139,924,940	112,400,879
Percent Change		16.17%	6.24%	6.75%	24.49%	

Source: Futures Industry Association

and exports. Also included in the balance of trade are agricultural commodities, computers, and tourist spending.

The main determinants of balance of payments include:

1. *Economic conditions.* This refers primarily to income in the private sector. Individuals and businesses with money to spend are a source of demand for foreign products and foreign investment. This demand creates a flow of money out of the country and can weaken the currency by stimulating demand for other currencies. This weakening influence is often offset by incoming investment flows that are attracted by the strong economy.

2. *Prices and inflation.* A nation's price level is an important determinant of its export/import balance. Countries whose products and services are highly priced will export less of them than will

countries with similar products and services that are priced lower. Also, the country that has higher prices will be a good market for less expensive foreign imports. The more that imports exceed exports, the weaker a country's currency becomes, because there is less foreign demand for its currency to pay for the products that it exports.

3. *Interest rates.* These are an equally important element in balance of payments swings. If a country's interest rates are high, foreigners will be more inclined to invest money there than if interest rates are low. This results in an inflow of capital and has a positive effect on balance of payments and on that country's currency. Eventually—provided the economy is otherwise in balance—the inflow of funds tends to bring down interest rates and stems foreign-driven investment.

TRY THIS

The balance of payments is a country's economic condition plus prices and inflation. True or False?

HERE'S WHY

False. The balance of payments is the sum of a country's commercial and financial transactions with the rest of the world. These transactions include exports, imports, foreign investments, foreign aid transactions, and tourist spending.

Government and Central Bank Influence

Government influence on foreign exchange can be significant. Fiscal and monetary policy shape the course of interest rates. Trade policies—including treaties, quotas, tariffs, and embargoes—can produce important changes in the export/import balance.

A government's attitude toward the value of its own currency is also very important. A central bank, sometimes acting in concert with other central banks, will often buy or sell large amounts of its own currency on foreign exchange markets in an attempt to raise

or to lower the currency's value. This type of intervention can have both short-run and long-run effects on currency relationships.

Seasonal Factors

Exchange rates are also influenced by seasonal considerations. Demand for a country's currency will be high during a season of heavy exports, as foreigners need the currency to pay for goods. Likewise, periods of peak imports are negative for a country's exchange rate. Countries that have important tourist industries often have weather-related currency flows.

Spot and Forward Price Relationships

There are two types of foreign exchange transactions, spot and forward. Spot transactions are used to meet immediate demand and are for two-day settlement among major banks. They include everything from tourist purchases of currency to the purchase of a foreign currency by a multinational corporation to pay for imported machinery.

Forward transactions are for deferred delivery. Most banks that deal in foreign exchange will enter into a contract with an established customer to buy or sell almost any amount of a currency at any date in the future that suits the customer. This forward market is a part of the interbank market, which also includes spot transactions among banks and their large customers. Forward transactions in the exchange market are similar to those of most physical commodities. They are tailor-made transactions that call for the delivery of a specific amount of a currency, at a specific exchange rate on a specific date or range of dates.

Foreign Currency Futures Market

Trading in currency futures at the International Monetary Market (IMM) of the Chicago Mercantile Exchange began in May 1972. It was developed as a supplement to the established forward market in much the same way that grain futures developed as a supplement to their forward markets. Other exchanges have since

attempted to develop currency futures contracts, but as of mid-1987 only the IMM and the New York Cotton Exchange contracts had trading activity, with the IMM contracts accounting for more than 90% of the total volume.

Interest Rate Futures

Since the introduction of GNMA futures on the Chicago Board of Trade in 1975, the role of interest rate futures in speculation, hedging, and portfolio management has expanded a great deal. The rapid growth in the volume of these markets stemmed from the increased risk and opportunity that greater interest rate volatility created for both borrowers and lenders since the early 1970s. The significant profit opportunities that are available to speculators played an equally important role in the expansion of these markets.

Factors Influencing Interest Rates

Interest is the price paid for the use of money or credit. And like any price, it is fundamentally determined by the supply-and-demand forces at work in its marketplace. Many factors such as fiscal and monetary policy determine the level of interest rates.

It is important to keep in mind that there are many different interest rates. Each reflects the risk and maturity of a type of loan. Our discussion involves those factors that influence the "general" level of interest rates.

Business Conditions

The most significant demand for private sector credit comes from businesses. When the economy is expanding, demand for funds tends to be strong because businesses expect to make enough return on their borrowings to more than offset the payment of principal and interest. Conversely, a contracting economy restricts business activity and restricts the demand for credit.

To track business conditions, users of financial futures markets carefully watch various areas of economic activity including inven-

tories, construction, unemployment, capacity utilization, and re-
tail sales, among others.

Another important source of private sector demand is indi-
vidual households. Department store credit sales, credit card us-
age, automobile loans, and mortgages are just a few examples of
the types of borrowing made by households.

Fiscal Policy

The fiscal policies of both the federal and local governments can
have an extremely important effect on interest rates. When ex-
penses exceed revenues, the government must finance the debt by
borrowing in the open market. This exerts upward pressure on
rates. Economic policies designed to stimulate growth tend to
stimulate the demand for loans from both individuals and
businesses. Likewise, tax policies that encourage investment can
have a bolstering effect on interest rates. Some important compo-
nents of fiscal policy are military spending, interest rates, public
works, entitlement programs, and tax rates.

Monetary Policy

In recent years U.S. monetary policy, as implemented by the
Federal Reserve Board (the Fed), has been one of the most impor-
tant factors influencing interest rates. The Fed uses three main
tools to achieve its broad objective of maintaining a healthy eco-
nomy through its management of the nation's money supply.

1. Open market operations involve the purchase and sale (on the
 open market) of Treasury bills, notes, bonds, and other obliga-
 tions. Fed purchases tend to raise bank reserves, while sales
 tend to lower them.
2. Regulation of member bank discount rates. The discount rate is
 the amount the Fed charges its member banks for short-term
 loans. Increases in this discount rate tend to bolster short-term
 rates, while decreases have the opposite effect.
3. Member bank reserve requirements. Changes in member bank
 reserve requirements are a less frequently used method of in-
 ducing changes in interest rates. Every member bank of the

Federal Reserve is required to keep a certain percentage of its deposits in reserve. When the Fed reduces this requirement, added funds are made available for loans—and interest rates tend to decrease. Increases in reserve requirements tend to cause rates to rise because fewer funds are available for loans.

Money Supply

Of the Fed statistics that are watched by traders, the money supply is by far the most widely followed. As of mid-1987, money supply was defined three ways: M1 is the narrowest definition, consisting of currency that is held by the public, travelers' checks, and deposits at banks and other depository institutions. Bank deposits include demand deposits and other checkable deposits. M2 and M3, the more broadly defined aggregates, include M1 and such other assets as savings deposits, time deposits, and shares in money market mutual funds.

In theory, it would seem that an increase in the money supply would tend to push interest rates lower because more money is available to borrowers. Higher rates might be expected to follow reductions in the money supply as credit availability tightens. However, the actual relationship between interest rates and changes in the money supply can be both complex and unpredictable. A rapid increase in money supply, for instance, may be regarded as inflationary and therefore lead to higher interest rates. Lenders, fearing a devaluation of the money they lend, demand a higher interest rate. Interest rates are sensitive both to the supply of money itself and to the effect that any changes in the money supply might have on inflation.

Interest Rate Markets

The heart of activity for short-term interest rate instruments is a broad, vaguely defined trading arena known as the *money market*. The term generally refers to the market for short-term credit instruments such as Treasury bills, commercial paper, bankers' acceptances, certificates of deposit, and Federal funds.

It is characteristic of business and financial institutions that their cash receipts and disbursements are not usually balanced. For

instance, a business may find that on some days its cash holdings accumulate because receipts have exceeded expenditures. At other times the same business may be short of cash because expenses have outpaced income. Most businesses prefer to maintain some cash reserve so that both normal and "unusual" expenses can be satisfied with minimal dependence on current cash inflow. Financial institutions, such as commercial banks, also must maintain cash reserves so as to comply with legal reserve requirements. To minimize the cost of these cash reserves, business and financial organizations invest the cash in highly liquid, virtually riskless short-term instruments. During periods of excess cash, they buy these instruments. When in need of cash, they sell them. The money market and the instruments that comprise it exist to meet the alternating cash requirements of these enterprises.

The term *capital market* is used to describe the arena for raising long-term capital. The capital market differs from the money market primarily in the maturity of the instruments. A second distinguishing feature is that the capital markets include both debt and equity instruments, but the money markets deal in only debt securities. The money market is designed for short-term financing while the capital market finances long term. Because of these longer maturities, securities in the capital market usually have greater risk than do money market instruments.

An important instrument of the money market is the repurchase agreement (repo). Repos are used both privately and by the Fed when it seeks to steer the Federal Funds rate. Basically, a repo is the sale of a security (usually a government security) by a dealer or the Fed, to a buyer, with the agreement that the dealer will repurchase the security at a stated time at a higher price. The difference between the purchase and sale price provides the holder with a previously agreed-upon rate of return. When we hear that "the Fed is doing repos," this means that the Fed is lending money and increasing bank reserves. Reverse repos by the Fed entail the borrowing of funds, that is, the absorbing of reserves.

TRY THIS

"The Fed is doing repos" means the Fed is:

a. decreasing bank reserves
b. borrowing money

c. lending money and increasing bank reserves

d. buying securities

HERE'S WHY

The correct answer is (c). This expression means that the Fed is lending money and increasing bank reserves. Reverse repos by the Fed entail the borrowing of funds.

TABLE 9-1

Money Market Instruments (Short Term)	Capital Market Instruments (Long Term)
Treasury Bills (T Bills)	GNMAs
T-Bill Futures Contract	GNMA Futures
Commercial Paper	Treasury Notes
Commercial Paper Futures	Treasury Note Futures
Certificates of Deposit (CDs)	Treasury Bonds
CD Futures	Treasury Bond Futures
Eurodollars	Municipal Bonds
Eurodollar Futures	Municipal Bond Futures

Price Relationships and Interest Rates

Now that we have examined the instruments that make up the financial futures markets, we will very briefly discuss how the prices of these instruments relate to one another and their underlying cash article. The first important step in this process is an understanding of something called the yield curve.

The Yield Curve

In the *normal yield curve*, yields increase as the maturity is extended. This is because the longer-term maturity is subject to more uncertainty from inflation and security factors. Also the longer-term securities command higher yields because price volatility

tends to increase with longer maturities. Therefore, less risk is associated with short-term maturities, and the returns are less.

The normal yield curve also tends to flatten at extended maturities. This is because liquidity preference is a more significant issue for nearby maturities than for distant maturities. Differences between 20 years and 30 years forward are much more difficult to project than between 2 and 3 months forward.

Implied Forward Yields

To understand the nature of interest rate futures prices, it is necessary to look at this concept. The *implied forward yield* is what interest rates are expected to be for a specified period in the future.

To understand implied forward yield, you should understand the yield curve. The yield curve is a graphical representation of the rates that are associated with instruments of different maturities at a given time. Figure 9-6 is a hypothetical plot of the yields on United States Treasury securities that range from 90 to 360 days maturity.

Another example might depict the yields on government notes and bonds out to the year 2000. In any case, the curve is the net result of all the buying and selling that has taken place. It represents the willingness of investors to hold securities of varying maturities.

The yield curve has two characteristics of particular importance:

• Yields increase with maturity.
• The rate of increase tends to be steepest between the early maturities and flatter between the later ones.

This is the way yield curves are shaped under normal circumstances. It is therefore known as a normal yield curve.

The normal yield curve takes its shape largely because of a concept known as *liquidity preference*. The liquidity preference theory argues that shorter-term securities have relatively greater value (lower yields) because they entail less risk. This is true because longer maturity instruments have greater uncertainty associated with them. As an extreme example, take the case of a 20-year Treasury bond versus a 90-day Treasury bill. The bond is

FIGURE 9-6 Normal Yield Curve

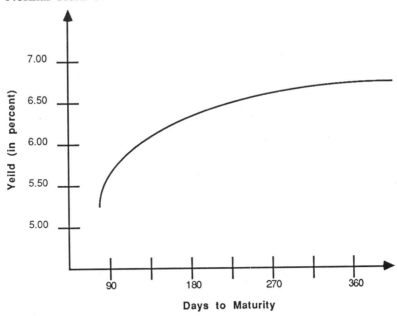

subject to greater risks from such factors as inflation or even default than the shorter-term bill. Investors, therefore, will normally require higher yields to compensate for the higher risks that are attendant to owning long-term securities. Another reason that longer-term securities command higher yields is that price volatility tends to increase with term to maturity. An example will help illustrate this point: A 1% increase in the annual yield of a one-year security that has a face value of $1 million would result in a $10,000 decline in the value of the security. The same 1% increase in the yield of a two-year security would produce a decline in value of about $20,000. This is true because yields are expressed on an annual basis. Thus, the $10,000 price decline equates to a 1% increase in yield for the one-year instrument. But for the two-year instrument, a $20,000 decline ($10,000 in each of two years) is necessary to achieve a 1% annual change in yield. For these reasons, the normal yield curve shows rates that increase with maturities.

The normal yield curve also tends to become flatter at the extended maturities. This phenomenon occurs because liquidity preference is a more significant issue for two nearby maturities than for two distant ones. The risks that are associated with own-

ing a two-year versus a one-year security are fairly significant. However, the risk difference between a 30-year instrument and a 29-year one is difficult to imagine. Therefore, investors will ordinarily require a much greater yield premium for the two-year over the one-year instrument than they will for the 30-year over the 29-year instrument.

At times when short-term funds are unusually tight, short-term interest rates can be higher than long-term interest rates. This situation is reflected in an *inverted yield curve*, which is depicted in Figure 9-7. This situation tends to be less common than the normal yield relationship for the reasons described previously.

The upward slope of the normal yield curve tells us quite clearly that rates increase with maturity. It also reveals something about interest rate expectations. To illustrate, assume that the yield of a one-year instrument is 8% and that of a two-year instrument is 9%. What does this imply about the market's expectation of interest rates during the second year? In other words, interest rates are 8% for year one and 9% for years one and two together. Does this reveal anything about expected rates during year two? Indeed

FIGURE 9-7 Inverted Yield Curve

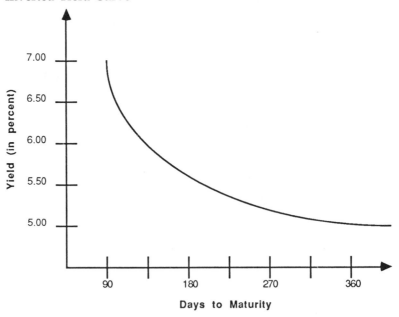

Days to Maturity

it does. It tells us that rates during year two are expected to be about 10% because 8% in year one and 10% in year two average out to 9% for years one and two together. This derivation of the expected interest rate for a future time period from the rates on two existing instruments is known as the *implied forward rate*.

Spreads

To spread interest rate futures, a trader looks at the yield curve of the underlying security and compares it to the yield curve of the futures, which should be equal to the implied forward rates.

The principles to remember are: (1) When the yield curve is normal and the trader expects it to flatten, he sells the nearby and buys deferred maturities (bull spread); (2) should a trader expect a steepening of the curve, he would do the opposite—buy the near-by and sell the deferred (bear spread).

Hedging

Many financial institutions and other businesses attempt to protect themselves from interest rate volatility by hedging with interest rate futures.

TRY THIS

If the yield curve is normal, a bullish spreader expects:

I. Long-term rates to decline more than short-term rates
II. Short-term rates to decline more than long-term rates
III. Treasury note prices to rise faster than Treasury bond prices
IV. Treasury note prices to fall faster than Treasury bond prices

 a. I only
 b. III only
 c. I and IV only
 d. II and IV only

HERE'S WHY

The correct answer is (a). A bullish bond trader wants rates to decline so that prices may rise. Because long rates tend to move faster than short rates, long bonds should move up faster than shorter notes, causing the spread to widen.

TRY THIS

The monetary policies of both federal and local governments influence interest rates. True or False?

HERE'S WHY

False. *Fiscal policies*, the spending policies of both the federal and local governments can have an extremely important effect on interest rates.

Commodities

Agricultural

The element that distinguishes crops from other commodities is that they are produced (harvested) during a brief period of the season and their supply must last until the next year's harvest. The "tone" of any given season is usually set by the size of that season's crop; consequently, much effort goes into accurately forecasting it. Supply is usually the main variable in the price equation of field crops.

There are several commodities that are designated as agricultural because their source of origin is essentially from the land. A discussion of each of these follows.

Corn

The United States is by far the world's largest corn producer, accounting for about 40% of total world output. China ranks second with some 15% of the global total. With annual production

in recent years of more than 8 billion bushels, corn is easily the largest crop grown in the United States. Approximately 80% of U.S. production is concentrated in the Corn Belt states of Iowa, Illinois, Minnesota, Indiana, Missouri, Ohio, and South Dakota. About 60% of this production is used as domestic animal feed. Cattle, hogs, and poultry are the primary consumers. Roughly 25% of the rest is exported, with Japan, West Germany, and Mexico almost always among the largest importers. The Soviet Union sometimes purchases large amounts of U.S. corn, depending largely on the size of its own grain crop. The amount of Soviet purchases varies widely from season to season and is often a key influence on prices.

Cotton

Domestic production of cotton is concentrated in the range of Southern states known as the Cotton Belt. The largest producing area is the Delta region, made up of Mississippi, Arkansas, Tennessee, Louisiana, and Missouri, although there is substantial production in the Far West. Cotton consumption falls into two categories: domestic mill production (apparel/household use) and exports. Cotton's share in these and other markets varies according to the prices of competing synthetic fibers and the sizes of foreign crops. Demand for cotton products generally depends on price level, per-capita income, and overall economic conditions.

Soybean Complex

Soybeans compete with corn as the nation's number one cash crop. Soybean products represent a major source of protein for poultry and livestock as well as key ingredients in the manufacture of shortening, margarine, and cooking and salad oils.

Most U.S. production is concentrated in the Corn Belt states of Illinois, Indiana, Iowa, Ohio, Missouri, and Minnesota. Two major products obtained from soybeans are soybean oil and soybean meal; the value of soybeans is determined by the value of the meal and oil, as well as by the size of the crop. The difference between the value of the soybeans and the value of its end products is known as the crushing margin and represents a yardstick of profit to the soybean processor. A large crushing margin represents

profit for soybean processing, thereby strengthening the demand for soybeans and increasing supplies of oil and meal. Conversely, a low or negative crushing margin will discourage demand for soybeans and reduce the production of products.

With soybean oil, because of the fairly high degree of interchangeability among fats and oils in the domestic and international market, the availability and price of competing edible oils can be a major factor in its price.

Soybean meal prices are very dependent upon sudden and unanticipated changes in demand or production because meal cannot be stored for long periods. There are, also, competing foodstuffs that impact on the price level.

Wheat

Wheat is harvested somewhere around the world in every month of the year. In the United States, harvesting begins in the southern end of the Wheat Belt (Texas) in early summer and progresses northward. Kansas, Washington, Nebraska, Oklahoma, and North Dakota are major producing states.

Exports are a major influence on wheat prices and are heavily dependent on world crop conditions. The United States sells approximately half of its crop abroad and is traditionally the world's largest exporter. Conditions in the Soviet Union, both a major producer and a major consumer of wheat, play an important role in determining wheat prices.

Live Hogs

The Corn Belt states of Iowa, Illinois, Indiana, and Missouri account for more than half the hogs raised in the United States. From the farms where they are raised, hogs are brought to terminal markets where they are bought by meat packers, slaughtered, and processed into pork products such as ham and bacon.

The demand for hogs is determined by consumer purchases of fresh pork and pork products. Consumer purchases are a reflection of pork prices, prices of competing meats, disposable income, and diet preferences. Pork demand tends to reach its peak during the summer and early fall and drops to a seasonal low during the winter and early spring.

Pork Bellies

Pork bellies are the part of the hog that is used to produce bacon. The demand for bacon tends to be fairly stable, responding significantly only to the most extreme price moves. This inelasticity of demand means that small changes in supply can produce magnified changes in price.

Live Cattle

The cattle business is one of the largest components of the U.S. agricultural sector. In a typical year more than 20 million head of cattle are marketed with a total wholesale value of more than $10 billion. Only corn and soybeans are comparable to the beef industry in terms of market value produced. Cattle are almost exclusively consumed in the countries where they are produced, so futures traders need focus only on the fundamentals in the U.S. beef industry. The reason, of course, is that the bulk and perishability of live cattle preclude meaningful exports.

TRY THIS

A. ____ Corn	1.	Inelasticity of demand produces magnified changes in price
B. ____ Cotton	2.	Third only to corn and soybeans as largest component of agricultural commodity sector
C. ____ Soybeans	3.	Approximately one-half of the U.S. crop is exported
D. ____ Wheat	4.	Demand reaches peak in summer and early fall
E. ____ Live Hogs	5.	Value is determined by value of end products, as well as by size of crop
F. ____ Pork Bellies	6.	Demand dependent on prices of synthetics
G. ____ Live Cattle	7.	United States the largest producer

HERE'S WHY

Now check your answers against the following: A-7; B-6; C-5; D-3; E-4; F-1; and G-2.

Imported/Tropical Commodities

The commodities that fall into this category are as follows.

Cocoa

Cocoa is a truly international commodity. It is produced almost exclusively in Africa and South America and consumed primarily in the industrialized countries of Europe and North America. Cocoa trees are indigenous to the West Indies and were transplanted to West Africa in the latter half of the nineteenth century. Africa subsequently became the center of world cocoa production and retains that position despite the emergence of Brazil as a major force in the market. Ghana was the world's leading cocoa producer for much of the twentieth century but lost this title to the Ivory Coast in the late 1970s.

As with most agricultural commodities, weather plays an important role in cocoa production. The major threat is usually hot, dry weather during the summer growing season. Cocoa trees are also susceptible to excessive rains that can wash the cocoa-producing flowers off the tree before maturity. Available output can sometimes be restricted by labor or transportation difficulties in some of the African producing nations. Problems with the Brazilian crop can have a dramatic impact on prices even though this crop is less than 20% of the world total. This is because the Brazilian harvest comes after the African harvest has moved to market, so an unexpected shortfall can leave the market with smaller-than-expected supplies in the final months of the crop year.

Coffee

Coffee, which is indigenous to Africa, became a major commercial commodity in the nineteenth century and is now one of the most important agricultural products in the world. The dollar value of

the world's coffee crop usually approximates that of the major grains such as wheat, corn, and soybeans.

Coffee demand has grown steadily through the years, with particularly dramatic growth during the 1950s and 1960s. The 1970s showed a decline in interest due to high prices caused by frost on the Brazilian crop. Although coffee demand exhibited signs of improvement during the early 1980s, a number of difficulties lingered on the demand side. For example, the United States, by far the world's largest consumer of coffee, has seen demand for the product moderate because of a discernible shift in consumer preference. Beer and soft drinks have apparently gained favor at the expense of coffee consumption. In 1960, for example, daily per-capita American consumption was estimated at 3½, compared to just under 2 cups in 1981. Also, growth in Western European coffee consumption has apparently moderated, suggesting that much of the prevailing coffee market is reaching saturation. Thus, the third-world and Soviet-bloc nations may have to pick up the slack if coffee demand is to hold steady or increase.

Sugar

Sugar has a history as an internationally traded commodity that dates back to ancient times. There are two types of sugar-producing plants, but the sugars that they produce are identical. Sugar cane is grown above ground in a grass that is indigenous to tropical and subtropical regions of the world. Sugar beets grow underground and because of an extensive root network, are relatively unaffected by droughts. However, the leaves of the beet are affected by extended periods of cloudy or inclement weather. Thus, while rainfall affects tropical sugar cane, cloudy weather influences the important European beet crop.

Sugar demand has consistently increased through the years. This is largely because of the steady growth in world population. Sugar demand was also aided by the high oil prices of the 1970s. A number of Middle Eastern and third-world oil-producing nations found themselves with unexpectedly high foreign exchange revenues. This resulted in increases in per-capita sugar consumption. Conversely, the subsequent decline in oil prices limited sugar consumption by these nations. The bearish influence of this development was heightened by a reduced incentive for Brazilian sugar producers to divert processing of cane to ethanol. In the

United States, sugar prices are directly affected by government subsidy programs.

In general, North and South America, Western Europe, Asia, and the Eastern-bloc nations are the largest consumers of sugar. Demand trends in these nations often have an influence on long-term sugar prices.

Frozen Concentrated Orange Juice

Frozen concentrated orange juice (FCOJ) is a market that developed in the United States after World War II. Florida is the largest orange-producing state by a wide margin, usually accounting for 75% or more of total U.S. output. Florida's dominance is such that traders seldom pay attention to production data from any other state. California produces about one-fourth the quantity of oranges that Florida does, but a large percent of these are eaten as fruit rather than processed into juice. Until the late 1970s, imports were a negligible factor in the FCOJ market. However, since then, Brazil has emerged as an important supplier to the U.S. market. This followed a combination of high U.S. orange prices and Brazil's desire to increase agricultural exports.

The important Florida orange crop is harvested between December and March. Valencia oranges, which are harvested toward the end of this period, receive particular attention from futures traders because they are the key ingredient in FCOJ.

Precious Metals

The commodities considered part of this category include the following.

Gold

South Africa is by far the largest producer of gold in the world. During the last century it has produced more than 40% of the gold in existence today and still boasts substantial reserves of relatively rich ore.

However, a number of factors are responsible for stagnant levels of gold production in South Africa. First, the sharp devalua-

tion of the rand (South African currency) against the U.S. dollar in the world's currency markets lowered effective mine costs and encouraged the mining of low-grade ore. Second, the depletion of very high-grade ore reserves has taken its toll on production. Finally, South African laws that require mine reserves to be preserved have also moderated output in recent years.

The demand for gold is very price elastic. This is particularly true because demand by the jewelry industry, the largest single consumer of gold, is extremely sensitive to the prevailing price of bullion.

Gold is often looked upon by investors as an inflation hedge that is likely to retain its value during periods of widespread price increases. As a result, gold soared above $800 per ounce in 1980 in reaction to increases in oil and grain prices. The deflationary economic climate of later years, however, brought about a decline in the price of gold.

Platinum

South Africa dominates free world production of platinum and is the only nation that is a primary producer of this metal.

Platinum prices, like gold prices, generally rise during periods of dollar depreciation, international tension, inflation, or economic uncertainty. As with gold, investors often forecast the swing of platinum demand and can play a large role in the determination of prices. Platinum is also regarded as an industrial metal because of its use in chemical manufacturing and automobile exhaust catalysts.

Silver

Mexico has become the free world's largest producer of silver, with annual output in excess of 60 million ounces. Most of the output stems from primary operations that also produce smaller quantities of lead, zinc, and occasionally copper.

Secondary production of silver is very important to the market's overall equation. Because new mine output of silver usually falls short of demand, secondary sources of the metal determine whether the market is in a surplus or deficit situation. Scrap consists of silver that has been recovered from melted silverware, used

photographic solutions, and discarded electrical contacts. During times of low prices, silverware and other items containing silver are thrown away by people not connected with the industry. Scrap recovery of silver is extremely price elastic. It has been estimated that a 10% change in silver prices impacts scrap recovery by 5%. Silver is also regarded as an industrial metal.

Copper

Copper, unlike the other metals discussed so far, is strictly an industrial metal. However, it sometimes reacts to broad price trends in the precious metals and, like gold and silver, often responds to general currency and interest rate movements. Similarly, broad developments in the industrial sector influence metals, such as copper, which boast relatively defined manufacturing uses. On the whole, however, copper remains most sensitive to its own specific fundamentals.

Palladium

This metal is a platinum-group metal. However, the market for palladium is much smaller than that for platinum as it is almost entirely industrially based. The dominance of gold, silver, and to a lesser degree, platinum, combined with palladium's industrial base, has limited the usefulness of this metal as a speculative vehicle.

TRY THIS

A. ____ Gold 1. Secondary production very important and influential to overall market prices

B. ____ Sugar 2. Inflation hedge

C. ____ Cocoa 3. Produced almost exclusively in Africa and South America but consumed primarily in North America and Europe

D. _____ Coffee

E. _____ Silver

F. _____ Copper

4. Strictly an industrial commodity

5. Demand trends influence long-term price

6. Much of the market may be reaching the saturation point

HERE'S WHY

Now check your answers against the following: A-2; B-5; C-3; D-6; E-1; and F-4.

Stock Index Futures

Stock index futures began to trade in February 1982 when the Kansas City Board of Trade introduced a contract based on the Value Line Average (VLA). Soon thereafter, trading in two other stock indexes was introduced. In April 1982, the Index and Options Market of the Chicago Mercantile Exchange began to trade a stock index contract based on the Standard & Poor's (S&P) 500 Stock Index. In May 1982, the New York Futures Exchange received CFTC approval to begin to trade in a stock index futures based on the New York Stock Exchange (NYSE) Composite Index. Other stock index futures contracts have since been introduced, but of these only the CBOT's Major Market Index (MMI) has enjoyed much success. This index is made up of 20 leading blue-chip stocks and is used by some traders as a proxy for the popular Dow Jones Industrial Average.

A stock index futures contract is an obligation to deliver at a future date an amount in cash that is some dollar multiple of the value of the underlying index at expiration of the contracts. The profit or loss from a futures contract that is settled by "delivery" is the difference between the value of the index at expiration and the value when originally purchased or sold. Delivery at settlement cannot be in the underlying stocks of the index but must be in cash.

Major Index Futures

There are several stock index futures contracts. Four major ones are:

S&P 500

The S&P 500 Index is a value-weighted arithmetic mean of the market value of the component stocks. It consists of 500 stocks, with the price of each weighted according to its market value. The index reflects the total value of the underlying securities and can be viewed as hypothetical portfolios that consist of the entire market value of each security included in the index. Each day the index is recalculated so that the previous day's index has no bearing on the current day's value.

NYSE Index

The NYSE Index is computed in the same way as the S&P 500. The major difference is that the NYSE Index includes all of the more than 1500 stocks listed for trading on the New York Stock Exchange.

VLA Index

The Value Line Average has a different and somewhat more complicated method of calculation than the last two indexes we mentioned. It is derived by computing the percentage change of every stock in the index and adding their geometric mean to the previous day's average. The VLA is an equal-weighted index in terms of the percentage change of each stock. Thus, a given percent increase in the price of a small company has the same effect as the same percent change of a giant company. In all, there are approximately 1700 stocks contained in this index.

MMI Index

The Major Market Index is a broad-based stock index that measures the performance of 20 leading blue-chip securities on the New York Stock Exchange. The MMI is a price-weighted index,

computed by adding together the prices of the individual stocks and dividing by a factor that occasionally changes to account for splits and dividends.

Cash Settlement at Delivery

As mentioned earlier, unlike most other commodity or financial futures, deliveries against maturing stock index contracts are made by cash settlement. The primary reason for this is that the physical delivery of securities is not practical. The costs and the difficulties of delivering all the component securities of any broad-based index are too great. Also, the potential for manipulation at delivery time by those holding large blocks of the component stocks makes cash settlement a more viable method than that of traditional physical delivery.

TRY THIS

A. ____ S&P 500

B. ____ NYSE Index

C. ____ VLA Index

D. ____ MMI Index

1. Equal-weighted index of approximately 1700 stocks

2. Value-weighted index of specific stocks

3. Price-weighted index of blue-chip stocks

4. Value-weighted index of all listed stocks

HERE'S WHY

Now check your answers against the following: A-2; B-4; C-1; and D-3.

Index